"Let me be clear about this: I don't have a drug problem,
I have a police problem."

—KEITH RICHARDS

Art issues. Press

Series Editor: Gary Kornblau

The Invisible Dragon: Four Essays on Beauty, by Dave Hickey
Winner of the Frank Jewett Mather Award for Distinction in Art Criticism in 1994

The World of Jeffrey Vallance: Collected Writings 1978-1994
Co-editor: David A. Greene; Introduction by Dave Hickey

Last Chance for Eden: Selected Art Criticism by Christopher Knight 1979-1994
Edited by MaLin Wilson; Introduction by Dave Hickey

Mythomania: Fantasies, Fables, & Sheer Lies in American Popular Art, by Bernard Welt
With "The Dark Side of Disneyland" by Donald Britton
Finalist for a Lambda Literary Award in 1996

Art issues. Press
8721 Santa Monica Boulevard, #6
Los Angeles CA 90069
Telephone (213) 876-4508

FRONTISPIECE
Scott Grieger
Keith Richards Playing Don Judd Guitar, 1972
Collage, 11 x 8½"
Courtesy of the artist

AIR GUITAR

DAVE HICKEY

Essays on Art & Democracy

Art issues. Press
Los Angeles

Art issues. Press
The Foundation for Advanced Critical Studies, Inc.
8721 Santa Monica Boulevard, Suite 6
Los Angeles, California 90069

This publication has been made possible through the generous financial
support of Lannan Foundation, with additional funding provided by the
Bohen Foundation, the Challenge Program of the California Arts Council,
and the City of Los Angeles Cultural Affairs Department.

Designed by Tracey Shiffman
Printed by Sinclair Printing Company

Manufactured in the United States of America

Library of Congress Cataloguing in Publication Number: 97-60779
International Standard Book Number: 0-9637264-5-5

This book is dedicated to the memory of my grandparents
Harriet Rebecca Boswell & Samuel Edwards Balch
Who never wanted anything, who gave away the things they had

And to the memory of my parents
Helen Virginia Balch & David Cecil Hickey
Who wanted it all, for everyone, now

You must have a little patience. I have undertaken, you see, to write not only my life, but my opinions also; hoping and expecting that your knowledge of my character, and of what kind of a mortal I am, by the one, would give you a better relish of the other: As you proceed further with me, the slight acquaintance which is now beginning betwixt us, will grow into familiarity; and that, unless one of us is in fault, will terminate in friendship. . . . Therefore, my dear friend and companion . . . if I should seem now and then to trifle upon the road,—or should sometimes put on a fool's cap with a bell to it, for a moment or two as we pass along,—don't fly off,—but rather courteously give me credit for a little more wisdom than appears upon my outside;—and as we jogg on, either laugh with me, or at me, or in short, do any thing,—only keep your temper.

—LAURENCE STERNE, *The Life and Opinions of Tristram Shandy, Gentleman*

Contents

Unbreak My Heart, An Overture

Two nights ago, I was talking with some local artists about things that used to be cool and weren't anymore—things that we missed. These artists were mostly kids, so they missed some really stupid stuff, I thought, like Adam Ant and giant shoulder-pads in women's clothes. I told them that I missed "standing alone"—the whole idea that "standing alone" was an okay thing to do in a democracy. "Like *High Noon,*" I explained, and one of them said, "Oh, you could do that today . . . (pause for effect) . . . But first you'd have to form a *Stand-Alone Support Group!*" Everyone laughed at this, and I did too, because she was probably right, but I didn't laugh that hard, because, at the time, I was proofing this book, which constitutes my own last, tiny fling at standing alone. It's hardly *High Noon,* I know, but these essays do represent an honest effort to communicate the idiosyncrasy of my own quotidian cultural experience in the United States in the second half of the twentieth century—to recount some of that experience and, whenever possible, account for it.

The stories that this book tells populate the deep background of everything I have ever written, and I am telling them now because too often in the past I have spoken their lessons in the shorthand of authority. I spent my childhood, for instance, in the cacophonous, postwar milieu that gave birth to bebop—to Dizzy Gillespie and Charlie Parker. It was my father's world, and I remember it today with the brightness of a child's vision. Its stresses and permissions are manifest in things that I have seen with my eyes and felt in my body, so I know, in a physical sense, what virtuosity and improvisation meant in that moment, as a style and a lifestyle, how necessary they seemed. Too many times, however, alluding to these complexities, I have simply written "Jackson Pollock," and let it go at that. On too many other occasions, rather than trying to evoke the sense of queasy dread that

has accompanied my every encounter with the diffuse network of proprietary surveillance that permeates this society, I have simply written "the diffuse network of proprietary surveillance, etcetera," footnoted Foucault, and moved along.

This book is an apology for that sort of authoritarian behavior, because, in truth, I have never taken anything printed in a book to heart that was not somehow confirmed in my ordinary experience—and that did not, to some extent, reform and redeem that experience. Nor have I had any experience of high art that was not somehow confirmed in my experience of ordinary culture—and that did not, to some extent, reform and redeem that. So I have tried to reinstate the connective tissues here, and, in the process, have written an odd sort of memoir: a memoir without tears, without despair or exaltation—a memoir purged of those time-stopping exclamation points that punctuate all our lives.

So there are no Mozart Requiems here, nor masterpieces by Velázquez, no mind-bending sexual encounters or life-confirming acts of friendship, no bloody curtains or puking withdrawals, no heartbreaks, gunshots, humiliations, or bodies hanging in the bedroom. This is just the ordinary stuff—the ongoing texture of the drift, where, it has always seemed to me, things *must* be okay, or the rest will certainly kill you; and if I have any real qualification for the job that I have undertaken, it is that I have always been okay with everyday life and beguiled by the tininess of it—and beguiled as well by the tininess and intimacy of artistic endeavors—by The Bird with his horn and Velázquez with his tiny brush—and by the magical way these endeavors seem to proliferate.

When I was a kid, books and paintings and music were all around me, all the time, but never in the guise of "culture." They were remarkable domestic accouterments that I encountered nowhere else. They were not to be found in the homes of my friends, and I can assure you that my family played no part in any "larger cultural community." We played no part in anything,

except America. We were just out there in the middle of it, on the edges of it, and on the move. So cut apart were we, in fact, that I can remember being amazed that whatever city we landed in, my folks could always find these little bookstores and record shops, art galleries and jazz clubs that no one else knew about. I thought of them as secret places where you could go and meet other people who were part of this secret thing.

So the whole cultural enterprise, when I was growing up, was at once intimate and a little mysterious. It took place at home, in other people's homes, and in little stores. Yet, as we moved around, I begin to get a sense of how *huge* an enterprise it really was. Everywhere we went there were bookstores and record shops, art galleries and jazz clubs, where otherwise normal-looking people did all these cool things. *And nobody noticed. Nobody knew anything about it!* My teachers didn't know about it. The newspapers didn't know about it. My scoutmasters didn't know about it. The television didn't know about it. My friends didn't know about it. Even their parents didn't know about it. For a kid, this was awe inspiring. I was like Oedipa Maas, in *The Crying of Lot 49,* when she discovers the Tristero, because, thanks to my folks, I was privy to this vast, invisible, underground empire that, unlike the Tristero, trafficked in nothing but joy.

I chose to dwell in that underground empire for the first forty-seven years of my life—in record stores, honky tonks, art bars, hot-rod shops, recording studios, commercial art galleries, city rooms, jazz clubs, cocktail lounges, surf shops, bookstores, rock-and-roll bars, editorial offices, discos, and song factories. I lived the freelance life, in other words, and did okay at it, until 1987, when this nation, in its wisdom, decided that citizens who lived the way I did were no longer deserving of health insurance, by virtue of their needing it a lot. Faced with this reality, I began to take teaching gigs in universities and soon discovered that, for the length of my whole life, from birth until the day I stepped on campus, I had been consorting with the enemy. According to the

masters of my new universe, all the cruelties and inequities of this civilization derived from the greed and philistinism of shopkeepers, the people who ran those little stores, who bought things and sold them, as I had done.

I found this amazing, because the problem for me had never been who sold the dumb object, or bought it (it was just a dumb object), but how you acquired the privilege of talking about it—how you found people with whom you *could* talk about it. My new masters were obsessed with *things*. So I wondered if they had known any shopkeepers. What, I wondered, would these people have thought of Sumpter Bruton, a tasty jazz drummer by night and shopkeeper by day, who ran the little record store where I learned about everything from bel canto to Blind Lemon to Erik Satie, who loved every kind of noise that human beings made—with the possible exception of the noises made by Neil Diamond? And what would they have thought of Mickey Ruskin and Hilly Kristal who ran great bars where new worlds were made, where you could talk about things and listen to music? And what would they have thought of Harold Garner and David Smith, whose bookstore was their baby and the site upon which I discovered *Twentysix Gasoline Stations* and *Logique du sens,* who would order weird books because they thought I might be interested in them, and never tell me if they weren't returnable? The books I didn't buy would just lay around, gathering dust, until I figured that out. Then I would buy them for cost, and cheap at the price.

I know, of course, what my colleagues think of Leo Castelli, Richard Bellamy, Paula Cooper, Klaus Kertess and the Janis brothers, because they are (or used to be) art dealers and, thus, the very embodiment of Satan. Even so, when I was a youngster adrift in Manhattan, these people recognized me the second or third time I wandered into their stores. They came out and talked to me about what was hanging on the walls. They even pulled stuff out of the back so we could talk about that, knowing full well (by my outfit) that I was a cowboy and no kind of a collector at all. That was the

best thing about little stores. If you were a nobody like me, and didn't know anything, you could go into one of them and find things out. People would talk to you, not because you were going to buy something, but because they loved the stuff they had to sell. The guy in the Billabong Surf Shop, I can assure you, wants to talk about his boards. Even if you want to buy one, right now, he *still* wants to talk about them, will talk you out into the street, you with the board under your arm, if he is a true child of the high water.

And I love that kind of talk, have lived on it and lived by it, writing that kind of talk for magazines. To me, it has always been the heart of the mystery, the heart of the heart: the way people talk about loving things, which things, and why. Thus it was, after two years on university campuses without hearing anything approximating this kind of talk, I began feeling terrible, physically awful, confused and bereft. I kept trying to start this kind of talk, volunteering my new enthusiasms like a kid pulling frogs and magic rocks out of his pocket, but nothing worked. There was no *bounce*, just aridity and suspicion. It finally dawned on me that in this place that we had set aside to nurture culture and study its workings, culture didn't work.

It couldn't work, in this place, because all the things that I wanted to talk about—all those tokens of quotidian sociability that had opened so many doors and hearts for me—all those occasions for chat, from *Tristram Shandy* to *Roseanne,* from Barnett Newman to Baby Face—*belonged* to someone. But not to everyone. All the treasures of culture were divvied up and owned by professors, as certainly as millionaires own the beach-fronts of Maine. So, even though, in the course of a normal day, I might chat with the lady in the check-out line about *Roseanne,* might discuss the Lakers' chances with some guy at the blackjack table, might schmooze on the phone with Christopher Knight about Karen Carson's new paintings, and maybe even dish with Karen herself about an all-male performance of *Swan Lake,* there was no hope of my having a casual conversation with an English profes-

sor about what a cool book *Tristram Shandy* was.

Because, in this place, books and paintings and music were not "cool stuff." In society, these objects were occasions for gossip—for the commerce of opinion where there is no truth. In school, they were occasions for *mastery* where there is no truth—an even more dangerous proposition—although my colleagues, being masters, had little choice but to behave masterfully. Exempted by their status from the whims of affection and the commerce of opinion, they could only mark territory from the podium, with footnotes, and speak in the language of authority about things they did not love—while I listened. Which I did, and I learned a lot, returning to school. All the secrets of the universe would have been poor recompense, however, for the miasma of social desolation; they could never have redeemed the fact that, within the cloister, we moved among one another, and among all the treasures of human invention, like spiteful monks sworn to silence, like silly, proprietary eunuchs in some sultan's harem—while all the joys that bind the world together kept us sullenly apart.

So this book is about other, more ordinary, uses for art and books and music—about what they seem to do and how they seem to do it on a day-to-day basis. It is not about how they *should* work, or *must* work, just about the way they seem to have worked in my experience, and the ways that I have seen them work for others. The pieces in this book, then, are quite literally "speculative writing," neither stories nor essays but something more like fables: compressed narratives, grounded in real experience and as true as they need to be, with little "morals" at the end. They move directly from what I have seen and experienced to what I think about it, from the particular to the general, with none of the recursiveness of ordinary essays and short stories. So there is a lot more "thus," "then," "therefore," and "because" than I would ordinarily tolerate. This is endemic to the form and the consequence, as well, of my having written them straight through, under deadline, in hope of enlisting haste as an aid to candor.

Unfortunately, since some of these deadlines were *very* short, there is probably a surfeit of candor in this book, occasionally at the expense of felicity. I have tried to smooth out some rough spots in revision, but the fact remains that some of these pieces end in places that I should never have gone, had I not started out in the direction that I did. Some of them conclude on notes that I should never have played, had I not begun with the simple little riff that I did. So understand that I have not set out to shock or offend, only to speculate on the consequences of my own experience, the shape of it; and be assured, as well, that all of these essays began in innocence, in extremely simple, even childlike questions that begin with "Why?"

The real heart of this book, in fact, lies in a little "why?" During the nineteen seventies, when I was writing rock criticism and pop songs, and playing music, I used to wonder why there were so many love songs. More specifically, I wondered why ninety percent of the pop songs ever written were love songs, while ninety percent of rock criticism was written about the other ten percent. My own practice complied with these percentages. When I wrote songs, alone or with cowriters, I wrote love songs—happy ones and sad ones, mean ones and sweet ones, hip ones and square ones: hundreds of them. When I wrote about music, I wrote about other things, mostly about music history, politics, drugs, hanging out, and playing the guitar.

Why? I wondered—and I wondered all the time, because it's disquieting to be doing something and not know why you're doing it. I came up with a provisional answer on a cool, windy afternoon in the *zócalo* of a little town on the slopes above Mexico City. I was sitting in a shady arcade with my old friend Brownie, who isn't called that anymore, since he is presently in the Federal Witness Protection Program. We were down in Mexico on a nefarious errand that doubtless contributed to Brownie's uncomfortable accommodation with the Feds, but, on this afternoon, nothing very nefarious was going on. We were just sitting at a lit-

tle table, shooting nothing but the breeze and enjoying the air. Brownie was drinking a beer. I was drinking coffee. At one point, Brownie reached over and touched my arm, nodding at something in the square behind me. I turned around and beheld a perfect Latin American tableau.

On the edge of the curb, on the other side of the square, three people were standing in a row. There was boy of about seventeen, wearing a cheap black suit, a white shirt, and a narrow black tie. Beside him was a beautiful girl of about the same age, in a white lace dress, and, beside her, a duenna in full black battle-regalia with a mantilla over her hair. The duenna was a large woman, and looked for all the world like Dick Butkus in drag. The three of them had been about to cross the street into the plaza when they found their way blocked. Now, they were just standing there, at a loss, lined up on the curb with two dirt-brown dogs fucking in the street in front of them.

It was a scene deserving of Murillo. The boy was biting his lip, full of antic life but holding onto his composure, trying not to grin at the ludicrous spectacle. The girl had lowered her eyes demurely to gaze at the tips of her black patent-leather shoes. The duenna was discombobulated, agitated. Her eyes were darting about. First she would glare at the offending canines, who showed no signs of stopping, then she would glance sideways at the young couple, policing their responses, then she would scan the square with her social radar, hoping against hope that no one was *seeing* them seeing brown dogs fucking. Brownie and I, being gringo assholes, were cracking up, and suddenly it occurred to me (probably because I had written a nice melody that morning) that these kids, having a duenna and a lot of other structure besides, did not require a wide selection of love songs. Then, perversely, it occurred to me that the dogs didn't need any love songs at all.

That was my answer. We need so many love songs because the imperative rituals of flirtation, courtship, and mate selection that are required to guarantee the perpetuation of the species and

the maintenance of social order—that are hardwired in mammals and socially proscribed in traditional cultures—are up for grabs in mercantile democracies. These things *need* to be done, but we don't know how to do them, and, being free citizens, we won't be *told* how to do them. Out of necessity, we create the institution of love songs. We saturate our society with a burgeoning, ever-changing proliferation of romantic options, a cornucopia of choices, a panoply of occasions through which these imperative functions may be facilitated. It is a market, of course, a job and a business, but it is also a critical instrumentality in civil society. We cannot do without it. Because it's hard to find someone you love, who loves you—but you can begin, at least, by finding some one who loves your love song. And that, I realized, sitting there in the *zócalo* with Brownie, is what I do: I write love songs for people who live in a democracy. Some of them follow.

A HOME IN THE NEON

It's the strangest thing. I have lived in a lot of cities, some of them for substantial lengths of time, but I have never thought of any of them as home. I thought of them as "where I'm living now." Then, the other morning, I woke up and realized that Las Vegas has, indeed, become my home—that I routinely think of it as such. Somehow, in the few years that I have been living here and traveling out of here, this most un-homelike of cities has come to function for me as a kind of moral bottom-line—as a secular refuge and a source of comforts and reassurances that are unavailable elsewhere—as a home, in other words.

Even as I write this, however, I realize that claiming Las Vegas as my home while practicing "art criticism" in the hyper-textualized, super-virtuous high culture of the nineteen nineties probably sounds a little studied—a bit calculatedly exotic—as if I were trying to make a "statement," or something. In truth, this condition of feeling at home in Las Vegas makes me wonder just how far back things really go, since, when I was a child, whenever I heard about Las Vegas, it was always being discussed as a potential home by my dad's jazz-musician buddies and their "so-called wives" (as my mom invariably referred to them).

This was back in the nineteen fifties, when Las Vegas was rapidly becoming the only city in the American West where a professional musician might hold down a steady gig without living out of a suitcase. So, for my dad's pals, Vegas shone out there in the desert like a grail, as a kind of outlaw town, like Butch Cassidy's Hole in the Wall or Fritz Lang's Rancho Notorious, where a tiring swing musician or a jive-talking bopster might find a refuge from the road and from respectability as well. A player might work steadily in Vegas, and perhaps get a taste of Fat America, might rent a house in the suburbs, for instance—with a two-car garage and a yard, even—and still be able to play Charlie Parker in the

kitchen at 4:00 A.M. and roll the occasional funny cigarette. The only time I was ever *in* Las Vegas as a child, we spent a hot afternoon in the dark kitchen of a pink-stucco bungalow doing approximately that.

While the sun glared outside, my dad and his friend Shelton drank beer out of tall brown bottles and played Billie Holiday's *Gloomy Sunday* about a zillion times. The whole afternoon, Shelton kept marveling at the ease with which he would pick up his axe later that evening, put it in the trunk of his Pontiac, and drive down to his gig at the Desert Inn. He pantomimed this procedure two or three times, just to show us how easy it was. That night, we got to go with him to the Desert Inn, where there were a million lights, roulette wheels clicking, and guys in tuxedos who looked like Cornel Wilde. Through the plate-glass windows, we could see a turquoise swimming pool surrounded by rich, green grass, and there were white tablecloths on the tables in the lounge, where we sat with other sophisticates and grooved to the music. I thought it was *great*, but my dad got progressively grumpier as the evening wore on. He kept making remarks about Shelton's musicianship, and I could tell that he was envious of his friend's steady gig.

So, having told you this, if I tell you that I now have a steady gig in Vegas, that I live two blocks from the Desert Inn and eat lunch there about once a week, you will understand my reservations about the possibility of our ever growing up—because, even though the days of steady gigs for sax maniacs are long gone, I still think of Vegas the way Shelton did: as a town where outsiders can still get work, three shifts a day, around the clock, seven days a week—and, when not at work, may walk unmolested down the sidewalk in their choice of apparel. My brother calls Vegas a "cowboy town," because fifty-year-old heterosexual guys still room together here, and pairs of married couples share suburban homes, dividing up the bedrooms and filling the communal areas with beer cans and pizza boxes.

Most importantly for me, Vegas is a town that can serve as the heart's destination—a town where half the pick-up trucks stolen in Arizona, Utah, Montana, and Wyoming are routinely recovered in casino parking lots—where the vast majority of the population arises every morning absolutely delighted to have escaped Hometown, America and the necessity of chatting with Mom over the back fence. This lightens the tone of social intercourse considerably. To cite an example: While I was having breakfast at the local IHOP the other morning, my waitress confided in me that, even though the International House of Pancakes wasn't the *greatest* organization in the world, they *had* transferred her out of Ogden, Utah, and she was thankful for that. But not so thankful, she said, that she planned to stay in "food." As soon as she got Lance in school, she was moving up to "cocktail," where the tips were better.

She was looking forward to that, she said; and, to be honest, it's moments like this that have led me to adopt Las Vegas as *mi varrio*. I mean, here was an *American*, in the nineties, who was thankful for something and looking forward to something else. So, now, I affectionately exchange stories of Vegas's little quirks with my fellow homies. I chuckle over the legendary teddy bear in the gift shop at Caesars Palace that was reputedly sold five hundred times. Every night, it seems, some john would buy it for a hooker. Every morning, the hooker would bring it back for cash. That night another john would buy it for another hooker—and thus the cycle continued until Herr Teddy, that fuzzy emblem of middle-aged desire, became irretrievably shopworn. I also defend my adopted hometown against its detractors—a great many of whom are disconsolate colleagues of mine down at the University—lost souls whom I must count among those who are *not* looking forward to moving up from "food" to "cocktail," who do *not* arise from their slumber thanking their lucky stars to have escaped Mom and Dad and fucking Ithaca.

These exiles, it seems, find Las Vegas lacking in culture.

(Define culture!) They think it is all about money, which, I always agree, is the worst way of discriminating among individuals, except for all the others. They also deplore the fact that Las Vegas exploits people's weaknesses—although, in my view, Vegas rather theatrically *fails* to exploit that most plangent American weakness, for being parented into senility. This is probably why so many of them regard Vegas as an unfit atmosphere in which to raise children—although judging by my students, the town turns out an amazingly resilient and insouciant brand of American adolescent, one whose penchant for body decoration seems to me a healthier way of theatricalizing one's lack of prospects than the narcotics that performed this function for my generation.

Most of all, I suspect that my unhappy colleagues are appalled by the fact that Vegas presents them with a flat-line social hierarchy—that, having ascended from "food" to "cocktail" in Las Vegas, there is hardly anywhere else to go (except, perhaps, up to "magician"), and being a *professore* in this environment doesn't feel nearly as special as it might in Cambridge or Bloomington, simply because the rich (the traditional clients of the *professore* class) are not *special* in Las Vegas, because money here is just money. You can make a lot of it here, but there are no socially sanctioned forms of status to ennoble one's *having* made it—nor any predetermined socio-cultural agendas that one might pursue as a consequence of having been so ennobled.

Membership in the University Club will not get you comped at Caesars, unless you play baccarat. Thus, in the absence of vertical options, one is pretty much thrown back onto one's own cultural resources, and, for me, this has not been the worst place to be thrown. At least I have begun to wonder if the privilege of living in a community with a culture does not outweigh the absence of a "cultural community" and, to a certain extent, explain its absence. (Actually, it's not so bad. My *TLS* and *LRB* come in the mail every week, regular as clockwork, and just the other day, I took down my grandfather's Cicero and read for nearly an hour

without anyone breaking down my door and forcing me to listen to Wayne Newton.)

This deficiency of haut bourgeois perks, I should note, also confuses visiting Easterners whom I have docented down the Strip. So attentive are they to signifiers of status and exclusivity that they become restless and frustrated. The long, lateral blend of Vegas iconography unrolls before them, and they are looking for the unmarked door through which the cognoscenti pass. They want the "secret Vegas." But Vegas is about stakes, not status—real action, not covert connections. The "high-roller" rooms with satin walls are secure areas for high-stakes gambling, not hideouts for high-profile dilettantes. If Bruce Willis and Shannen Doherty just want to get their feet wet, they shoot dice with the rest of us. This seems to confuse my visitors, who don't, of course, *believe* in celebrity, but still, the idea of People with Names gambling in public offends their sense of order—and mitigates their aspirations as well, I suspect.

In any case, when visiting culturati actually start shivering in the horizontal flux, I take them to one of the restaurants in town where tank-tops are (sort of) discouraged. This is the best I can do to restore their sense of propriety, because the "secret of Vegas" is that there are no secrets. And there are only two rules: (1) Post the odds, and (2) Treat everybody the same. Just as one might in a democracy (What a concept!), and this deficiency of secrets and economy of rules drives writers crazy! They come here to write about Vegas. They are trained in depth-analysis. They have ripped the lid off seamy scandals by getting behind the scenes, and Las Vegas is invisible to them. They see the lights, of course, but they end up writing stories about white people who are so unused to regulating their own behavior that they gamble away the farm, get drunk, throw up on their loafers, and wind up in custody within six hours of their arrival. Or they write profiles of the colorful Runyonesque characters they meet in casinos, oblivious to the fact that such characters populate half the bar-

rooms in America, that, in truth, they need only have driven a few blocks for their "colorful characters," had they been inclined to transgress the rigid stratifications that (in *their* hometowns) stack the classes like liqueurs in a dessert drink.

America, in other words, is a very poor lens through which to view Las Vegas, while Las Vegas is a wonderful lens through which to view America. What is hidden elsewhere exists here in quotidian visibility. So when you fly out of Las Vegas to, say, Milwaukee, the absences imposed by repression are like holes in your vision. They become breathtakingly perceptible, and, as a consequence, there is no better place than Las Vegas for a traveler to feel at home. The town has a quick, feral glamour that is hard to localize—and it arises, I think, out of the suppression of social differences rather than their exacerbation. The whole city floats on a sleek *frisson* of anxiety and promise that those of us addicted to such distraction must otherwise induce by motion or medication.

Moreover, since I must regularly venture out of Vegas onto the bleak savannas of high culture, and there, like an aging gigolo, generate bodily responses to increasingly abject objects of desire, there is nothing quite as bracing as the prospect of flying home, of swooping down into that ardent explosion of lights in the heart of the pitch-black desert—of coming home to the only indigenous visual culture on the North American continent, a town bereft of dead white walls, gray wool carpets, ficus plants, and Barcelona chairs—where there is everything to see and not a single pretentious object demanding to be scrutinized.

I remember one particular evening in the spring. I was flying back from Washington, D.C. after serving on a National Endowment for the Arts panel. For four solid days, I had been seated on a wooden chair in a dark room looking at racks of slides, five at a time. Blam, blam, blam, blam, blam, ad infinitum. All hope departed somewhere near the end of the second day, and I started counting popular iconography: skulls, little houses, little boats, altars, things in jars, etc. By the end of the third day, despair

had become a very real option, but we finally selected the correct number of winners—and a number of these actually won. The rest won the privilege of having their awards overturned by a higher court on the grounds of propriety.

The moment I stepped off the plane, I sat down in the terminal to play video poker. Basically, I was doing the same thing I had been doing in Washington: looking at banks of five images, one after another, interpreting finite permutations of a limited iconography, looking for a winner. Sitting there at the slot machine, however, I was comfortable in the knowledge that Vegas cheats you fair—that, unlike the rest of America (and Washington in particular), the payoffs are posted and the odds easily calculable. I knew how much of a chance I had to win. It was slim, of course, but it was a real chance nevertheless, not some vague promise of parental benevolence contingent on my behavior.

In the reality of that chance, Vegas lives—in those fluttery moments of faint but rising hope, in the possibility of wonder, in the swell of desire while the dice are still bouncing, just before the card flips face-up. And win or lose, you always have that instant of genuine, *justifiable* hope. It is always there. Even though we know the rules governing random events are always overtaken by the law of large numbers, there is always that window of opportunity, that statistical crazy zone, before this happens, when *anything* can happen. And what's more, if you win, you win! You can take it home. You cannot be deemed unworthy after the fact—as we all were in Washington, where we played our hearts out and never had a fucking chance. So right there in the airport, I could make a little wager, and there was a real chance that luck and foolish courage might, just for the moment, just for a couple of bucks, override the quagmire of status and virtue in which we daily languish. And if I got *really* lucky, I might move up from food to cocktail. Hey, don't laugh. It could happen.

SIMPLE HEARTS

In the autumn of 1875, Gustave Flaubert suspended his Herculean labors on *Bouvard and Pécuchet* to write three stories about saints. They were published together in April of 1877 under the title *Trois Contes*. The finest and strangest of these stories he wrote for his friend George Sand, who never stopped pleading with him to mitigate his customary bleakness a little and write "a work marked by compassion"—and "A Simple Heart" (*Un coeur simple*) is certainly so marked, although not in any way that George Sand would have recognized. Set in the early years of the nineteenth century, in the bleak, provincial milieu around Pont-l'Évêque and Trouville (only a few miles from Flaubert's home at Croisset), "A Simple Heart" tells the story of Félicité, an isolated, illiterate, Catholic house-servant; it narrates her life from birth to death as a poised, sotto voce litany of labor and loss, of emotional neglect and wasted time that dissolves, suddenly, in the last sentence of the story, into this dazzling image of mercy—a vision of grace as gaudy and permissive as a Tiepolo ceiling.

Eighty years after Flaubert finished writing "A Simple Heart" in provincial France, I finished reading it in provincial Texas, sitting in the wooden swing on the shady porch of my grandparents' house in south Fort Worth, and, having finished it, Flaubert's story, which had transported me out of the present, delivered me back into it with sharpened awareness. I can still remember the hard angle of the morning light and the smell of cottonseed in the lazy air as I sat there on the swing with my forearms on my knees and *Trois Contes* between my hands, amazed that writing could do what it had just done.

Since I was reading not just as a reader, but as a reader who wanted to be a writer, I also felt a glimmer of insight into a question that had troubled me since I had read *Madame Bovary* and *Salammbo* in quick succession, as Flaubert wrote them. Why, I

wondered, would the cold-eyed master of *Madame Bovary,* the scourge of provincial ennui (whose consequences I felt qualified to judge) have abandoned that worthy project to write a romance of Mediterranean antiquity? Why would he have barricaded himself with books and dreams in the study of his mother's house, out there amidst the fields of mud and vegetables, to reimagine the oriental glamour of ancient Carthage?

To what end? I wondered, and, now, in the tiny apotheosis at the end of "A Simple Heart," I saw a door opening between the two books—between the banality of *Madame Bovary* and the splendor of *Salammbo*—and I understood, if only vaguely, something about writing and what it does in the world. Since then, I have come to regard "A Simple Heart" as Flaubert's great allegory of his own vocation—and have always assumed that if Madame Bovary is none other than Flaubert as a fool in abjection, as he himself suggested, the servant Félicité is almost certainly Flaubert as a saint in glory, rising up, in the final moments of the story, out of the banality of his home country into the opening wings of this dazzling, improbable parrot.

The tacit parallel between Flaubert's endeavors and those of his character, I think, may be inferred from the peculiarities of tense and tone that complicate "A Simple Heart"—more certainly since, given Flaubert's methods, we may presume that these peculiarities are far from inadvertent. In two passages describing the local landscape, for instance, Flaubert slips abruptly into the present tense. This jolts in French, but it has the effect of collapsing the distance between Flaubert and his narrative by substituting the voice of Gustave, the local citizen, for that of Flaubert, the all-seeing author. A similar collapse of authorial distance occurs in those moments when Flaubert's cool narration of Félicité's existence suddenly glitters with sophisticated contempt. In these passages, I suspect, the cosmopolitan Flaubert wants to remind us that, even though he can forgive Félicité's provincial innocence, he cannot forgive his own lost innocence in her—for they are two in one.

Considering Félicité as a character in a story, then, it helps to think of her as Flaubert's Job, a character equally afflicted, yet bereft of Job's anger at the injustice of his afflictions. Because, although Félicité suffers, she never feels that she is suffering injustice. Things are stolen from her that she never suspects are hers to claim. Her family abandons her, then exploits her. She doesn't even notice. Her only beau humiliates her, then abandons her. She accepts the rejection and seeks no further. Her employer, a provincial widow, underpays her and treats her like a domestic animal. She is grateful for the shelter. She goes to church and prays for everyone.

Beyond this, Flaubert would have us understand, the entire society of Félicité's adult life consists of two relationships with children (who die in childhood) and a single comforting embrace from her employer (which is never repeated). First, Félicité becomes helplessly devoted to her employer's daughter, Virginie. Then, when Virginie is sent off to school, Félicité settles her devotion on her own nephew Victor, whose parents send him to visit Félicité with instructions to extort gifts from her—a packet of sugar, a loaf of bread. Young Victor, however, is soon sent off to sea, where he dies of yellow fever in the Americas, and, not long thereafter, Virginie dies of consumption while away at school. Both Félicité and her mistress are desolated, but their lives move on. The years pass quietly until, one summer afternoon, the two of them visit Virginie's room, which has been left intact. They clean the shelves, reorder the toys, and refold the dead girl's clothing. As Flaubert tells it:

> The sun shone brightly on these shabby things, showing up the stains and creases caused by the movement of her body. The sun was warm, the sky blue, a blackbird trilled, every living thing seemed to be full of sweetness and light. They found a little hat made of furry brown plush; but it was all moth-eaten. Félicité asked if she might have it. Their eyes met, filled with tears; finally the mistress opened her

arms, the servant fell into them; and they embraced, appeasing their grief in a kiss which made them equal.

It was the first time in their lives, for Madame Aubain was not naturally forthcoming. Félicité was as grateful to her as if she had received a gift, and from then on loved her with dog-like devotion and religious adoration.

This, in Flaubert's telling, is the single moment of companionable human solace in Félicité's existence. In its aftermath, Félicité embarks upon a career of kindness. She stands in the doorway dispensing cider to passing soldiers. She looks after cholera victims and Polish refugees, assists derelicts and attends to the dying; and it is in this section of the narrative (as is obvious above) that the tone goes strange, as if Flaubert, appalled by the image of his own vanquished innocence, cannot withhold his anger at the neediness of Félicité's generosity—at the spectacle of her giving so much back in return for so little—and, finally, at the fact that nothing remains of Félicité's life, as silence, darkness, and old age close around her, but the dubious companionship of a third-hand pet, an obnoxious parrot named Loulou.

Félicité, of course, is delighted with the parrot. She feeds it, pampers it, and teaches it to say "Hail Mary." The parrot rebels, complains, tries to escape, and ultimately dies on the hearth, but this time Félicité has a response. She has the parrot stuffed, installs it in her room, and proceeds to worship it—to reconstruct it mentally as an embodiment of her loss and desire. At this point, the entire artifice of the narrative snaps into focus. It becomes clear that throughout the story Flaubert has been wholly devoted to explicating those attributes and significations that Félicité will ultimately invest in the parrot: The parrot's gaudy wings are those of the Holy Spirit in stained glass; its truculent masculinity an attribute of her lost lover; its loveliness that of Virginie; and its American homeland an homage to young Victor, who died there. The parrot embodies all of these attributes for Félicité, and thus,

in the final scene of the story, she is reunited with all that she has lost, or never had—all those things she never knew she might deserve:

> A cloud of blue incense smoke rose up to Félicité's room. She opened wide her nostrils as she breathed in deeply, in an act at once sensual and mystical. She closed her eyes. Her lips smiled. Her heartbeats grew steadily slower, fainter every time, softer, like a fountain running dry, like an echo fading; and as she breathed her last, she thought she saw, as the heavens opened, a gigantic parrot hovering over her head.

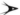

This is splendid writing, of course, as plain and lovely here, in A.J. Krailsheimer's English, as it is in Flaubert's French. The dying fall of Félicité's existence settles slowly toward inaudibility, then refuses to fade, and, in the last instant, blossoms forth in a crisp, unsentimental image of redemption. Most amazingly, however, through the evocation of this image, Flaubert manages the most elegant rhetorical maneuver available to writers on the page: He manages to do in the doing what he describes in the writing. In the act of describing Félicité's secret construction of her loss and desire in the form of a parrot, Flaubert constructs his *own* parrot, publicly, in the form of a story that redeems Félicité's isolation and his own—by narrating his own journey toward the business of making stories, embodying the attributes of his own loss and desire in Félicité's story.

We know now, for instance, that in the telling of Félicité's story, Flaubert reconstitutes his own romantic disasters and hapless, needy generosity—that he sets the story in his mother's hometown and describes that world as he saw it—that he redacts the loss of his sister Caroline in the death of Virginie and describes Félicité struck down by a coachman's whip at the very spot on the very road where *he* was first struck down by the epileptic illness

that plagued his existence. And all of this is good to know, of course, but only insofar as it reinforces what we already know, which is that Flaubert was concerned most critically with *socializing* his parrot, with offering it up to us in public, not as an act of vanity or seduction, but as an emblem of what works of art might do in the world—how they might redeem isolation like Félicité's by creating about them a confluence of simple hearts, a community united not in what they are—not in any cult of class, race, region, or ideology—but in the collective mystery of what they are *not* and now find embodied before them, like Félicité and Madame Aubain in the presence of that brown, plush hat.

Thus, when I finished reading "A Simple Heart" that morning in Texas, I did not retire to my couch to savor the experience. Nor did I pick up the copy of *Bouvard and Pécuchet* that lay on the corner of my desk with its pages still uncut. Nor did I start making notes for my own story in the manner of "A Simple Heart." I started calling my friends. I wanted them to read the story immediately, so we could talk about it; and this rush to converse, it seems to me, is the one undeniable consequence of art that speaks to our desire. The language we produce before the emblem of what we *are,* what we know and understand, is always more considered. This language aims to teach, to celebrate our knowledge rather than our wonder. It also implies that we, and those like us, are at least as wonderful as the work we know so much about.

The language that we share before the emblem of what we lack, however, as fractious and inconsequent as it often seems, creates a new society. It is nothing more or less than the kiss that makes us equal—and had George Sand lived to read the story her friend wrote for her, I think she would have understood this. Or, more precisely, she would have felt the thorn in the rose her friend offered up to her and recognized, in the very title of the story, *Un couer simple,* a repudiation of *le couer sensible* (the feeling heart) that stood as an emblem for the cult of *sensibilité* of which Sand

was the natural inheritor. As you will remember, this cult (or culture) of *sensibilité* defined virtue in terms of one's superior ability to empathize with those less fortunate than one's self. What those "less fortunates" might themselves have been feeling was (as W.H. Auden shrewdly pointed out) simply beside the point. Because then, as now, the cult of *sensibilité* defined itself as an aristocracy of feeling, wholly dedicated to the connoisseurship of its own virtuous empathy.

What Flaubert proposes in place of this refined aristocracy of virtuous identity—and what I continue to propose—is just democracy: a society of the imperfect and incomplete, whose citizens routinely discuss, disdain, hire, vote for, and invest in a wide variety of parrots to represent their desires in various fields of discourse—who elect the representatives of their desire and occasionally re-elect them. Thus, unconcerned with class, culture, and identity, this society is perpetually created and re-created in nonexclusive, overlapping communities of desire that organize themselves around a multiplicity of gorgeous parrots. Unfortunately, this democracy of simple hearts is founded on the dangerous assumption that gorgeous parrots, hewn from what we lack (as *Salammbo* blossoms out to fill the arctic absences of *Madame Bovary*), will continue to make themselves visible and available to us. But this is not necessarily so. Flaubert is dead, and the disciplines of desire have lost their urgency in the grand salons of comfort and privilege we have created for the arts. The self-congratulatory rhetoric of *sensibilité* continues to perpetuate itself, and in place of gorgeous parrots, we now content ourselves with the ghostly successors of Marie Antoinette's peasant village, tastefully installed within the walls of Versailles.

SHINING HOURS / FORGIVING RHYME

On a Saturday morning when I was eight or nine years old, my dad and I set out in our old Chevrolet to play some music at a friend's house. Actually, my dad was going to play music, but he let me carry his horn cases, and both of us were decked out in jazz-dude apparel: penny loafers, khakis, and Hawaiian shirts with the tails out. First, though, we had to pick up our new neighbor, Magda, who had only moved to Texas about three months before. We had become friends with her because people left their windows open back then, and we heard each other playing Duke Ellington 78s. Now, Magda and my mother went shopping together and hung out, so I knew her as this nice, relaxed German lady who sat around in the kitchen with Mom, dicing things.

When Dad beeped the horn in front of her house, however, a different Magda came out. She was all gussied up, with her hair in a bun, wearing this black voile dress, a rhinestone pin, and little, rimless spectacles that I associate to this day with "looking European." She was also carrying an armload of sheet music, and as she approached the car I whispered to my dad that this must be Magda's first jam session—because nobody looked at sheets at a jam session. Dad said to shut up, dammit, that Magda was a refugee, that she was a Jew who fled the Nazis, first to London and then, after the war, down here to Texas. So cool it! he whispered, and I cooled it. Problems with the Nazis were credentials enough for me. I hopped in the back seat, let her ride up front with Dad.

Then we had to stop and pick up Diego, who worked at the Jiffy Dry Cleaners where we took our clothes. We beeped, and Diego came trotting out with his bongo drums in a paper sack—a really cool-looking guy, I thought, with his thin black mustache and his electric-blue, fitted shirt with bloused sleeves. Usually, Diego played percussion in Latino bands on the North Side, but he loved to sing jazz, so he was fairly bouncing with excitement as he ducked into the back seat beside

me. Then all the way out to Ron's, he flirted so outrageously with Magda that my dad and I kept cracking up.

Magda blushed down into her dress, but she seemed not to mind Diego's attention. At one point, she turned around and scolded him good-naturedly: "Herr Diego," she said, shaking her finger at him, "You are a stinker!" And that cracked us up too, so we laughed all the way out to south Fort Worth where Ron lived in this redneck subdivision, in a ranch-style house with a post-oak in the lawn. As we pulled up in front, two black guys, Butch and Julius, were advancing warily across the lawn. They were dressed in white dress shirts and high-waisted zoot-suit slacks, carrying instrument cases, and glancing around them at the neighborhood.

Butch and Julius were beboppers, but, like my dad and Ron, they played pick-up gigs with dance bands around town, so I saw them all the time. I waved, and Butch, who was carrying a guitar case, waved back. Julius was lugging his stand-up bass, so he just grinned, and Ron, who stood in the front door holding the screen, waved too. Ronno was my dad's best friend, and as usual, he was barefoot, wearing a sleeveless Marine Corps T-shirt and camouflage fatigues. "Not many jazz fans in this neighborhood," Butch remarked when we were all in the living room. Ron allowed there weren't, but the VA had approved his loan so he took it. Julius just smiled and took his bass out of its case. Then he took a Prince Albert tin out of the string pocket inside it, flopped down in Ron's easy chair and began rolling a joint.

Magda's eyes got big at this, but I could tell she wasn't upset. She was tickled to death. You could almost hear her thinking, "Oh boy! I have made it all the way from Birkenstrasse to this! I am out in the Wild West—at an American Jazz session with Negroes smoking marijuana!" To cover her excitement, she marched over to Ron's baby grand, set her music on it and began striking octaves and fifths, checking the tuning. Butch gave her an appraising sideways glance. Julius just grinned and lit up his reefer. After he had taken a couple of hits, Ron's wife Mary stuck her head out of the kitchen, sniffing

*the air. "Guess y'all are gonna be wantin' cookies," she said. "I am!"
I said, and everybody laughed.*

*Ron took a hit from Julius's reefer and climbed behind his drum
kit, clanging his ride cymbal as he did. Butch and Diego took up posi-
tions on the couch—Butch with his Gretsch guitar, Diego with his
bongos between his thighs. My dad opened his horn cases on the floor.
He fiddled with the saxophone, then took out his clarinet, wet the
reed and leaned back against the piano with his ankles crossed, exam-
ining the instrument, blowing lint off the pads. They all tweaked and
twanged for a minute, getting in tune, then Ron counted off Artie
Shaw's "At Sundown." Magda was really shaky at first, pale with fear,
but Diego just kept grinning at her and nodding, and she started to
firm up.*

*Then, Dad swung around, aimed his clarinet at her, and she
seemed to wake up. In less than a bar, she found herself and started
hitting the note, crisply; and the lady had some chops, you know. She
could play jazz music, but it was strange to watch, because here in
this smoky, shadowy room full of swaying, agitated beboppers was this
nice German-Jewish lady in a black voile dress with her back rigid
and her eyes glued to the sheet, her wrists lifted in perfect position,
playing in such a way that, if you couldn't hear the music, you would
have guessed Schumann or something like that. But Magda was really
rapping it out, and she had such great attack that Diego had to sit
up straight to sing the choruses. Mary even came to the kitchen door
to listen, which she rarely did.*

*After that, Magda got into it, even bouncing her bottom on the
bench once or twice (much to Butch's whimsical delight). But she
wouldn't solo. They would give her the space, nod in her direction
and say, "Take it, Maggie!" but she would shake her head and vamp
through her sixteen bars. Then Butch or Dad would come in and solo.
But I was really proud of them. They always gave her the space—in
case she changed her mind. And I was proud of Magda too, for get-
ting her confidence up, and letting it build, so the best thing they
played all afternoon was the very last thing: "Satin Doll" by Duke*

Ellington, Billy Strayhorn, and Johnny Mercer.

By this time, the room was very mellow and autumnal. Ruby light angled through the windows, glowing in the drifting strata of second-hand ganja *as Ron counted off the song. He and Julius started alone, insinuating the Duke's sneaky, cosmopolitan shuffle. Then Magda laid down the rhythm signature, Butch and my dad came in, and they played the song straight, flat out. Then they relaxed the tempo, moved back to the top and let Diego croon his way through the sublime economy of Johnny Mercer's lyrics—calling up for all of us (even me) the ease and sweet sophistication of the Duke's utopian Harlem, wherein we all dwelt at that moment:*

> *Cigarette holder,*
> *Which wigs me,*
> *Over her shoulder,*
> *She digs me,*
> *Out cattin'*
> *That satin doll.*

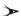

As it turned out, that satin doll was that. There were no more jam sessions, due to circumstances beyond anyone's control, and, within three years, my dad was dead. After that, our life remained improvisational, but it was never as much fun. So I kept that musical afternoon as a talisman of memory. I handled it carefully, so as not to knock the edges off, keeping it as plain and unembellished as I could, so I could test the world against it, because it was the best, concrete emblem I had of America as a successful society and remains so. My dad is a part of it, of course, but I see him differently now—not as my dad, so much, but as this guy who would collect all these incongruous people around him and make sure that everybody got their solos.

So, I have always wanted to tell this story, because it is a true story that I have carefully remembered, but frankly, it is a sentimental story, too—as all stories of successful human society must

be—and we don't cherish that flavor of democracy anymore. Today, we do blood, money, and sex—race, class, and gender. We don't do communities of desire (people united in loving something as we loved jazz). We do statistical demographics, age groups, and target audiences. We do ritual celebrations of white family values, unctuous celebrations of marginal cultural identity, multiethnic kick-boxer movies, and yuppie sit-coms. With the possible exception of *Roseanne*, we don't even do ordinary eccentricity anymore. In an increasingly diffuse and customized post-industrial world, we cling to the last vestige of industrial thinking: the presumption of mass-produced identity and ready-made experience—a presumption that makes the expression, appreciation, or even the perception of our everyday distinctions next to impossible.

When I wrote the narrative that introduces this essay, I wanted to do one thing: I wanted to tell you a little story about ordinary, eccentric citizens coming together to play some extraordinary music in a little house on the edge of town—to communicate some sense of my own simple wonder—to have you appreciate its majesty. When my wife read what I had written, however, she immediately (and quite correctly) pointed out that my narrative would not be read this way. Most likely, she suggested, it would be read as an allegory of ethnic federalism in which two African-Americans, a Latino, four Irish-Americans, and a German Jewess seek refuge from the dominant culture in order to affirm their solidarity with the international underclass.

But it was not that way at all! I squealed. My dad and his friends were *musical* people in postwar Texas, in the nineteen forties, and that was really special in its quiet way. Imposing the cookie-cutter of difference onto their society not only suppressed their commonality, it suppressed their differences, as well—and these people were *very* different people. All of the people I had known in my life had been very different people, I argued. I had just assumed. . . . Assuming, my wife explained, never won the pony.

So having failed in my portrayal, I began wondering who *could* have portrayed that scene. Who could have captured that room in ruby light—the benign whimsy of Butch's glance at Magda's sturdy bottom bouncing on the piano bench—my dad and I in our jazz-dude threads—Magda turning in the front seat, good-naturedly shaking her finger at Diego? And to my own surprise, I came up with Norman Rockwell of the *Saturday Evening Post*. For worse or for glory, I realized, he was the dude to do it— that, in fact, he probably *had* done it—had painted that scene in my head, because when I was eight years old, Johnny Mercer was teaching me how to listen, and Norman Rockwell was teaching me how to see. I was a student of their work, and they were good teachers. Years before I heard of John Donne, I learned about the intricate atmospherics of "metaphysical conceits" just by walking down the sidewalk singing: *Fools rush in / Where wise men fear to tread. / And so I come to you my love, / My heart above my head.*

Moreover, I have no doubt that Rockwell taught me how to remember that jam session, because I could never polish it. I clung to the ordinary eccentricity, the clothes, the good-heartedness, the names of things, the comic incongruities, and the oddities of arrangement and light. So, it has always seemed to me that Rockwell and Mercer must certainly be important artists, not so much because people love them (although that is a part of it) but because I had learned so much from them—and because they both denied it so strenuously. Still, for a long time, I really didn't know what *kind* of art they made, or what it did. I only knew that it wasn't high art, which is defined by its context and its exclusivity—and is always, in some sense, *about* that context and that exclusivity.

I decided that, if high art is always about context and exclusivity, the art of Rockwell and Mercer, which denies both with a vengeance, must be about that denial. To put it simply: Norman Rockwell's painting, like Johnny Mercer's music, has no special venue. It lives in the quotidian world with us amidst a million

other things, so it must define itself as we experience it, embody itself and be remembered to survive. So it must rhyme, must live in pattern, which is the mother of remembering. Moreover, since this kind of art lacks any institutional guarantee of our attention, it must be *selected* by us—and since it aspires to be selected by all of us, it must accept and forgive us too—and speak the language of acceptance and forgiveness. And since it can only flourish in an atmosphere of generosity and agreement, it must somehow, in some way, promote that atmosphere.

Thus, there is in Rockwell (as there is in Dickens) this luminous devotion to the possibility of domestic kindness and social accord—along with an effortless proclivity to translate any minor discord into comedy and forgiving *tristesse*—and this domain of kindness and comedy and *tristesse* is not the truth, but it *is* a part of it, and a part that we routinely deny these days, lest we compromise our social agendas. We discourage expressions of these feelings on the grounds that they privilege complacency and celebrate the norm as we struggle to extend the franchise. But that is just the point (and the point of our struggle): Kindness, comedy, and forgiving *tristesse* are not the norm. They signify our little victories—and working toward democracy consists of nothing more or less than the daily accumulation of little victories whose uncommon loveliness we must, somehow, speak or show.

The wicked *norm,* like the name of a vindictive God, is never spoken or shown, not by human beings, whose acts are necessarily willful, who only speak and show to qualify that norm, to distinguish themselves from it, to recruit more dissenters, to confirm some area of mutual dissent from its hegemony. So if, for no apparent reason, I tell you "The sky is blue," you will not believe I am telling you that. You will read for the subtext of dissent, for the edge of qualification. You will suspect that I am indulging in lyrical effusion, perhaps, trying to awaken your dulled senses to the "blueness" of the sky at this moment. Or, if you are more suspicious, you will suspect that by saying "The sky is blue," I am

inferring that whatever *you* have just said is too fucking obvious to qualify as human utterance. If, on the other hand, you receive a memorandum from the government officially stating that the sky is blue, you will shrug, but you will believe it, since the government labels things, then counts them, and averages them out. Defining the norm is its instrument of control over idiosyncrasy.

So here is my point again: Human art and language (as opposed to institutional art and language) *always* cite the exception, and it was Norman Rockwell's great gift to see that life in twentieth-century America, though far from perfect, has been exceptional in the extreme. This is what he celebrates and insists upon: that "normal" life, in this country, is not normal at all—that we all exist in a general state of social and physical equanimity that is unparalleled in the history of humans. (Why else would we alert the media every time we feel a little bit blue?) Yet, we apparently spend so many days and hours in this state of attentive painlessness that we now consider it normal—when, in fact, normal for human creatures is, and always has been a condition of inarticulate, hopeless, never-ending pain, patriarchal oppression, boredom, and violence—while all our vocal anguish is necessarily grounded in an ongoing bodily equanimity, a physical certainty that we are safe enough and strong enough to be as articulately unpleasant as we wish to be.

Most artists understand this, I think, and consequently, most of the artists I have known actually *like* Norman Rockwell and understand what he is doing. De Kooning loved Rockwell's pictures and admired his paint-handling. Warhol reverently stole from him, extending the franchise of Rockwell's face-to-face domestic set-ups by copping them for paintings and Factory films. My pal Jeffrey Vallance actually lent me the Rockwell book I am looking at now. The people who hate Rockwell, however—the preachers, professors, social critics, and radical sectarians—inevitably mistake the artist's profession for their own. They accuse him of imposing norms and passing judgments, which he

never does. Nor could he ever, since far from being a fascist manipulator, Rockwell is always giving as much as he can to the world he sees. He portrays those aspects of the embodied social world that exist within the realm of civility, that do not hurt too terribly. But it is not utopia.

People are regularly out of sync with the world in Rockwell's pictures, but it is not the *end* of the world. People get sick and go to the doctor. (Remember that!) Little girls get into fights. Puppies are lost, and jobs too. People struggle with their taxes. Salesmen languish in hotel rooms. Prom dresses don't fit. Tires go flat. Hearts are broken. People gossip. Mom and Dad argue about politics. Traffic snarls, and bankers are confused by Jackson Pollock. But the pictures always rhyme—and the faces rhyme and the bodies rhyme as well, in compositions so exquisitely tuned they seem to have always been there—as a good song seems to have been written forever. The implication, of course, is that these domestic disasters are redeemed by the internal rhymes of civil society and signify the privilege of living in it, which they most certainly do.

You are not supposed to forget this, or forget the pictures either, which you do not. I can remember three *Post* covers from my childhood well enough to tell you *exactly* what they meant to me at the time. One is a painting of a grandmother and her grandson saying grace in a bus-station restaurant while a crowd of secular travelers look on. The second depicts an American Dad, in his pajamas, sitting in a modern chair in a suburban living room on a snowy Sunday morning. He is smoking a cigarette and reading the Sunday *Times* while Mom and the kids, dressed up in their Sunday best, march sternly across the room behind him on their way to church. The third depicts a couple of college co-eds changing a tire on their "woody" while a hillbilly, relaxing on the porch of his shack, watches them with bemused interest. The moral of these pictures: *Hey! People are different. Get used to it.*

So let me insist that however strenuously ideologues strive

to "normalize" popular art, popular artists like Rockwell do not create normality. Governments, religions, and network statisticians create normality, articulate it, and try to impose it. Artists like Rockwell celebrate ordinary equanimity for the eccentric gift that it is—no less than the bodily condition of social justice in a society informed by forgiving rhyme and illuminated by the occasional shining hour. Because if social justice is a statistical norm, everybody at that jam session fell short of it—Magda, Butch, Ron, Julius, Mary, Diego, Dad, myself, all of us. Nor did we believe in statistical norms. We believed that social justice resides in the privilege of gathering about whatever hearth gives warmth, of living in a society where everyone, at least once, might see themselves in a Norman Rockwell, might feel themselves rhyming with Johnny Mercer as he sings:

This will be my shining hour,
Calm and happy and bright,
In my dreams your face will flower,
Through the darkness of the night,
Like the lights of home before me,
Or an angel watching o'er me,
This will be my shining hour,
Till I'm with you again.

Pontormo's Rainbow

This could never happen today, so you'll have to believe me when I tell you that I made it all the way into sixth grade before a bunch of people whom I did not know, who weren't my family and weren't the government, tried to deprive me of something I really wanted—for my own good. Up until that time, my parents had routinely deprived me of things I wanted, but they always deprived me for *their* own good, not mine ("No, you can't go out. I'm too tired to worry about what you're doing while you're out there."), and this tactic was annoying enough. For years, I attributed it to my folks' bohemian narcissism. Now I suspect they were shrewder than I thought, because, finally, since my parents were always more concerned with my thoughtfulness than with my goodness, I grew up well assured that I could decide what was good for me—and maybe get it—if I could get away with it.

So I was shocked by my first encounter with communitarian righteousness—all the more shocked because, at that point in the life of our family, things were really looking up. We had just escaped air-conditioned custody in this lily-white, cookie-cutter suburb of North Dallas and moved to Santa Monica, to a house right under the Palisades, between the Pacific Coast Highway and the beach. The house was the quintessence of coolness. There was a big deck on the second floor where we could sit and gaze off across the Pacific toward China. There was a white brick wall around the house, low in front and high in back, covered with bougainvillea. There were hydrangea bushes and hardy hibiscus in the front yard, honeysuckles along the side wall where a small yard ran, a mimosa tree in the front and a wisteria in the back—and, because of the wall and the breeze off the ocean, we could crank the windows open and let the house fill up with colored light, cool air, and the smell of flowers.

Died and gone to heaven. That's the only way to describe it.

After creepy, prissy Dallas, the escalation of sensory and social information was so overwhelming that I would lie in bed at night, in the sweet darkness, listening to the trucks rumbling on the PCH and the murmur of the surf on the sand, and literally *giggle!* There was just *so much,* and it was all so cool! I had black friends at school, like my dad's jazz buddies. I got to be the only gentile in this kooky B'nai B'rith Boy Scout troop down in Venice (Reformed). Whenever I wanted, I could just walk out the glass front door with my dog, Darwin the Beagle, and slog through the sand down to the ocean. Or we could turn left and stroll down to the Santa Monica Pier where there was a dark pool hall with surfer criminals in residence. Or we could wander past the pier to Muscle Beach where multitudes of semi-naked women loved to pet Herr Darwin.

About once a month, on Sunday afternoon, we would pile in the car and tool down to Hermosa or Redondo to listen to jazz music, and every Saturday morning my brother and sister and I would climb the concrete stairs up the Palisades (or scramble up, commando style, through the ice plant), and make our way over to the Criterion for the Kiddie Cartoon Carnival. There we would sit for three hours, happy as clams, communing with Donald Duck, Bugs Bunny, the Road Runner, and Tom and Jerry, just fucking blown away; and this, it turned out, is what the three ladies wanted to talk to us about. They showed up at Santa Monica Elementary about four months after we got there and set up shop in the lunch room. There was a crackly announcement on the speaker in home room that said if we wanted to talk to them, we would be excused from class to do it. So, *naturellement,* everybody did.

When my time came, I was marched down the hall to the lunch room and ushered to a seat across from this lady wearing a blue suit and pearls, just like June Cleaver. She had a three-ring binder and a bunch of papers on the table in front of her, and, since the table was kid-sized, she looked really big, looming behind

it like a Charlie Ray lady. When I was seated, she looked up with a big smile, called me *Davey*, and asked me if I liked animated cartoons. I knew then I had made a terrible mistake. But what could I do? I said yes, I liked cartoons, a lot—and that my name was *Dave*. She smiled again, not meaning it this time, and persevered. And what about Donald Duck? she asked. Did I like Donald Duck? Yes, I liked Donald Duck, I told her, although I withheld my opinion that the Duck was the only Disney character who had any soul, any edge, that he was sort of the Dizzy Gillespie of Disney characters. This was not the sort of insight one shared with June Cleaver.

Well then, she said, what did I think about Donald's relationship with his nephews, Huey, Dewey, and Louie? Did it bother me that he screamed at them all the time? Did this frighten me? Did it, perhaps, remind me of . . . my mom or dad!? She looked at me solemnly, expectantly. I wanted to tell her that, first, Donald Duck was a *cartoon*. Second, he was an animal, a duck, and, finally, he was only about *this* tall. But I couldn't. I could tell from the penetration of her gaze that she wasn't really interested in ducks, and I felt my face getting hot. My inquisitor smiled faintly, triumphantly, taking this blush as a tell-tale sign of guilt, which it wasn't. I felt like a downed American pilot in the clutches of the Gestapo, determined to protect the secrets of his freedom.

Clearly, this lady wanted to know stuff about my parents, and since, in all my peregrinations through five states and thirteen grammar schools, I had never met any other adults who were even remotely like my mom and dad, I was dedicated to concealing their eccentricity. Because it had its perks. I had seen enough of my friends' home lives to know this. According to *their* parents, my parents let me run wild. I got to do things that my friends never could, because my parents were weird. But they were *not* like Donald Duck! My dad was cool and poetic—like me, I thought (wrongly!). And my mom was not cool at all. She was serious, high-strung, and fiercely ironic, like Joan Crawford,

always bustling around: painting bad paintings in the back bedroom and reading books while she cooked dinner (setting the occasional paperback aflame)—always starting up little businesses, and telling me stuff about Maynard Keynes or Karl Marx when she gave me my allowance. (Keynes and Marx, I should note, marked the poles between which my mom's sensibility flickered on a daily, nay hourly, basis, for reasons that were not always apparent. This made things exciting, since you never quite knew if you were dealing with the sky-walking entrepreneur or the hard-eyed revolutionary. My dad was more reliable in the realm of fiscal theory. He thought money was something you turned into music, and that music, ideally, was something you turned into money. It rarely worked out that way, but, in this at least, we were of one mind.)

Anyway, that was my folks. Donald and Daisy they weren't, but neither were they Ward and June, so I was scared and covetous of my perks as an outlaw child. I didn't know quite how to respond, and then, amazingly, I did. I told the truth. Donald Duck, I said, was not like my mom or dad. He was like my dog, Darwin the Beagle, excitable but lovable. Like, whenever people would walk by in front of our house, Darwin would just explode, squawking and baying and bouncing along behind the brick wall until they went past; and since the beach sidewalk in front of our house was a well-traveled thoroughfare, Darwin was one busy beagle. But when you yelled at him to stop, he just stopped and walked over to you, tilting his head and giving you that look so you had to give him a big hug.

The giant lady looked at me, but not the way Darwin did. She didn't move. She sat there like a statue and didn't blink. She didn't write anything down. She just looked, and now I was pissed, because I had given her a *great* answer. I knew this because, after thirteen grammar schools, I knew how to deliver a professional, precocious answer—how to build those extended point-by-point analogies that boosted your score on the tests they gave

you when you came to a new school. But June Cleaver wasn't buying. She turned over a piece of paper and asked me about the Road Runner cartoons. Did I like them? Yes, I did. Did I identify with the Road Runner or the Coyote? Again, I wanted to tell her that I didn't *identify* with cartoons. They were just cartoons. But, in truth, I sympathized with the coyote, so I said, "Wile E. Coyote."

Wrong! Clearly, wrong again, from the look on her face, but I was committed and I wanted to win, so I pressed on. I *identified* with the coyote, I said (like a pitiful slut), because he was always sending off in the mail for stuff from ACME that didn't work, like when I sent off for that Lone Ranger Badge and Secret De-coder, and when it came, it was just this dumb piece of cardboard. Again, I considered this a very suave, precocious kid answer. But again, nothing. She didn't write anything down, and I couldn't believe it. I was *flunking* a quiz on cartoons! So I withdrew into sullen hostility. This was my standard response to intransigent adults. My little brother, on the other hand, being a little brother, invariably turned silky sycophant, so I have no doubt that a few hours later he was sitting there smiling away at June Cleaver, saying yes, our home was pretty much a Satanic cauldron.

I folded my arms and stuck out my lower lip. June turned the page and asked me if I liked Tom and Jerry. A testy nod from little Davey. And was I ever, perhaps, *frightened* by the violence? she asked emphatically. A moment of thought and then, with an edge of icy sarcasm that would have impressed even my mom, I said: "Oh yeah, I'm always terrified." *And she wrote this down!* Thus, I discovered virtue's invulnerability to contextual irony. And I couldn't take it back! For years, I would replay this scene in my head, wishing that I had said something more sophisticated, like Claude Rains in *Casablanca:* "I am shocked, *shocked!*" Something like that, but I didn't, damn it. I had never felt quite so betrayed by the adult world—until six months later when the "results" of this "study" hit the news nationwide.

Even Dave Garroway talked about it on *The Today Show,* and

he was shocked, *shocked.* Children were being terrorized by cartoons! We trembled at Donald Duck in the role of an abusive parent. We read the Road Runner as an allegory of fear. And, worst of all, we were terrified and incited to violence by the aggressive carnage we witnessed in *The Adventures of Tom and Jerry.* And maybe so. Maybe some kids actually said this stuff, but speaking for the student body at Santa Monica Elementary I can assure you that we were mostly terrified and incited to violence by those enormous, looming ladies. They were *real,* not cartoons, and we knew the answers they wanted. But like good, brave little Americans, we were loathe to provide them, since they did not coincide with our considered opinions as citizens of this republic.

So, we did our best, you know. We told the truth and were betrayed—for our own good—and I am being perfectly candid when I tell you that this experience of betrayal was more traumatic and desolating to me than any representation I have ever encountered. All of the luxurious freedom and privacy I had felt in California dissolved in that moment. Because those ladies, in their presumption that we couldn't distinguish representations from reality, treated *us* like representations, to be rendered transparent and read like children's books. What's more, we kids *knew* whereof we spoke. We held symposia on "issues of representation" at recess, and it turned out that *everyone* knew that if you ran over a cat with a lawn mower, the cat would be one bloody mess and probably die. Thus, when the much-beleaguered cartoon, Tom, was run over by a lawn mower and got only a shaved path up his back, we laughed.

It was funny *because* it wasn't real! Which is simply to say that the intimidated, abused, and betrayed children at Santa Monica Elementary, at the dawn of the nineteen fifties, without benefit of Lacan or Lukács, managed to stumble upon an axiom of representation that continues to elude graduate students in Cultural Studies; to wit, that there is a vast and usually dialectical difference between that which we wish to *see* and that which we wish

to see *represented*—that the responses elicited by representations are absolutely contingent upon their status as representations—and upon our knowledge of the difference between actuality and representation.

What we did not grasp was just exactly *why* the blazing spectacle of lawn-mowered cats, exploding puppies, talking ducks, and plummeting coyotes was so important to us. Today, it's clear to me that I grew up in a generation of children whose first experience of adult responsibility involved the care of animals—dogs, cats, horses, parakeets—all of whom, we soon learned, were breathlessly vulnerable, if we didn't take care. Even if we did take care, we learned, those creatures, whom we loved, might, in a moment, decline into inarticulate suffering and die—be gone forever. And we could do nothing about it. So the spectacle of ebullient, articulate, indestructible animals—of Donald Duck venting his grievances and Tom surviving the lawn mower—provided us a way of simultaneously acknowledging and alleviating this anxiety, since all of our laughter was premised on our new and terrible knowledge that the creatures given into our care dwelt in the perpetual shadow of silent suffering and extinction.

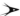

So, what we wanted to see *represented* were chatty, impervious animals. What we wanted to *see*, however, was that wall of vibrant, moving color, so we could experience the momentary redemption of its ahistorical, extra-linguistic, sensual embrace—that instantaneous, ravishing intimation of paradise that confirmed our lives in the moment. Which brings me, by a rather circuitous route, to the true occasion for this essay: a moment, a few days ago, when I looked around my living room and realized that, for once, the rotating exhibition of art that I maintain there was perfectly harmonious. Even the painting sitting on the floor, leaning against the bookcase, worked. The whole room hummed with this elegant blend of pale, tertiary complements and rich,

bluey reds. I even recognized the palette. Flipping open a large book on my coffee table, I found it displayed on page after page in the paintings of Pontormo.

I found this perfectly amazing. Since I never consciously "arrange" things, the accidental harmony spoke of some preconscious, developing logic in my eye, and I loved the idea that after years of living with color I would end up with Pontormo. Not such a bad place to be, I thought, but it spoke of more than that—since I realized in that moment that I had, indeed, spent a good portion of my life creating, discovering, or seeking out just such color-saturated atmospheres—in my glowing, scented room in the house below the Palisades, in art galleries, artists' studios, museums, casinos, and cathedrals—at the old Criterion in Santa Monica, in the Bishop's residence at Wurzburg, and on the beach in San Diego, standing with the water around my knees, peering through the surf spray at some extravagant orange and teal sunset that flashed back in the glassy curl. Even as I considered this, another such spectacle, the Las Vegas Strip, was blazing away right outside my windows.

I already knew, of course, that the condition of being ravished by color was probably my principle disability as a writer, since color for a writer is, finally, less an attribute of language than a cure for it. But it was a disability that afflicted most of the writers I loved, so I took comfort in it—and in the thought of Flaubert in North Africa, of Djuna Barnes in the salons of Berlin, of Fitzgerald in St. Tropez, DeQuincey in his opium dreams, Stendhal in Florence, Ruskin and Henry James in Venice, and even Thomas Jefferson, my old companion in self-indulgence, who was physically discombobulated by the gardens at Versailles. In my own life, I could pinpoint the moment I came into this knowledge. When I was very young, my grandparents had a little flower shop in south Fort Worth, the centerpiece of which was a large walk-in refrigerator for storing fresh flowers. The refrigerator had glass windows and doors. The first time I stepped into it, closed the door behind me,

and stood there amidst all that color, coolness, and scent, with the light streaming in, I was like Dorothy transported to Oz. I knew why I hated Texas, and this was something important to know.

So, I liked hanging around the flower shop and riding in the delivery truck with my grampa as he made the rounds of hospitals and funeral homes. I liked the way sick people always smiled at the flowers, and I even liked setting up the sprays of flowers around the coffins with dead people in them—which is probably why I felt like I had died and gone to heaven when we moved to California. Because there, at the flower shop, as in those Saturday-morning cartoons, color always occurred in league with and in opposition to suffering, negation, and death. As my friend Jeremy Gilbert-Rolfe has argued persuasively, there is an element of positivity in the visible world, and in color particularly, that totally eludes the historicity of language, with its protocols of absence and polarity. The color red, as an attribute of the world, is always there. It is something other than the absence of yellow and blue— and, thus, when that red becomes less red, it becomes *more* one or the other. It never exists in a linguistic condition of degradation or excess that must necessarily derive from our expectations.

The branch upon which the blossom hangs may be long or short, rough or smooth, strong or weak according to our expectations, but the redness of the blossom is irrevocable, and the word "red" tells us next to nothing about it. There are thousands of colors in the world and only a few hundred words to describe them, and these include similitudes like teal and peach and turquoise. So, the names we put on colors are hardly more than proper names, like Smith or Rodriguez, denoting vast, swarming, diverse families of living experience. Thus, when color signifies anything, it always signifies, as well, a respite from language and history—a position from which we may contemplate absence and death in the paradise of the moment—as we kids in Santa Monica contemplated the death of puppies in the embrace of cartoon rainbows.

Moreover, when art abandons color, as it did in the nineteen seventies, it can only recede into the domain of abjection—into the protocols of language, history, and representation. The consequence of this (which I suffered at the hands of June Cleaver) is that all discussion of art under such régimes begins at a position of linguistic regress that renders invisible the complex dialogue between what we want to *see* and what we want to see *represented*. In a more civilized world, the question I would have been asked as a child was not: "Do you like animated cartoons?" but "Do you prefer animated cartoons in color or in black-and-white?" I know what my answer would have been, but if I had been asked, I would have had a running start. I would have begun wondering, right then, why I liked cartoons in color and would have known, long before now, why I did. Instead, I moped around feeling betrayed by unction, punishing myself for not coming up with something as cool as Claude Rains in response to it. I am still shocked, *shocked.*

A Rhinestone as Big as the Ritz

The balcony of my apartment faces west toward the mountains, overlooking the Las Vegas Strip; so, every evening when the sky is not overcast, a few minutes after the sun has gone down, the mountains turn black, the sky above them turns this radical plum/rouge, and the neon logos of The Desert Inn, The Stardust, Circus Circus, The Riviera, The Las Vegas Hilton, and Vegas World blaze forth against the black mountains—and every night I find myself struck by the fact that, while The Strip always glitters with a reckless and undeniable specificity against the darkness, the sunset, smoldering out above the mountains, every night and without exception, looks bogus as hell. It's spectacular, of course, and even, occasionally, sublime (if you like sublime), but to my eyes that sunset is always fake—as flat and gaudy as a Barnett Newman and just as pretentious.

Friends of mine who visit watch this light show with different eyes. They prefer the page of the landscape to the text of the neon. They seem to think it's more "authentic." I, on the other hand, suspect that "authenticity" is altogether elsewhere—that they are responding to nature's ability to mimic the sincerity of a painting, that the question of the sunset and The Strip is more a matter of one's taste in duplicity. One either prefers the honest fakery of the neon or the fake honesty of the sunset—the undisguised artifice of culture or the cultural construction of "authenticity"—the genuine rhinestone, finally, or the imitation pearl. Herein I take my text for the tragicomedy of Liberace and the anomaly of his amazing museum.

As its emblem, I cite my favorite *objet* in his collection—its keystone, in fact—the secret heart and sacred ark of Las Vegas itself: "The World's Largest Rhinestone," 115,000 karats revolving in a circular vitrine, dazzling us all with its plangent banality. It weighs 50.6 pounds and is fabricated of pure lead glass. It was

manufactured by Swarovski Gem Company, the rhinestone people of Vienna (where else?), and presented to Liberace as a token of appreciation for his patronage, for the virtual fields of less substantial rhinestones he had acquired from them over the years to endow his costumes, his cars, his furniture, and his pianos with their ersatz spiritual dazzle. In my view, this was money well spent, for, within the confines of the Liberace Museum, dazzle they certainly do.

Within these three large showrooms, spaced around a shopping center on East Tropicana Boulevard, dazzle rules. Everything fake looks bona fide. Everything that Liberace created or caused to be created as a function of his shows or of his showmanship (his costumes, his cars, his jewelry, his candelabra, his pianos) shines with a crisp, pop authority. Everything created as a consequence of his endeavor (like the mega-rhinestone) exudes a high-dollar egalitarian permission—while everything he purchased out of his rising slum-kid appetite for "Old World" charm and *ancien régime* legitimacy (everything "real," in other words) looks unabashedly phoney.

Thus, in the Liberace Museum, to paraphrase Ad Reinhardt, authenticity is something you bump into while you're backing up to look at something that interests you. And there is much of interest there, because Liberace was a very interesting man. He did interesting things. When I think of him today, I like to imagine him in his Palm Springs home sitting before his most "priceless antique": a full-tilt Rococo, inlaid and ormolued Louis xv desk once owned by Czar Nicholas ii. He is wearing his Vegas-tailored "Czar Nicholas" uniform. (He said he never wore his costumes off-stage, but you *know* he did.) He is making out his Christmas list. (He was a *fool* for Christmas.) There is a handsome young "hillbilly" (as his mother called them) lounging nearby.

In this scene, everything is "real": The entertainer, the "hillbilly," the white, furry shag carpet, the Vegas-Czarist uniform, the red ink on the Christmas list, even *Palm Springs* is real. Every-

thing is real except that silly desk, which is fake just for his own-
ing it, just for his wanting to own it—fake, finally, for his not
understanding his own radicality. He had, after all, purchased the
1962 Rolls Royce Phantom v Landau sitting out in the driveway
(one of seven ever made), then made it disappear—let it dissolve
into a cubist dazzle of reflected desert by completely covering it
with hundreds of thousands of tiny mirrored mosaic tiles—a ges-
ture comparable to Rauschenberg erasing a de Kooning. But Lee
didn't get that.

He was an innocent, a pop naïf, but he was more than that.
Most prominently, Liberace was, without doubt and in his every
facet, a genuine rhinestone, a heart without malice, whose only
flaw was a penchant for imitation pearls—a certifiable neon icon,
a light unto his people, with an inexplicable proclivity for phony
sunsets. Bad taste is real taste, of course, and good taste is the
residue of someone else's privilege; Liberace cultivated them both
in equal parts and often to disastrous effect. But if, by his reac-
tions—his antiques and his denials—he reinforced a tattered and
tatty tradition of "Old World" respectability, then by his actions—
his shows and his "showmanship" (that showed what could not,
at that time, be told)—he demonstrated to m-m-m-my genera-
tion the power of subversive theatricality to make manifest atti-
tudes about sex and race and politics that could not, just for the
mo', luv, be explicitly avowed.

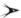

In Liberace's case, they were never avowed. He never came
out of the closet; he lived in it like the grand hypocrite that he
was, and died in it, of a disease he refused to acknowledge. But
neither, in fact, did Wilde come out of it, and he, along with
Swinburne, and their *Belle Époque* cronies, probably *invented* the
closet as a mode of subversive public/private existence. Nor did
Noel Coward come out of it. He tricked it up with the smoke and
mirrors of leisure-class ennui and cloaked it in public-school dou-

ble entendre. What Liberace did do, however, was Americanize the closet, democratize it, fit it out with transparent walls, take it up on stage and demand our complicity in his "open secret."

In-crowd innuendo was not Liberace's game; like a black man in black-face, he took it to the limit and reveled in the impertinence of his pseudo-masquerade. He would come striding onto the stage in a costume that was, in his description, "just one tuck short of drag." He would stop under the big light, do a runway turn, and invite the audience to *"Hey, look me over!"* Then, flinging his arms upward in a fountain gesture, like a demented Polish-Italian diva, he would shoot his hip, wink, and squeal, *"I hope ya' like it! You paid for it!"* And the audience members would signify their approval and their complicity by their applause. They not only liked the dress, they were happy to have bought it for him. So, unlike Coward, whose veiled naughtiness remained opaque to those not "in the know," Liberace's closet was as democratically invisible as the emperor's new clothes, and just as revolutionary. *Everybody* "got it." But nobody said it.

Even my grandfather got it, for Chris'sake. I can remember sitting before the flickering screen of an old Emerson at my grandparents' house, watching *Liberace,* which was one of my grandmother's "programs." At one particularly saccharine moment in the proceedings my grandfather leaned forward, squinting through his cataract lenses at the tiny screen.

"A bit like cousin Ed, ain't he," my grandfather said. Getting it but not saying it.

"Yes, he is," my grandmother said, with an exasperated sniff. "And just as nice a young man, I'm sure." She got it, too. She didn't say it, either. And my point here is that, if my grandmother and grandfather (no cosmopolitans they) got it, if they perceived in Wladziu Valentino Liberace's performance, in his longing gaze into the television camera, a covert acknowledgment of his own sexuality—and if they, country people to the core, covertly accepted it in him, then "the closet" as a social modality was, even

then, on the verge of obsolescence. All that remained was for Liberace and the people who accepted him to say the words. But for the most part they never did and some, recalcitrant to the last, never have.

Those who got it and didn't accept it, however, never stopped yelping. Liberace's career from first to last was beleaguered by snickers, slimy innuendo, and plain invective with regard to his sexuality . . . and his bad taste. The two, perhaps not surprisingly, seem so inextricably linked in attacks on his persona that you get the feeling they are, somehow, opposite sides of the same coin. At any rate, he was so regularly attacked for dramatizing his sexual deviation while suppressing the formal deviations of Chopin and Liszt, you get the impression that, had he purveyed a little more "difficult" art, he would have been cut a little more slack with regard to his behavior.

He chose not to do either, and, as a consequence, if Liberace had been a less self-confident figure, a more fragile and self-pitying soul, it would be all too easy now to cast him in the loser's role, as a tragic and embattled sexual outlaw. But beneath the ermines and rhinestones, Wladziu Liberace was a tough cookie and a high-roller—a positive thinker and an American hero. He came to the table to take away the money, so he cashed in the invective and, in his own immortal phrase, "cried all the way to the bank." His response to the virulent accusations that dogged his progress was always impudent passive-aggression: aggrieved, tearful, categorical denials followed immediately by further and even more extravagant behavior. So, by the end, he was gliding through the showplaces of the Western World with his handsome young "hillbillies" in tow, wearing that outrageous denial like an impregnable invisible shield. Like an old bootlegger smuggling legal booze, he continued to brandish the hypocrisies that he himself had helped make obsolete, just for the thrill of it.

Honesty is nice, they say, but transgression is sexier. So, in his final days, he must, like Wilde, have decried "the decay of lying."

It was what he did best, and over the years he took some shots for it—the best and most lucrative of which he took on his first tour of the British Isles in 1956, at the peak of his television and movie celebrity. In the autumn of that year, he and his manager, Seymour Heller, decided to skim a little cash off his brimming European popularity and so set sail, with Mom and brother George in tow, on the Queen Mary for an initial round of engagements in London. His reception, as they say in show business, both fulfilled his wildest dreams and confirmed his worst suspicions.

He was greeted at Southampton by a squadron of press and a gaggle of cheering fans all of whom trooped aboard the chartered "Liberace Special" for the train ride to Waterloo. There, his reception, in volume and hysteria, outstripped anything hitherto experienced in the category of pop celebrity welcomings. An unnerving crush of little old ladies and teenage bobby-soxers screamed, giggled, fainted, waved signs, and scattered paper rose-petals (thoughtfully provided) in his path. Chauffeurs and foot-men bowed as his party approached the pair of Daimlers rented to "whisk them to their hotel." Then, as he was about to step into one of the limousines, a reporter shouted above the crowd,

"Do you have a normal sex life?"

Liberace, looking blandly back over his shoulder, said, "Yes. Do you?"

That night at the Royal Festival Hall, he was greeted by hostile pickets outside ("Down with Liberace!") and by a standing room audience inside that reacted to his every remark with enthusiastic shrieks and shouts and responded to every number with thunderous and unruly cheers. The press reaction, needless to say, was uniformly uncomplimentary—ranging from bored, Coward-esque dismissal, a wave of the napkin, "Take it away, please, it's corked," to hostility that bordered on panic. The masterpiece of this latter category was produced by Cassandra (William Conner) for the tabloid *Daily Mirror,* with a national circulation of 4.5 million. I quote it at length here because it is world-class screed—

but also because I would like to think that, in its little way, it changed the world.

He is the summit of sex—the pinnacle of masculine, feminine and neuter. Everything that he, she, and it can ever want. I spoke to . . . men on this newspaper who have met every celebrity coming from America for the past thirty years. They said that this deadly, winking, sniggering, snuggling, chromium plated, scent-impregnated, luminous, quivering, giggling, fruit-flavored, mincing, ice-covered heap of mother love has had the biggest reception and impact on London since Charlie Chaplin arrived at the same station, Waterloo, on September 12, 1921 . . .

He reeks with emetic language that can only make grown men long for a quiet corner, an aspidistra, a handkerchief, and the old heave-ho. Without doubt, he is the biggest sentimental vomit of all time. Slobbering over his mother, winking at his brother, and counting the cash at every second, this superb piece of calculating candy floss has an answer for every situation.

Nobody since Aimee Semple McPherson has purveyed a bigger, richer and more varied slag heap of lilac-colored hokum. Nobody anywhere has made so much money out of high speed piano play with the ghost of Chopin gibbering at every note.

There must be something wrong with us that our teenagers longing for sex and our middle-aged matrons fed up with sex alike should fall for such a sugary mountain of jingling claptrap wrapped up in such a preposterous clown.

Liberace would ultimately sue the *Mirror* for impugning his manhood and, all evidence to the contrary, win £40,000 in damages. But what intrigues me about Cassandra's invective is the possibility that it just might mark the official beginning of the "Sixties," as we call them. Because Liberace had this great idea.

He had touched a jangling nerve, and I like to imagine young John and Paul up in Liverpool, young Mick and Keith down in London, little David Bowie, and the soon-to-be Elton John, in their cloth caps, all full of ambition and working-class anger, looking up from their *Daily Mirrors* with blinking lightbulbs in talk balloons above their heads.

At this point, I would like to think, the rhetoric of closet homosexuality as practiced by Wilde, Coward, and Liberace is on the verge of being appropriated for a broader attack upon the status quo, demonstrating the fact that it was *never,* in the hands of its masters, a language of disguise, but a rhetoric of deniable disclosure—a language of theatrical transgression that had its own content. This strategy of theatrical subversion would eventually resonate throughout the entire culture and would end, I suggest, very near where it began with Wilde, whose "effeminacy" was regarded as indicative of his dissent and cultural disaffection, rather than the other way around.

By the time we reach the watershed marked by the heterosexual drag of The New York Dolls, I think, this re-reversal has taken place in American popular culture. Sexuality is no longer a mere matter of biology and whim. It *means* something. The battle for sexual tolerance has moved on to other, more political, battlefields, and, in view of this transformation, I think we can regard the Liberace Museum as having some general historical significance beyond the enshrining of a particularly exotic entertainer. Its artifacts, genuine rhinestones, and imitation pearls alike mark an American moment—the beginning of the end of the "open secret." So the cars and the costumes and the silly pianos might be seen as more than just the memorabilia of an exotic saloon singer: because they are, in fact, the tools with which Liberace took the "rhetoric of the closet" public, demonstrated the power of its generous duplicity, and changed the world.

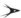

I would like to think that Liberace knew this, somehow, in some way, as he stood in the sunny parking lot of his Las Vegas shopping center on Easter Sunday, 1979, with the mayor and other dignitaries in attendance, and opened his amazing museum. Maybe it's sentimental of me, but I would like to think that, as he stood there, the guy had some sense of his own authenticity. The reporters noted that he was wearing a pink, blue, and yellow checkered jacket with matching yellow shirt and slacks. A large gold cross hung around his neck and six diamond rings adorned his fingers.

"Welcome to the Liberace Museum!" he cried to the assembled multitude. "I don't usually wear diamonds in the afternoon, but this is a special occasion!"

The Birth of the Big, Beautiful
Art Market

In the beginning was the Car, and the Car was with Art, and the Car was Art. Thus it was in the American boondocks during the nineteen fifties and sixties. Especially for me. For me, cars were not just art, they were everything. None of the schools I attended (as we gypsied around the American West) were ever that great, nor ever quite real to me. So such secondary education as I received, I received in the physical culture of cars. Wherever I found myself, kids bought them, talked them, drew them, and dreamed them—hopped them up and dropped them down—cruised them on the drag and dragged them on the highway, and I did, too. Thus, of necessity, I learned car math and car engineering, car poli-sci and car economics, car anthropology and car beaux-arts.

Even my first glimmerings of higher theory arose out of that culture: the rhetoric of image and icon, the dynamics of embodied desire, the algorithms of style change, and the ideological force of disposable income. All these came to me couched in the lingua franca of cars, arose out of our perpetual exegesis of its nuanced context and iconography. And it was worth the trouble, because all of us who partook of this discourse, as artists, critics, collectors, mechanics, and citizens, understood its politico-aesthetic implications, understood that we were voting with cars—for a fresh idea of democracy, a new canon of beauty, and a redeemed ideology of motion. We also understood that we were *dissenting* when we customized them and hopped them up—demonstrating against the standards of the republic and advocating our own refined vision of power and loveliness.

My own endeavors in this regard were devoted to a black 1946 Chevrolet Coupe, a coral-and-cream 1955 Ford Victoria, a turquoise-and-white 1957 Chevrolet Bel Air, and a bronze-lacquered 1937 Chevrolet pick-up, dago-raked with a Chevy 357

under its pin-striped hood. I bought these cars in sequence, trading one in on the next and paying out the balance with money I earned from before-and-after-school jobs—and this was important, because the guys whose folks bought them their cars tended to be dilettantes, were less inclined to know their vehicles intimately, to tear them down and put them back together at a whim, to adjust and refine their operation and iconography.

We true devotees aspired to full consciousness of our rides. There was no aspect of their technology and design whose historicity we did not comprehend, whose efficacy we had not analyzed, whose aesthetics we had not contemplated. We *knew* these cars and knew what they *meant;* and what they meant, over and above everything, was freedom. But freedom is a gem with many facets: So we pondered the halting gurgle of big v-8s with racing camshafts, the rhetoric of shrouded headlights, the ethics of "cherry" restorations, and the proprieties of altering a vehicle's profile by chopping, channeling, lowering, and raking.

Thus, years before I had ever seen an official "work of art," I could claim an evolved aesthetic. I could have told you, if you had asked, that I was neither minimalist nor formalist. I did not hold with the suppression of text and ornament in order to create a blank, reflective sleeve of aerodynamic color. Nor was I a modernist, in the architectural sense, devoted to stripping away the cosmetic surface of a vehicle to reveal its glamorized functional apparatus. Nor was I an expressionist beguiled by Gaudi lead-work and gaudy flame jobs. Why? Because I didn't want to drive a singular, autonomous work of *art.* I wanted to dissent, not defect.

So I was always looking for something fresh and disconcerting. To borrow Edward Ruscha's expression, I wanted to achieve "Huh? Wow!" (as opposed to "Wow! Huh?"). I wanted that subtle jolt of visual defamiliarization as a prelude to delight. So I liked appropriating décor, subtly redesigning details and trim to reconstitute the car's composition and profile. I liked enhancing dumb stuff that other guys just instinctively trashed, like the cartouche

on the trunk lid. And I *loved* tiny pin-stripes that nuanced the highlights, and big engines with no high-end acoustics, just that low rumble bubbling on the edge of audibility, like my Fender bass run through a concert stack. My optimum set of wheels, then, looked and sounded like a high-performance production model from a company you never fucking heard of—as if I had walked into a Dave dealership one afternoon and bought it off the showroom floor—and now you wanted to buy one, too. That was my idea of cool.

As a consequence of this apprenticeship, my inadvertent discovery of the commercial art world of the nineteen sixties felt just like coming home. In a twinkling, I was back where I never had been. Andy Warhol's customized Marilyns and Edward Ruscha's standardized Standard Stations confirmed my aesthetic, of course, but most importantly, *I knew the whole gig*—the entire business of dreaming and drawing and talking and trading and buying and selling—the deep rituals of sitting around in a big room filled with disconcerting objects, chatting about them, looking at them, privately balancing your desire and your vision of America against your bank account.

There were structural differences, of course, the principal one being that, since production was disseminated, the custom-model came first in this art economy. It was clear, however, that the large institutions of the art world, like the Whitney Museum uptown and the art school out at Yale, functioned like General Motors, establishing brand-names, institutional agendas, and hierarchies of value out of materials provided by the custom market. I could live with this. I didn't care about it, but I could live with it, as long as Richard Bellamy, in his dumpy little gallery downtown, continued to function like George Barris in his Kustom Kar Shop out in Los Angeles—promoting rebellion, proposing outrageous reconfigurations and different ideas of how the world should look.

63

So, this new world was exciting to me, not least of all because it meant that I hadn't squandered my youth, that I was bringing something to the table. I remember sitting at a table, in a bar down in El Paso, with Luis Jiménez, one afternoon in the late sixties, saying just that, marveling at the fact that, for dudes like us, who had grown up in the protean discourse of American cars, the permutations of American art from Jackson Pollock's drip paintings to Frank Stella's protractors were virtual child's play. What we did not understand, as we sat there smugly sipping our Dos Equis, was that the age of incarnate ideology was over and the Protestants had won.

If we had thought about it from the perspective of old car freaks, however, we would have known and surely could have predicted that the General Motors of the art world—the museums and universities—would ultimately seek to alleviate their post-market status and control the means of production. They would soon succeed in doing this by revisions in the tax code, by the expansion of public patronage and the proliferation of graduate education—all of which eroded the distinction between art history and art now—and eroded, as well, the even more critical distinction between art and the "liberal arts." Within ten years, the art world was well on its way to becoming a transnational bureaucracy. Everybody had a job description and a résumé. Junior professors (!) began explaining to me that non-portable, non-object art had arisen during the nineteen sixties as a means of "conceptualizing" the practice of art in response to the increasing "commodification" and "commercialization" of the art object during the postwar era.

This would have been a wonderful argument if a painting by Edward Ruscha or Jacques-Louis David were any less "conceptual" than a pile of dirt on a museum floor—or if that pile of dirt were any less "commercial" for being financed by minions of the corporate state. My own experience of those years suggested quite the reverse: that non-object, non-portable art arose in the mid six-

ties as a strategic reaction to a commercial reality: all the walls were full! After fifteen years of the greatest and most broadly-based painting market in the history of the world, every inch of available wall space was expensively inhabited by Pollocks and Poonses, Rothkos and Rosenquists. Thus, the fashion for conceptual, documentary, and installation art arose ("floor and drawer art," as Richard Serra called it). Over the next seven or eight years, this new art had its commercial cynosure, and no one I knew even considered the possibility that it couldn't be sold. As a dealer friend told me at the time, "Anybody who can't sell a handful of air with a dream in it doesn't deserve to call himself an American, much less an art dealer." That was the temper of the time.

In the early seventies, however, as these "new" practices began to lose steam in the natural course of things (as other practices had lost steam before them), they were adopted by a whole new set of venues, by museums, kunsthalles, and alternative spaces across the country, first as trendy, economical exhibition fodder for the provinces, and then as "official, noncommercial, anti-art"—as part of a puritanical, haut bourgeois, institutional reaction to the increasing "aesthetification" of American commerce in general. Works of art, after all, had been commercial objects for two hundred years, but commercial objects, like the cars we loved, had only recently become works of art—and they did so in response to the market conditions that would ultimately create the post-industrial world. As Warhol was fond of telling us, the strange thing about the sixties was not that Western art was becoming commercialized but that Western commerce was becoming so much more artistic.

So, to return to the lingua franca of cars, we should remember that America's industrial base—and its automotive industry particularly—came out of World War II in great shape. Its production potential was greatly expanded, its technology much

improved, and its facilities unscathed by the conflict. Its products, however, were no longer being consumed by violence, so it soon became clear that if these enterprises were to continue at postwar production levels with prewar marketing and design strategies, they would almost immediately out-supply demand and effectively put themselves out of business. Thus, American industry found itself facing the challenge that has confronted every artist since Watteau, that of a finite, demanding market for a necessarily overabundant supply of speculative products.

The problem is this: As any dealer will tell you, it is perfectly possible for any artist with decent work habits to produce more work in three or four years than there are buyers worldwide who might possibly acquire them, ever. The pool of *probable* purchasers is even tinier. So the logic is inescapable: *Somebody, sometime, is going to have to buy more than one.* In the years following World War II, American mercantile culture found itself in exactly the same situation, and in response to this challenge, those enterprises that survived completely transformed their design, production, and marketing strategies to an artistic model.

First, companies introduced a hierarchy of "lines." As an artist might produce prints, drawings, and paintings, American manufacturers began introducing "economy" and "luxury" lines to bracket their mid-range product—thus creating the possibility of the consumer "moving up" without moving out. Second, and again like artists in the nineteenth century, these manufacturers began designing visual obsolescence into their products by institutionalizing style change. In this way, manufacturers hoped to create cyclical demand for their products by shifting emphasis from their value or utility to their extrinsic "currency," by having one style supplant another.

And, finally, American business stopped advertising products for what they were, or for what they could do, and began advertising them for what they *meant*—as sign systems within the broader culture—emphasizing what every collector wants to

know: who owned them and where they were owned. Thus, rather than producing and marketing infinitely replicable objects that adequately served unchanging needs, American commerce began creating finite sets of objects that embodied ideology for a finite audience at a particular moment—objects that created desire rather than fulfilling needs. This is nothing more or less than an art market. If you don't think so, price out a 1965 Ford Thunderbird.

The Leonardo of this new art market (or more precisely, its Monet) was an ex-custom-car designer from Hollywood named Harley Earl, who headed the design division at General Motors during the postwar period. Earl's most visible and legendary contributions to American culture were the Cadillac tailfin (based on the tail assembly of the P-38 fighter plane) and the pastel paint-job—design innovations that, when combined, as they often were, simultaneously "masculinized" and "feminized" the American automobile, translating it into a distinct, all-purpose polymorphous object of desire in the best tradition of the Rococo.

Most importantly, however, Earl invented the four-year style-change cycle linked to the Platonic hierarchy of General Motors cars, and this revolutionary dynamic created the post-industrial world. Basically, what Earl invented was a market situation in which the consumer moved up the status-ladder within the cosmology of General Motors products—from Chevrolet to Pontiac to Buick to Oldsmobile to Cadillac—as the tailfin or some other contagious motif moved *down* the price-ladder, from Cadillac to Chevrolet, year by year, as styles changed incrementally.

From the viewpoint of production, this sliding dynamic greatly mitigated the cost problems that traditionally proved the downfall of rapid style-change in mass-produced products; to wit, the accelerated obsolescence of hugely expensive production technology. In Earl's scheme, the tailfin technology, say, that had become stylistically obsolete on the Cadillac, could be retooled and used to produce Oldsmobiles, then Buicks, then Pontiacs,

then Chevrolets, by which time it had been totally redesigned. From a marketing point of view, it was heaven. It bound consumers to the parent company and invited them to make incremental steps up the price ladder, as that exquisite, finny grail gradually descended toward their aspiring spirit.

As a consequence, the "commercial art" that advertised American commodities during this period (1950-1970) took on the qualities and functions that "religious art," "courtly art," and "official art" served in other eras. It became a theater and a palimpsest of the competing values and contexts that made the wheels go round—a contextualizing discourse for the democracy of objects we all inhabit. Like the courtly, religious, and official art of the past, then, these images functioned in aid of commerce, society, religion, and official policy, illustrating without actually embodying those particular values. The task of embodying cultural values, in all their multifarious complexity, has fallen, in this century, to "art objects" like *Les Demoiselles D'Avignon*, the Brillo Boxes, or the Pink Cadillac. These objects propose for moral and monetary investment those redeemed values that are distorted and submerged by the advocacy of the market or the institution.

Today, of course, it is all an art market, the whole of American commerce. We can't make a toaster anymore, a VCR, or even a decent faucet, but we can create desire. We can make fetching footwear, beautiful games, exquisite motorcycles, hot TV, great rock-and-roll records, and dazzling movies. Such artifacts constitute our principal contribution to global commerce. The alternative discourse of embodied dissent, however, has all but disappeared. Those customized and hopped-up objects and images we might expect, that demonstrate against the standards of the republic and advocate their own refined vision of power and loveliness, are nowhere to be seen—since power and loveliness themselves are presumed to be at issue—as if they might be talked away, along with the image, the object, and commerce itself, as evidence of human vanity, so that art might more closely emulate the paper

body of bureaucracy.

In today's art world, then, in place of the ongoing struggle for refinement and redemption, we have pre-millennial renunciation. In place of the tumultuous forum, we have the incestuous cloister, and in place of customized art, we have an academic art, which, like the commercial, courtly, religious, and official art of yesteryear, is content to advertise its pre-approved corporate values and agendas. Why? What happened? My own suspicion is that something new came into being and could not be let to stand. So let me return for a moment to my conversation with Luis Jiménez in that bar in El Paso in the late sixties. On that afternoon, while we were talking about cars and art, Luis explained to me that his earliest ideas of becoming an artist had come from watching the glimmering lowriders cruising the streets of Juárez and El Paso. They seemed to him, he said, the ultimate synthesis of painting and sculpture—the ultimate accommodation of solidity and translucency—and more importantly, for Luis, they seemed a bridge between the past and the future because he recognized the visual language of the Baroque in these magical automobiles, in the way the smooth folds of steel and the hundreds of coats of transparent lacquer caught the light and held it as the cars slipped through the bright streets like liquid color—like Caravaggio meets Bernini, on wheels.

Now, let me carry Luis's argument one step further and suggest the precise manner in which these wonderful cars fit into the visual tradition that Hispanic America inherited from the age of the Baroque. First, we must remember that the technique of glazing transparent color was invented in fifteenth-century Italy to do one thing: to paint the body of Christ as a physical being filled with light. This image of luminous materiality stood as a metaphor for the central tenet of Western Catholicism: that Christ was the word of God made flesh—the Incarnate Word— a creature who had lived and suffered and experienced temptation in corporeal form . . . and died a real death. This is the central

message of the Eucharist and of the polychrome sculptures that still populate the churches and homes of Hispanic America.

After World War II, however, Chicano car-cultists in the American Southwest began secularizing this central, sacramental metaphor, creating gleaming, iconic automobiles that embodied, not the Word of God, but the freedom and promise of effortless mobility—honoring the traditions of democratic America that they had inherited, as well. Then, under the aegis of custom-car designer Harley Earl, Detroit would begin to incorporate the principles of lowrider design into its products, and, in doing so, effect one of the great iconographic syntheses in the history of Western culture. The masters of American industry would embody—in the Catholic language of material light, of chrome and polychrome—the disembodied intellectual tenets of the Enlightenment: the values of Protestant America's founding fathers.

Thereafter, the emblem of the automobile as an embodiment of the promise of America—as an icon of Life, Liberty, and the Pursuit of Happiness—would permeate the entire culture, Catholic and Protestant alike, and this metaphor of corporeal intelligence would be reinforced throughout the nineteen fifties and sixties by other proliferating iconographies of embodied light: by the luminous materiality of new plastics and Technicolor film and by refinements in color photography. Then, amazingly, the metaphor would be confirmed by the new science of genetics, which would inadvertently prove those antique Popes to have been right in their wrongness by demonstrating scientifically that we are *all*, indeed, the genetic word made flesh.

So this is my idea: The historical confluence of accident, insight, commerce, and iconography in postwar America created the nineteen sixties as America's transcendent Mediterranean moment—gave birth to the big, beautiful art market as an embodied discourse of democratic values that partook, in equal parts, of the Eucharist and the stock exchange. Thus, the United States emerged from the sixties as the only nation in the history

of the world with a freely-elected, fully-embodied iconography of promise—and we might have one yet, I suspect, if the sages of puritan New England had chosen that moment to do what they desperately wished to do: secede from a Union they saw sinking into the mire of idolatry and democracy—vices they might just tolerate in politics, but never in culture. Never.

So, what we got was a secular Reformation—a return of the Word at the expense of the flesh and a new jihad against idolaters, now guilty of "commodification." The old quarrel between "grace" and "works" was reconstituted as a new quarrel between "theory" and "practice." Once again, we drove the money-changers from the Temple of Art, *which was not a temple,* nor ever had been, not in America, where it had always been a secular discourse in the form of a market. Even so, academic civil servants of the Word, horrified by the image and scandalized by looking, mounted an attack on them both on behalf of their own practice—a "critique of representation," which, at its heart, is a critique of representative government—bald advocacy for a new civil service of cultural police.

And for what transgression did we suffer all this theological nit-picking and sensory deprivation? Well, a bunch of citizens made some objects that other citizens thought looked great. Still other citizens thought they could make them look even greater and manifested their dissent by customizing these objects. Other citizens thought these new objects did indeed look greater. They argued with the advocates of the previous objects, and since these objects didn't *do* anything, weren't *worth* anything, and came without labels or instructions, people were actually arguing about the values they perceived to be embodied in these objects, values they held dearly enough to argue about and invest in.

It was, in fact, nothing more dangerous than a democratic forum of free opinion that, in its protean liveliness and free-form contingency could only expand, did expand, in fact, and persists today in all our quotidian discussions of popular art in this nation.

In the world of high art, however, a bunch of tight-assed, puritanical, haut bourgeois intellectuals simply legislated customized art out of existence, in a fury of self-important resentment. Because Hollywood trash like Harley Earl and lowriders like Luis Jiménez became conversant with the economics of their beautiful, powerful game.

A Life in the Arts

When a friend of John O'Hara's called to inform him of George Gershwin's death, O'Hara responded appropriately, shouting into the phone: "I don't have to believe it if I don't want to!" Would that I could have been so willful. When Terry Allen called me in San Diego with the news that Chet Baker was dead, I just said, "Aw, shit!" and hung up. Because I believed it, and believing it, I sat there for a long time in that cool, shadowy room, looking out at the California morning. I stared at the blazing white stucco wall of the bungalow across the street. I gazed at the coco palm rising above the bungalow's dark green roof. Three chrome-green, renegade parrots had taken up residence among its dusty fronds. They squawked and flickered in the sunshine.

Above and beyond the bungalow and the palm, the slate-gray Pacific rose to the pale line of the horizon, and this vision of ordinary paradise seemed an appropriate, funereal vista for the ruined prince of West Coast cool. So I sat shivah for Chet Baker in that quiet room, acutely aware of my own breathing—aware, as well, that I had been listening to Baker breathe though his trumpet and through the language for more than thirty years. Now, suddenly, Chet Baker wasn't breathing any more, and I missed him immediately. In more ways than I could count, he had been the secret sharer and unwitting accomplice in the best and most disgusting of my adventures.

I only met him once, in the nineteen seventies, in a little pub called Stryker's in Manhattan. That night, he moved and talked like some kind of noir athlete, at once tough and passive, obsessed with little things—a hangnail, a fever blister on his lip—the physical business of making music. Beyond that, he just seemed "out there," untroubled in any serious way, comfortably embarked on his own secret journey. Now, knowing that he was dead, I realized that somehow, day in, day out, as I had gone about my own

fugitive endeavors, just knowing that Chet was out there too, somewhere in the drift, had been a kind of validation. Just knowing that someone else, more gifted than I, whom I respected, had made the same foolish, Draconian decisions and made it work, had made it better.

Baker was, after all, the first artist whose work I had *discovered*—the first artist whom I had never heard of, whom no one had told me about, who spoke to me purely out of the air—whose work I was forced to divine by the pure logic of sense. That was in 1954. As I did every day after school and before my paper route, I was flipping through the jazz albums in Sumpter Bruton's record shop. I came across a Chet Baker Quartet album and decided, on impulse, to buy it, because I thought the cover was cool. (It was, I must admit, an early ab-ex effort of Robert Irwin's). I took the record up to the counter, and Sumpter, who was a jazzman himself, approved of my purchase, so I took the record home and was hardly through *Happy Little Sunbeam* before I realized that for once, finally, I had found my own place.

My dad had been a jazz musician—an old swing guy with aspirations to bebop. My friends were all hillbillies. Chet Baker's music was in some new place between them. It was horizontal music that flowed in a steady groove and sang those haunting double lines that—from Bob Wills's twin-fiddles to The Allman Brothers' twin-guitars—put unrequited sadness into country music. Chet, however, infected that Oklahoma lonesome with L.A. city-lights *tristesse,* so, the songs seemed to glide past me like low-riders down Pico Boulevard, sleek and self-contained, with the fleet glimmer of the city chasing down their dark reflective surfaces. And they did swing, with the shrewd harmonics of hard bop, but without its hyperkinetic posturing.

Everybody else, I realized, was playing *jazz.* Chet Baker was playing the song, and, innervated as I was by the ornament of bebop, this seemed like an *incredibly* neat idea to me. So I went back to Sumpter's the next day and bought *Chet Baker Sings,* my all-

time favorite record—and, not coincidentally, the best make-out record in the history of modern romance. I played it all the time, morning and night, and it spoke to me then of a special kind of elegiac cool; it dispensed with all pretension to musical heroism without repudiating the idea of heroism itself; it muffled the sentiment of the sung lyrics without denying the possibility that somewhere, at some time, for someone, such sentiments might have had a certain validity. Today, having written some songs myself, I see that Baker knew what all songwriters know, what singers like Judy Garland and Patsy Cline and Karen Carpenter knew most profoundly, that *all songs are sad songs,* borne as they are on the insubstantial substance of our fleeting breath. So, *Chet Baker Sings* sang the quintessential postwar, white-boy blues, but it did more than that.

By abandoning the prevailing rhetoric of spontaneity for a thoughtful kind of subversive premeditation, Baker's improvisational strategy spoke less of fashionable attitudes than it did of a new way of doing things, a new ethos of living into the world—one that, a few years later, would characterize the works of Edward Ruscha, another Oklahoma boy gone California. It was a reversal of priorities. It devalued the quest for instantaneous epiphany in favor of an ongoing temporal discourse. Looking back on it now, I know I learned to write prose (or how I wanted prose to sound) by listening to the long, lapidary lines on that record. Because that is what Baker is always doing: transforming the tight, *forme fixé* of pop music into this sensuous, elegant, paratactic prose—sotto voce—full of silences and recursive turns.

I also learned about the ideological imperatives of criticism by trying to figure out why most jazz critics failed to share my enthusiasm for Baker's music. From a distance, of course, I can see that those critics (Leonard Feather, Nat Hentoff, et al.) afforded me my first exposure to "high modernism" with its cult of "originality" and masculine "self-expression." Thus, Baker's playing was constantly derided as being derivative of Miles Davis, despite

the fact that it wasn't. They were both, admittedly, children of Clifford Brown, whose manner they purged of vibrato and invested with breath—with the bluesy sexiness of saxophone. But Miles, being the classic abstract-expressionist horn player, "developed" in aggressive ways that a modernist could understand, apparently leaving Baker "behind." Thus, the liner notes of Baker's albums were always protesting that he could, when he wanted to, play "hard" and "tough." Because "butch" was important, then. This also explains, if it doesn't excuse, why a critic like Feather would call Baker's singing "weak voiced, but appealing to feminine audiences." *(Yikes! Girl stuff! Say no more!)*

With a little historical distance, it's clear that what Chet Baker did with *Chet Baker Sings* is not unlike what the Ramones did with their first album: simply turned every contemporary expectation on its head. As Warhol would say, just a few years later, he "got it exactly wrong." Most importantly, Baker reintroduced the text into jazz music as a pivot of expression. He sang those great sentimental lyrics by Larry Hart, Johnny Mercer, and Ira Gershwin (previously considered suitable only for female vocalists), but he sang them at one remove, cool and plain, acknowledging the sentiment without buying into it—glancing at it over his shoulder, as through the window of a door closed behind him—so that what we get is not the feeling but the memory of it. In contemporary terms, Baker does not so much "perform" these songs as "simulate" them—appropriating their complete content to his own intentions while leaving the song itself with its formal integrity unmolested. To this end (unlike most jazz renditions at that time, which tend to appropriate, at most, the melodic release), Baker plays the whole song, including the verses, in sequence, never abandoning the contrapuntal presence of the melody in his improvisation.

So, while most jazz albums of the period include, at best, five long instrumentals, *Chet Baker Sings* is made up of eighteen two-and-one-half-minute cuts—played and sung without any of the

popular signifiers of "jazz expression." There is no vibrato, no "beautiful" singing, and no "strong" statement. There are no extended solos, no range dynamics, no volume dynamics, no tempo dynamics, no expressive timbre shifts, no suppression of extant melodics, no harmonic meandering, no virtuoso high-speed scales, and, in fact, very few sixteenth-notes—none of the stuff, in short, that told jazz critics of the time what the player was doing and how "good" he was at it. All you got was the *song*—dispassionately articulated with lots of spaces—swinging to be sure, but played mid-tempo and mid-range, shot through with melodic and rhythmic nuance that defied notation or interpretation. Baker's album, then, was a totally *other* form of expression for its time. Its only contemporary aesthetic analogy was in the cool economy and intellectual athletics of long-board surfing—another lost art of living in real time that may be coming back.

On the morning of May 13, 1988, the body of Chesney H. Baker, 58, was found in the street beneath the window of his hotel room in Amsterdam. Clearly he had either fallen, jumped, or was pushed, and certainly he had died as he lived—under suspicious circumstances. Suicide was ruled out by those who knew him— first, because Baker's was a temperament strikingly free of envy, theatrical disappointment, and self-pity, and second, because, even if he had been prone to these artistic vices, he had been, for the past three or four years, in good spirits. More than welcome in clubs all over Europe, he had been playing well, recording regularly, working often, and even, occasionally, getting paid for doing it.

Just prior to his death, Baker played a triumphant solo concert in Paris, with full orchestra, to a full house. After the concert, he thanked the musicians and promoters for their support, signed a few autographs and, pocketing the check, strolled out into the night. He was last seen tossing his horn case into the back of his

battered Alfa and buzzing off into the Parisian traffic, alone, on his way to the next gig. On the evening of the morning he was found dead in the street, he was scheduled to play a gig in Amsterdam. He was, by all accounts, looking forward to it.

Narcotics were suspected in his death. They always were. Since 1957, when Baker effectively wrecked what was always referred to as "a promising career" by getting sick on heroin, it was generally assumed (with some justification) that any altercation involving Baker was narcotics related. It seems strange now, but looking back at the press clippings and album notes that chart Baker's career, it is clear that, even though he was far from the only jazz musician of his generation to use junk, he was the only one who was *famous* for it—which is to say, he was the only one who ever lost a *movie role* because of it.

At the time he got sick and let everybody down, Baker was twenty-seven years old, the product of rural Oklahoma, Glendale Junior High School, the Presidio Army Band, and the University of the Night, where he studied with Charlie Parker. He had topped the *Downbeat* polls as a trumpet player and a vocalist at twenty-four, and what's more, he had a hit single—with Gerry Mulligan ("My Funny Valentine")—an unheard of achievement for any jazz musician who wasn't Louis Armstrong or Nat King Cole. So he was an icon-in-progress—the "next big thing," the "beautiful boy," the "great white hope," the *next James Dean,* for Christ's sake—of American pop culture: He was being considered for the role Robert Wagner would ultimately play in *All the Fine Young Cannibals.*

But he got sick, and for some reason the idea that this serious musician, this gifted player, this protégé of Charlie Parker, would submarine a movie career—would blow the chance to be a "fine young cannibal"—really pissed people off. It was a repudiation of everything the nineteen fifties were about. Baker was made to pay for this transgression. For twenty years, he was hounded by journalists anxious to be there when he overdosed, and narcs

anxious to bust him for trying. The narcs got a better return for their time, and Baker ended up doing some in Italy in the early nineteen sixties.

All the while, the minions and mavens of the "serious jazz world" stood on the sidelines, exasperated on the one hand that Baker refused to do something "historical," like Miles, that they could write about and teach in their college courses, and annoyed on the other hand that he continued to play so beautifully, that he refused to quit and be the bum they wished he was. "It really pissed them off," Lowell George told me once, "that they couldn't *learn* anything from Chet's playing, not anything they could teach. All they could learn was that he could do it, and they couldn't. It was all about thinking and breathing in real time, and they couldn't grasp that. It had too much to do with life, with how you live in time."

So Baker didn't have a "career," or make any of the noises that signify musical "history," but he kept on playing. Then, in 1967 in San Francisco, six junkies jumped him up for his stash and beat his teeth out—a death blow for a trumpet player. But Baker pumped gas for two years, entered a methadone program, got some new teeth and taught himself to play again. He continued to play, mostly in Europe, on the horse and off it, for the rest of his life. Still, his obituaries and posthumous liner notes inevitably speak of "wasted talent," "problems with drugs," and "lost opportunities" (to be a cannibal, one assumes).

Even today, the aura of romantic ruin will not go away. When an American ducks the gold ring rather than grabbing it, there has got to be a pathological explanation, and drugs were it. Baker would have understood this, I think, since he so casually reversed the priorities of artistic mythmaking in our culture. He wanted people to understand what he played; he didn't care a damn if they understood how he lived. Further, all the crocodile tears on the occasion of his death betray a certain level of resentment on the part of the jazz establishment at Baker's continuing

musical credibility. He had, after all, continued to play and find new listeners, in private, in Europe, while all their fusion gods were playing pop sessions, writing rap charts, or teaching theory in ivy-covered colleges.

Thus, in the days immediately following his death, a good deal was made of the "tragic" implications of a dope rig found in Baker's room. When an autopsy revealed that Baker was completely clean at the time of his death, the police pronounced themselves baffled—which is understandable, since fewer policemen than you would think have ever been junkies. They would be baffled as well by the fact that I carry around in my luggage a four-gram bottle with the crud still caked in the bottom—as a reminder that there is no statute of limitations on stupidity.

During the past few years, however, with the embarrassment of Baker's sly, resilient presence out of the way, his music has suffered a major comeback—as has his "image" (see Chris Isaak). It would be nice if this amounted to a serious reevaluation of Baker's endeavor, but I don't think this is the case. The music is still good; it always has been. It's just now that Baker is dead, he can be assumed to have paid his debt to society for refusing to worship the twin gods of Stardom and Historical Development. In the popular ethos, his life is "really" tragic now—meaning, he doesn't get paid for the record you buy.

In fact, Baker's life was in no sense a tragic one, nor was his talent wasted or unappreciated. Given the opportunity, I'm sure that he would say of himself, as he said of Charlie Parker: "He had a very happy life." He lived fifty-eight years, recorded sixty albums, played ten thousand gigs for millions of people, and died with gigs left to play, thus deserving the freelancer's ultimate epitaph: "If This Dude Wasn't Dead, He Could Still Get Work." Finally, by refusing to have a career or to make history, he managed to do both, and in the end achieved that rarest of prizes. He had a life in the arts . . . in real time.

But there is more to it than that, because Baker's music and

his way of making music *has* had its influence beyond the parochial world of high-modernist jazz theory. It provides the classic model for a new tradition of steady-state, postmodern popular music which is probably best exemplified by Lowell George's Little Feat and Lou Reed's Velvet Underground. These bands operated on Baker's premise: that the song plays the music and the music plays the player and that, consequently, the song, as played, is not a showcase for the player's originality, but a momentary acoustic community in which the players breathe and think together in real time, adding to the song's history, without detracting from its integrity, leaving it intact to be played again. "The thing you learn," Lou Reed told me in an interview, "is that popular music is easy. The song will play itself. So all you need to do is make it sing a little, make it human, and not fuck it up."

My Weimar

In the nightmare version of my life, I spend twenty-five years as the third person at this interminable dinner party at an Eastside restaurant. My fellow diners are Karl Marx and Count Montesquieu, who, in this nightmare, are very comfortable, companionable, and well-dressed. Karl, by this time, is a distinguished professor at Duke, pulling down something in the low six figures, just for showing up in his beard. The Count is not doing quite so well, but he has his MacArthur and a stipend from the French government to keep the wolf from his lacquered door. So they are having a wonderful time at this dinner, wading heartily through course after course of delectable goodies and slurping bottle after bottle of primo bubbly. As they eat and drink, they talk endlessly about art and what it meant and could mean, about why it doesn't mean that anymore, and can't, on account of mercantile society—the banality of it all. From time to time, they toast the coming apocalypse and launch witticisms at the vulgarity of "people in trade"—glancing in my direction as they do.

I am sitting off to the side, cracking breadsticks, sipping mineral water, and making notes on the tablecloth. Karl and the Count know, of course, that I am a petit-bourgeois tradesperson. They know that, in order to buy more breadsticks, I must go home that night and write something I can sell. My money grubbing disgusts them. So in this dream I wonder: Is this why they are speaking so volubly, why they are lingering so late over the remains of their repast? Is this why I am worrying about the check? Will I be stuck with it *again?* Do these guys *always* get to walk? Is this how they afford their wonderful shoes? I don't know; but this is my nightmare, and barring the unlikely event of something millennial happening at the millennium, it promises to continue unabated.

There is nothing to be done about it. In an elite culture in

which failure signifies injustice, the pleasures and contingencies of commerce cannot be defended, nor can any point upon which radicals and snobs agree be seriously contested. So lately, I have contented myself with trying to understand how I could have come to see things so differently—how my own experience in commercial culture could have been so different—how that culture could have afforded me and so many of my co-conspirators refuge from the very injustices that are regularly attributed to it. After giving it some thought, I have decided to blame it all on my old professor Walther Volbach, who was the greatest of many gifts the Third Reich bestowed upon my youth.

Herr Volbach was a refugee professor. By the time I signed up for his seminar in Weimar Theater, he had been one for nearly twenty years, but, to his credit, he was still pissed about it—pissed about being a refugee, pissed about being stuck in Texas, and pissed, most of all, about being a professor. Because Walther Volbach was a theater guy—a third generation, hard-nosed, German Jew theater guy with a very low tolerance for misty bullshit. To me, he was a messenger from another world—an older world, redolent with unfamiliar textures, with brighter brights and darker darks. Through him I could glimpse the harsh, antique modernity of the Weimar winter—because Herr Volbach *was* that world. From the cut of his prewar suits, to the crisp, military cadence of his speech, to the angular vocabulary of his body language (which made him look like a Max Beckmann *vivant)*, he embodied it—sharp, disdainful, and irrevocably embedded in the thickness of the past.

Volbach's father had conducted the first performance of Verdi's *Falstaff,* and Volbach himself had taken piano lessons as a child from Richard Strauss, whose hand, in the process of instruction, had strayed all too regularly onto young Walther's knee. As a youth, Volbach had worked the cabarets, acting and playing the piano. Later, he had directed for Max Reinhardt and collaborated with Piscator. So, not surprisingly, Volbach's idea of art was some-

thing flexed and rigorous, full of edges and bright lights—something smart that made your pants crackle. And he was such a tough old bird! Mean as a snake when aroused, but you couldn't hate him for it. He treated you like you were supposed to get out there and *do* something. He told me I was a callow redneck with all the spirituality of a toilet-seat—that I could possibly cure the former but would probably have to live with the latter—but that was *great!* Nobody had ever told me I was *anything* before, so I took it to heart.

I mean, Jesus, he was the real thing, and he had all this *stuff!* He would bring it to class in cardboard boxes: drawings (some by Gordon Craig), blocking diagrams, posters, account books, prompt scripts, photographs. I remember this brown snapshot of Volbach, Otto Dix, and two other men standing in some dingy street. I was shocked that they were wearing suits and vests. ("Dix was a pig," Volbach muttered.) And I remember the day he opened a cardboard box, reached in and pulled out a large, semi-automatic pistol. For a moment, he just held it in his old hand, and gazed down at it, as if surprised to find it there. Then he laid the pistol on the table. "Dangerous times," he murmured, and continued rummaging. The pistol lay there on the table throughout the afternoon. About halfway through class, however, Volbach noticed that the muzzle was pointed in our direction. He shook his head, as if to reprove himself for his carelessness. Then he reached down and carefully turned the weapon so the muzzle pointed out the window—and that was just perfect.

It was a piece of theater, of course. Volbach taught his Weimar seminar every year, so he could hardly have been surprised to find that pistol in the box. Still, I don't think we cared or even noticed, because it was such great theater—that ominous German firearm in that beige American classroom. It gave you the idea of art for high stakes, and I cannot think of Weimar today without calling up the image of that gun. The physical fact of that pistol on the table opened a window onto a world of unimaginable glamour

and evil that I would not rediscover until I wandered into War-
hol's Factory one afternoon, looking to cop some speed.

Volbach's seminar, however, took place before that, during
the heyday of Hemingway, Pollock, and Kerouac. So, the issue in
those days was the conflict between masculinity and commerce—
between the tragic condition of the heroic artist and the ludicrous
spectacle of the effeminate sell-out. The issue kept coming up in
the seminar because a couple of fledgling Brandos were as deeply
concerned with their putative masculinity as my sculpture pro-
fessor, Mr. Olivadetti, who reminded us about once a week that
"an artist—a *real* artist—is not a god-damned sissy!" I found this
daunting: As the product of smash-mouth Texas, I was looking
forward to a long career of unrepentant sissydom.

Thankfully, old Volbach set things straight, casually dis-
missing all this heroic posturing as misty bullshit. "These mus-
cle-bound whiners," he said, "they do not want to make the new
world. They want their power back. They want to turn back the
clock. You should not let them do it." He then proceeded to
explain to us that, in case we hadn't heard, there had been two
great wars in this century, and a number of smaller ones, into
which most of the able-bodied and apparently heterosexual men
in Europe and the United States had been drafted—excepting
those in critical industries, in government, or in education. More-
over, he pointed out, the arts—theater, dance, music, painting,
and sculpture—were *not* critical industries, nor were they gov-
ernment, nor were they education. They were little businesses,
so all the heterosexual men were drafted out of them. "So who is
left?" Volbach asked, thrusting his finger into the air and swaying
behind it, "Queers and women and a bunch of old Jews! Suddenly,
they are the arts! They do a little business in the night. They get
paid a little for it and do their best, while the government and the
goyim are out killing one another."

"Then the war is over, and all the big, brave soldiers come
home—feeling very angry and very heroic—and what do they

find? They find the world has changed. This was true in Weimar and it is true again today. All these soldiers look around and see the culture of their nation being run by effeminate, Semitic, commercial pansies! And they are shocked! For the first time in history, the songs we sing, the pictures we see, and the plays we attend are not being dispensed by over-educated, Aryan muscle-boys, and these muscle-boys are very upset. But what can they do? Business is business, after all. Even Aryan muscle-boys believe in that, and as long as pictures are being bought and plays are being attended and songs are being sung . . . ?"

"Well, you might think they can't do anything," Volbach said slyly, "but you would be wrong. Because the muscle-boys still control the government and the universities. The professors and the bureaucrats, they were not drafted. They are cozy in their little *Bunde* pleasing no one but themselves. And they tell themselves that even though business is business, culture is culture too, and culture is *public* business. So all the muscle-boy artists and writers, they will become professors and the darlings of professors, and they will teach the young to revere their pure, muscle-boy art, because it is good for them, and they will teach women and Jews and queers to make this muscle-boy art, too. And it will be *very* pure, because they are muscle-boys and they don't have to please anyone. So there will be no cabaret, no pictures, no fantasy or flashing lights, no filth or sexy talk, no cruelty, no melodies, no laughter, no Max Reinhardt, no *Ur-Faust,* no *A Midsummer Night's Dream.* And nobody will love it. And nobody will pay money to own it or to see it, but that will not matter."

"The government will pay for it, and the universities, because paying your own money for culture, and making your own money out of it, this is a *Jew* thing, a queer thing, and a silly woman thing. It means you are not satisfied with what the professors provide, with what the *Reichsminister* tells you is good. It means you want *more* and that is unpatriotic . . ." Here Volbach paused for a moment, and even though I hadn't said a single word, he fixed

his gaze on me and continued. "So all you Aryan muscle-boys down there at the end of the table, *Don't be Aryan muscle-boys!* I have seen enough official culture. I will teach you how to hit your marks and set the lights and make the tempo float. The rest you will have to learn from women and queers—out in the dark. Also, don't be too artistic to count your own receipts. Also, carry your pistol. There are thugs out there."

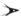

Thus spoke Herr Volbach; and, even though it's not Volbach verbatim and does not begin to convey the majesty of his disdain, this is the world he showed to me—which was the world that I found when I abandoned my graduate studies in 1967 and opened a commercial art gallery. It was heaven, in other words—danger, glamour, queers, women, and Jews—no structure, no credentials, just soldiers of desire doing a little business in the night. And even though that world is dead, thoroughly institutionalized and never to return, the pale, angular ghost of Herr Volbach continues to flicker in my consciousness—as he used to prowl the back of the darkened theater, like a lion-tamer banished to a petting zoo, berating us for our lack of energy and nerve.

"Hey! You up there!" he would shout, "Yes, you! Aryan muscle-boy! Can't you *count?* Don't you have any *bones?* You look like a piece of meat up there. Be electric! Act like a human creature! You poor fool, do you want to starve in the *streets?*"

FREAKS

I have not thought about psychedelics for a long time, nor thought with them for even longer, but I have been thinking about them lately because kids are tripping again. Techno-raves are brightening the nights in light-industrial neighborhoods, and fledgling hackers, crouched before their flickering monitors, are blowing their minds to get the feel of their brains, scrambling around for some kind of anti-protocol cyber-aesthetic. Even here in Las Vegas, local kids have taken to dropping acid and dragging The Strip. I have no intention of trying this myself, but my first response to learning of the practice was *Wow!* Because it really sounds like fun. Because I have not forgotten. Nor, unfortunately, have I forgotten the futility of trying to verbalize the lascivious intensity of such experiences on the page.

One just *knows*, as certainly as one knows anything, that recasting those folding, psychedelic moments in words simply undoes what the chemicals have done—but writers can't not try—and usually they try too hard. So, when I set out to write this essay on psychedelic art and its culture, I set myself a single parameter: *Nothing too fancy.* As it turned out, I needn't have bothered, since, almost from the outset, I was amazed at how marginally my actual, private psychedelic experiences figured in my memories of that time. This may be an idiosyncrasy, but when I recall the acid years, I remember a great deal about the culture that surrounded dropping acid and not much at all about those "mystic, crystal revelations," whose lessons I immediately internalized, whose specifics I immediately forgot, and whose intensity, I soon discovered, lessened dramatically when you stopped being anxious about losing control.

Thinking back on those days now, from the vantage of the present, I remember the people. I remember dropping acid with Gilbert Shelton and racing him to solve *The New York Times*

crossword puzzle. (After a while, we sort of forgot about the clues and just filled in the blanks with interesting words and even more interesting crosswords.) I remember Duane Thomas, who played running back for the Dallas Cowboys, describing what it was like to play pro football on acid. (Very sexy once you started running, but *veeery* scary when you popped out of the tunnel and got blasted with all that color and light and noise.) I remember the people I tripped with and the trips we took while tripping, to Mexico and beyond. I remember the people I bought from and the language we used to describe what happened. (Far-fucking-tastic!)

I also remember the music—early Stones, Coltrane, Bird, John Lee Hooker, Johnny Cash. And I remember the labs. I loved their stink and the atmosphere of techno-adolescent criminality—the priestly mock seriousness of the chemistry nerds who presided over the brewing batches. Actual psychedelic art and self-consciously psychedelic music would come later but only a little, since, for my generation, the psychedelic posters and the woozy musicology of bands like the Thirteenth Floor Elevators, Bubble Puppy, and Shiva's Headband were *products* of that original chemical experience—aids to enlightenment for the younger set, who would actually see the things we showed them and feel the things the lyrics made it possible to feel. My contemporaries, under the influence of psychedelics, tended to *understand* things rather than see them.

In fact, the only people I know who actually *saw* things were the two Billys. My friend Billy Joe Shaver, the songwriter, saw Jesus, but that didn't surprise us much, since Billy Joe also saw Jesus when he got drunk. My friend Billy Lee Brammer, the novelist, who was a fool for glamour and for grammar, saw Kim Novak reciting from *Tender is the Night* against a field of stars, but this didn't surprise us much either, since we were all familiar with Billy Lee's aspirations. Mostly, though, we just saw what was there, restructured, bejeweled, and radically recategorized. Once the cultural mythology of LSD was in place, of course, Shiva, Kali, Dick

Nixon, Jackie Kennedy, Jimi Hendrix, and various armadillos would make regular appearances in the acid visions of fledgling hippies and teenyboppers. But not in ours. This tends to reinforce Foucault's ideas about the cultural inscription of the body's chemistry, and to suggest further that the idiom of "psychedelic art" was as much the cause as the consequence of psychedelic vision.

In any case, psychedelic culture *was* a culture, and a surprisingly social and public one. So, one's actual, private chemical experiences functioned less as ends in themselves than as occasions for its discourse and confirmations of its politics. Other drugs produce intense experiences, of course, and other drug cultures produce artifacts, but none of them seduce the autonomy of the self. Consequently, they do not generate politics. Heroin culture has produced some great jazz and some even greater writing; amphetamine culture has cranked out zillions of good country songs, lots of hot rods, tons of high fashion, and some very shiny art; and thanks, but no thanks, to cocaine, we have Rambo flicks, disco, and Freudian analysis. In each of these cases, I would suggest, the artifacts are less products of the subculture than byproducts of its members maintaining their habits, their rushes, and their elite lifestyles.

Psychedelic culture was different. First, since LSD is not physically addictive, and second, since Protestant America finds it hard to denounce *anything* that promotes charismatic revelation, acid tripping in the sixties was perceived as less *bad* than *weird*—and dangerous to the weak of spirit. Thus, the minions of freakdom remained a motley republic with no trendy ambiance of street cruelty or elitist wickedness. (It helped that you didn't have to smoke it or shoot it.) Further, since psychedelic vision is bestowed by chemistry and not by character, dropping acid is about as antielitist as rapture is likely to get—a fact to which legions of Deadheads must bear mute testimony.

Moreover, since anyone *could* drop acid and tinker with their psyches, it didn't really matter if you did. A lot of people didn't

and said they did, but that was cool, too. Simply knowing what tripping was, and proclaiming it an okay thing to do was sufficient to confirm one's psychedelic politics. For a teenybopper in Idaho, a tie-dyed T-shirt and a Strawberry Alarm Clock album was as good as a tab of windowpane, since the republic of freakdom was neither a cult of experience nor a supply-side elite. Extreme experience was not required, nor was cultural production. One simply proclaimed a commitment to whatever ideology that psychedelic experience signified at that particular historical moment.

But timing was important, since the ideology of psychedelics shifted radically in its progression from the dharma beatniks of Kerouac's generation, though the feedback hedonists of my own, to the Day-Glo teenyboppers who followed soon after. I can honestly say, however, that I had no real cognizance of just how profoundly I had lived—and continued to live—within the ideological precepts of my own psychedelic generation until I read James Miller's *The Passion of Michel Foucault* and came across Simeon Wade's account of Foucault's first encounter with LSD. My response to Wade's narrative was strong enough and strange enough that, in the process of deciphering it, I was able to formulate, for the first time, the subliminal postmodernity that, unbeknownst to me, underpinned my own psychedelic ideology.

Foucault's initiation into acid culture took place one night in 1975, at Zabriskie Point in the Mojave desert, in the company of Wade and a friend, while the ditties of Karlheinz Stockhausen wafted out into the desert night. For the philosopher, it was an altogether salutary experience. He saw the stars fall and the sky fold, just as I had back in Austin in 1963. He also claimed to have understood something about his relationship to his sister that altered his philosophical understanding of sexuality and subsequently altered his ongoing history of it. Further, although he could not have known it then, this psychedelic moment marked Foucault's introduction into a world that he had only imagined back in France—into one of those "fissures" in the filigree of power

and surveillance whose existence he had theoretically extrapolated from his reading of modern culture. Columbus could not have been more delighted at finding the Indies. Subsequently, Foucault would follow that fissure from the acid-stained desert to the baths of San Francisco, reveling in the privacy of that cultural riptide, free at last in an environment where he might deploy his body's will in all of its power and perversity.

I was amazed at this narrative. Amazed, first, that my man Foucault (who had been on the barricades in '68) had made it to 1975 without acid, and unaware of the baths—and distressed as well that he had fought the brave fight without respite, without that ever-available American option of throwing up one's hands and slipping invisibly into the fissures that run through this society like fault lines across California. I had lived my *life* in these fissures, in their turbulent flux, and had followed them across the continent as they opened before me and closed behind, comfortable in their privacy. No wonder I was mystified by the dry anxiety that haunts Foucault's prose—and no wonder I found the scene of his psychedelic initiation so innocent and so fucking infelicitous.

Too late! I thought immediately. *Too Euro, and too Castañeda. Bad place! Wrong music! Yikes!* First, Zabriskie Point was wrong. One doesn't go to a landmark with the intention of getting lost. Also the desert was bad, too redolent with modernist metaphors of transcendence—Malevich's "desert of pure feeling" comes to mind—and the purity of Stockhausen's music only reinforced this aura of connoisseurship. Finally, I decided, Wade's psychedelic agenda seemed designed to mystify the chemistry while I had always, instinctively, held to the project of demystifying the mysticism, of literalizing rapture, of putting the hormones back into it, the molecules of desire.

If it was just another fucking *religion*, it didn't seem worth doing; and taking acid in an empty place, in a cosmic cathedral, seemed designed to reinforce all those fictions of spiritual interi-

ority that psychedelic experience, at its best, so readily dispels. Acid is best taken in the midst of things, so it can teach you how much is literally out there—how far away it really is and how important it is to reach out and touch it, to live in the middle of it and let the chemistry lead you toward it. Which is not the truth, of course, only the rock-and-roll, psychedelic agenda in which I was nurtured, and which I am only now putting into words—and which, having been put into words, sounds a little like Charles S. Peirce on acid. In any case, this scenario does, to the best of my knowledge, characterize the ideology of my generation of acid heads and distinguish it from the transcendental orientalism of the beatniks, who were somewhat older, and from the quasi-spiritual whimsy of the Day-Glo hippies, who were somewhat younger.

The generation-distinction is consequent, because it was the artists of m-m-m-my generation who made the first posters for the Fillmore, the Vulcan Gas Company, and the Family Dog—who designed the album covers and founded Zap Comix—establishing a canon of psychedelic art premised on an exteriority and complexity that was always political in its implications. Certainly none of us, in our connoisseurship of psychedelia, ever thought to attribute its quality to spirituality, or to the inspired or heroic individuality of the artists who made it, or even to their melancholic alienation. That was for Dutch dudes who cut off their ears. We were interested in the effect—in having our minds blown, and our vision reordered. So, for all its apparent celebration of interior vision, this art was always about the extension of that vision into the culture as a form of moral permission. It was a communal, polemical art, vulgar in the best sense and an international language.

Within the deeper history of image-making, psychedelia is yet another manifestation of those anti-academic strategies that arise in the seventeenth century concurrent with the rise of the academies. They manifest themselves first in the Rococo, then

reappear periodically in Pre-Raphaelite, Art Nouveau, Pop, Populuxe, Psychedelic, Las Vegas, and Wild Style graffiti incarnations—all of which are characterized by visual maneuvers that have been *permanently* out of academic fashion for nearly three hundred years, and show no signs of becoming otherwise (dealing as they do with extravagant permissions, rather than reductive disciplines and institutional prohibitions). All of these styles flourish and survive in opposition to everything that academic Western civilization is about, and so, not surprisingly, they all manifest a conscious orientalism whose focus shifts radically from generation to generation. Most hark back to pre-Renaissance strategies of patterning and elaboration—to that Venetian moment before East and West diverged.

So, in general, we might say that these anti-academic styles prioritize complexity over simplicity, pattern over form, repetition over composition, feminine over masculine, curvilinear over rectilinear, and the fractal, the differential, and the chaotic over Euclidean order. They celebrate the idea of space over the idea of volume, the space before the object over the volume within it. They elevate concepts of externalized consciousness over constructions of the alienated, interior self. They are literally and figuratively "outside" styles. Decorative and demotic, they resist institutional appropriation and always have. They distinguish themselves from apparently anti-academic styles like European Surrealism and gestural abstraction, which are easily academicized—whose transgressions against form are easily forgiven because they celebrate masculine interiority. For all their pretense to rebellion, these styles are only truly rebellious in their ebullient, pop-psychedelic appropriation.

What these anti-academic styles do *not* represent, however, is a radical tradition. They each signify a dissent from their own present and resemble one another only insofar as all post-enlightenment academic styles resemble one another. So all these psychedelic styles function as dialectical repudiations, spinning angrily away

from the centrist ideology of their particular moment. To achieve the Rococo one merely turns the Baroque inside out, privileging space over volume. To become a Pre-Raphaelite, one need only repudiate Joshua Reynolds, point by point, with Fra Angelico in mind. To generate a Psychedelic style, then, one need only do Albers backwards—inside out, too much and exactly wrong—or willfully elaborate any other unctuous manifestation of elitist taste.

Finally, however, the influence of psychedelic experience on psychedelic style remains a slippery issue, and rather than consulting some text that might inadvertently cite Alan Watts or Timothy Leary, I feel confident enough in my own experience with art and drugs to suggest that the efficacy of psychedelics with regard to art has to do with their ability to render language weightless, as fluid and ephemeral as those famous "bubble letters" of the sixties. Psychedelics, I think, disconnect both the signifier and the signified from their purported referents in the phenomenal world—simultaneously bestowing upon us a visceral insight into the cultural mechanics of language, and a terrifying inference of the tumultuous nature that swirls beyond it. In my own experience, it always seemed as if language were a tablecloth positioned neatly upon the table of phenomenal nature until some celestial busboy suddenly shook it out, fluttering and floating it, and letting it fall back upon the world in not quite the same position as before—thereby giving me a vertiginous glimpse into the abyss that divides the world from our knowing of it. And it is into this abyss that the *horror vacui* of psychedelic art deploys itself like an incandescent bridge. Because it is one thing to believe, on theoretical evidence, that we live in the prison-house of language. It is quite another to know it, to actually peek into the slippery emptiness as the Bastille explodes around you. Yet psychedelic art takes this apparent occasion for despair and celebrates our escape from linguistic control by flowing out, filling that rippling void with meaningful light, laughter, and a gorgeous profusion.

The Delicacy of Rock-and-Roll

In the mid nineteen sixties, when I was attending the University of Texas at Austin, Thursday nights were "Underground Flick Nite" at the Y on the Drag. The movies were supposed to start promptly at 7:00 P.M., but the projectionist was also a dedicated revolutionary, so they never really started until the New Left cabals, which also met at the Y, had adjourned for the day. So we always went. After a hot afternoon plotting the destruction of bourgeois society—and barring some previously scheduled eruption of spontaneous civil disobedience—Flick Nite was sort of radicals' night out. Imagine *Mystery Science Theater 3000* with a hot Texas *mise en scène:* The clatter of the projector in the glimmering darkness. Smoke curling up through the silvered ambiance. Insects swooping. The ongoing murmur of impudent commentary from the audience. References to Althusser, Marcuse, group sex. Like that.

On the evening I want to tell you about, the evening I experienced the paradigm shift, the program began with a couple of Stan Brakhage films. I don't remember the titles, but they might be characterized thematically as "very nervous" and sort of about "film itself." As I recall, there was a great deal of panning, swooping, jiggling, dipping, and zooming—a great many explosions (the "film itself" seeming to catch on fire, at one point)—and, overall, a bit more montage than I would have preferred. A young woman sitting in front of me in the darkness kept waving her cigarette languidly on the pivot of her wrist and muttering, "Boy, boy, boy, boy, boy, boy, boy," in a very bored voice.

She had a point. I can imagine these films coming back into vogue now, in this revisionist *momento macho.* Today, they would be minimalist action flicks—*Die Hard* sans Bruce Willis. Back then, they were the same old apocalypse—kinetic action paintings. People tended to mention Jackson Pollock when they talked

about them. They were doing this when the second half of Flick Nite began—*and we thought Brakhage was dull!* In this new flick, the camera just *sat there*, trained on this guy who just sat there, too, sideways to the camera in a chair, like Whistler's mother's gay nephew, getting a haircut. That was it. The barber was out of the frame. All we saw were his hands, the scissors, and the comb, fluttering around this guy's head. *Clip-clip! Clip-clip-clip!*

We couldn't fucking believe it. This was *really* boring. Mesmerizing, too, of course, but not mesmerizing enough to keep us from moaning, keening almost, and swaying in our chairs. *Clip-clip!* But we kept looking at the screen even though we knew, after the first minute, that this was going to be it: that it was just a guy getting a haircut. Still, we watched, and it just went on and on. *Clip! Clip-clip-clip!* In truth, it was no more than five or six minutes, but that's a long time in a movie, approximately the length of a Siberian winter. So, I began thinking about *theory*. "What about the *clip-clip* of the scissors and the *clip-clip* of the projector?" I wondered. "The analogy of the 'actual' and 'represented' white noise? What about that?"

Then it happened. The guy getting the haircut reached into his shirt pocket, pulled out a pack of cigarettes and casually lit one up! *Major action!* Applause. Tumultuous joy and release! Chanting even. And the joy may have been ironic (it almost certainly was), but the release was quite genuine. I remember every instant of Henry lighting up that cigarette and the laughter I could not suppress. Because it was fun, and amazing to realize how seriously you had been fucked with. The haircut continued at that point (*clip-clip!*), but we were alive now. Fifteen minutes earlier we had been dozing through Brakhage's visual Armageddon. Now we were cheering for some guy lighting a Lucky Strike.

Clearly, Mr. Warhol was onto something here. It was stupid, but it was miraculous, too. His film had totally recalibrated the perceptions of a roomful of sex-crazed adolescent revolutionaries into a field of tiny increments. It had restored the breath and

texture to things and then, with the flip of a Zippo, had given us a little bang in the bargain—and by accident, I have no doubt. We all knew, of course, that the events in a work of art are only large or small relative to one another, but our bodies had forgotten. Our bodies had become inured to explosions. The delicate increments of individual response needed to be reinscribed, and *Haircut* did that. When the lights came up, we were all looking at one another with new eyes.

"There has got to be some political application," the projectionist said to me as we stood around on the porch, finishing our beer. I doubted it, but I didn't say so, because I wanted to see more Warhol flicks, and I feared that once the critical instrumentalities of dialectical materialism were unleashed upon *Haircut*, it would become only too clear that Andy's film dissolved the idea of history and narrative into something tinier, more complicated and contingent. And for us, at that time, there were no politics without history. Politics *were* history—and vice versa—although, in truth, I found myself preferring the political morality of Warhol's film to Brakhage's. It was sadder and funnier, too.

Today, I know this wasn't quite fair to Brakhage, but at that moment the rhetoric of expressionist freedom had reached the point of rapidly diminishing returns. It just wasn't working anymore. I think I was correct, however, in assuming that Brakhage's practice (if it was not purely formal) was essentially tragic. His films strove toward a condition of freedom and autonomy, fully aware that the work itself, for all its abstract materiality, could never free itself from cultural expectations. Nor could the artist, for all the aleatory and improvisatory privileges he granted himself, free his practice from the traditions of picture-making. So, no matter how much you admired Brakhage's bird-on-a-wire lungings toward existential freedom, you had to admit, finally, that all the energy was in the wire.

Warhol's film turned that energy on its head. Warhol could not *invent* enough wires, nor try hard enough to impose norma-

tive simplicity—to avoid freedom at all costs—nor fail more spectacularly. The static camera, the static subject, the idiot narrative armature, the tiny non-individuated events *(clip-clip!),* only served to theatricalize the inherent imperfection and disorder of the endeavor, only served to foreground the sheer, silly ebullient *muchness* of the image moving in time. Thus, Warhol's self-inhibiting strategies liberated him as an artist and liberated his beholders, as well, into an essentially comic universe.

Brakhage told us what we already knew as children of the Cold War, that no matter how hard we tried, we could not be free—thus inviting us, paradoxically, into the rigors of utopian political orthodoxy. Warhol's film, on the other hand, told us what we needed to know, that, no matter how hard we tried, we could not be ordered—that insofar as we were tiny, raggedy, damaged and disorganized human beings, we probably *were* free, in some small degree, whether we liked it or not. All of this is probably self-evident to anyone who has lived through the past thirty years. The effect of these films on me, on that hot, Texas night, however, was nothing short of cataclysmic.

I knew, you see, that my encounter with Brakhage and Warhol was not, in any sense, a "high art" experience. It couldn't have been. I didn't know anything about high art—I knew about radical politics, jazz, rock-and-roll, and linguistics—and understanding this, I have gradually come to distrust the very *idea* of high art in a democracy. I mean, what would it be like? Aristocratic cultures have a high and low. They have higher-ups and lower-downs, and consequently they may, on occasion, create a socially engaged, commercially disinterested high art that trickles down to instruct and inform the "lower orders." In a mercantile democracy, however, the only refuge from the marketplace is in the academy. So democracies, I fear, must content themselves with commercial, popular art that informs the culture and noncommercial, academic art that critiques it—with the caveat that, even though most popular art exploits the vernacular, some pop-

ular art redeems it—even though it's still for sale.

To reach this conclusion, I asked myself these questions: Is a painting by Jackson Pollock or a film by Stan Brakhage high art? Yes? Well, if so, could the art of Pollock or Brakhage exist without the imprimatur of Dizzy Gillespie and Charlie Parker? Could I have understood it without its being informed by the cultural context of American jazz? Without the free-form exuberance of bebop? My answer: No way, José. And, conversely, could bebop exist without Jackson Pollock and Stan Brakhage? You betcha. And could rock-and-roll exist without Warhol? Yep. And could Andy Warhol exist without rock-and-roll? I don't think so. These answers, of course, tend to confirm my own predisposition to regard recorded popular music as the dominant art form of this American century. My point is that Pollock and Warhol do not exploit the lumpen vernacular, they redeem it—elevating its eccentricities into the realm of public discourse. As a consequence, the work of Pollock and Warhol, like that of Rembrandt or Dickens or David, is the best that popular, commercial art can be—doing the best things it can do.

So now I think of that evening in Texas as marking the end of the Age of Jazz and the beginning of the Age of Rock-and-Roll—the end of tragic theater in American popular culture and the beginning of comic delicacy. Both ages make art that succeeds by failing, but each exploits failure in different ways. Jazz presumes that it would be nice if the four of us—simpatico dudes that we are—while playing this complicated song together, might somehow be free and autonomous as well. Tragically, this never quite works out. At best, we can only be free one or two at a time—while the other dudes hold onto the wire. Which is not to say that no one has tried to dispense with wires. Many have, and sometimes it works—but it doesn't feel like *jazz* when it does. The music simply drifts away into the stratosphere of formal dialectic, beyond our social concerns.

Rock-and-roll, on the other hand, presumes that the four of

us—as damaged and anti-social as we are—might possibly get it *to-fucking-gether*, man, and play this simple song. And play it right, okay? Just this once, in tune and on the beat. But we can't. The song's too simple, and we're too complicated and too excited. We try like hell, but the guitars distort, the intonation bends, and the beat just moves, imperceptibly, against our formal expectations, whether we want it to or not. Just because we're *breathing*, man. Thus, in the process of trying to play this very simple song together, we create this hurricane of noise, this infinitely complicated, fractal filigree of delicate distinctions.

And you can thank the wanking eighties, if you wish, and digital sequencers, too, for proving to everyone that technologically "perfect" rock—like "free" jazz—sucks rockets. Because order sucks. I mean, look at the Stones. Keith Richards is *always* on top of the beat, and Bill Wyman, until he quit, was always behind it, because Richards is leading the band and Charlie Watts is listening to him and Wyman is listening to Watts. So the beat is sliding on those tiny neural lapses, not so you can tell, of course, but so you can feel it in your stomach. And the intonation is wavering, too, with the pulse in the finger on the amplified string. This is the delicacy of rock-and-roll, the bodily rhetoric of tiny increments, necessary imperfections, and contingent community. And it has its virtues, because jazz only works if we're trying to be free and are, in fact, together. Rock-and-roll works because we're all a bunch of flakes. That's something you can *depend* on, and a good thing too, because in the twentieth century, that's all there is: jazz and rock-and-roll. The rest is term papers and advertising.

Dealing

I spent the summer of 1967 at the University of Texas winding up a dissertation in literature and linguistics. Taking Henry James's advice, I had invented what I called a "paragraph grammar"—a model for encoding written English that took the paragraph rather than the sentence as its basic unit. I wanted to describe the chaotic flow of prose as one describes other dynamic systems, so the encoded text might reflect the musical aspects of literary practice: the pace of syntactic and lexical repetition, the shifting proportion of new and redundant information, the modulation of syntactical subordination, things like that. Specifically, I wanted to encode literary manuscripts in sequential states of revision—to discover just exactly what could be said, on good evidence, about authorial intentions.

My professors were helplessly and seductively circular on this subject. They would cite Freud to suggest D.H. Lawrence's "latent homosexuality," then cite Marx to infer his "class consciousness"—then presume henceforth that the textual evidence they had discovered of Lawrence's latent homosexuality and class consciousness somehow validated their faith in Freud and Marx—and this just would not do. If you believe in God, and you get wet when it rains, you may quite logically, on good, textual evidence, propose that God has caused your dampness. Your wet raincoat, however, does not confirm the existence of God. Nor would a million wet raincoats.

In search of one-way causation, then, I raided the university manuscript collection for texts by Lawrence, Ernest Hemingway, and Gertrude Stein in sequential states of revision. I encoded them and then compared them, to see what could be said about these demonstrably consequent, willful acts. Because, even though there could be no connective evidence that a particular text by Hemingway had been occasioned by his neuroses, his class consciousness,

or his family background, there was visible evidence that he first wrote "cows, bullocks and muddy-flanked water buffalo," then replaced it with "cattle"—and evidence as well that this substitution of the more general term for the more specific was programmatic in Hemingway's revision. I could also demonstrate that Hemingway habitually flattened the hierarchies of subordination in his prose and slowed the pace at which new information was introduced into his writing, substantially reducing its quantity.

These, it seemed to me, were things you could actually talk about—so the things that you said would be caused by what Hemingway actually did, and not by what he might have consciously or unconsciously intended to do as a consequence of some disembodied cause. In any case, by September of 1967, I had the project pretty much nailed, and only then, unfortunately, did its true eccentricity begin to dawn on me—only then did I begin to realize that there was no support *anywhere* in the academic world for what I was doing, nor was there any inkling that such support might be forthcoming. For the past three years, I had been studying great writing as a young painter might study great painting, struggling to understand the nuts and bolts of actual practice, seeking insight into the physical nuances of the medium. It had been very interesting and enormously rewarding, but the written result of my efforts, I found, sounded more like a repudiation of graduate study than an example of it—and this was far from my "intention."

I had just fucked up, and this realization came as a bit of a downer, to be sure, although it certainly explained the sense of nauseous dread I had been feeling at the prospect of laying my labors before my "interdisciplinary" committee. Because I knew what would happen. The two post-structuralists, confronted with the empiricism of my practice, would almost certainly fling themselves upon the barricades. The literary humanist, faced with the prospect of calculus, would go catatonic; and the two linguistics

wonks, who spent their summers taping Hopis and thought Gertrude Stein was something you drank beer out of, would bitch and moan about my "unscientific" literary parameters and probably resign from the committee. I figured I was looking at twelve months of spite, recrimination, misprision, and power politics. So I thought: What if I actually won? What if I confronted them and prevailed? The optimal positive outcome would be a little job at a big university in a place where it snows—and a six-year battle for tenure.

Even then I prided myself in being a gambler, but this was a *bad bet*. You don't send good money after bad, ever. So I dropped that stack of white bond back into its stationery box, placed the box in a drawer, and closed the drawer. I walked into the kitchen where my wife was sitting at the table reading *The Crying of Lot 49*. "I think I'm going to quit this shit," I announced. She looked up and stared at me for a minute, then she smiled and said, "Great!" That night I called up all my artist pals and told them I was going to become an art dealer. They all said, "Great!" Within the next two weeks, I had borrowed ten grand from a local banker who hung out in rock-and-roll bars, rented a space downstairs from a lawyer who defended drug offenders, had some stationery printed up by an outlaw printer in south Austin, and got a tax number from the State Comptroller.

I put in a phone, painted the walls, moved in some art, and that was it. I was in the art business. It was the easiest thing I'd done to date, and, at that time, the loan, the lease, the stationery, the tax number, and the phone constituted my total qualifications for entering the art world. My graduate readings in Derrida, Chomsky, Foucault, and Deleuze, unfortunately, would not become "art qualifications" for another fifteen years, but I opened the doors anyway and became a "gallerist"—although that is really too fine a word for it. In truth, Mary Jane and I opened a Mom and Pop store.

We repainted walls perpetually and burned our fingers on the lights. We typed labels, hung exhibitions, kept books, mailed invi-

tations, and served cheap champagne in plastic glasses to the locals. We were twenty-six years old. We sold works of art by artists who were twenty-six years old (and maybe a little younger) to collectors who were twenty-six years old (and maybe a little older). The gallery was called *A Clean Well-Lighted Place,* after the Hemingway short story that concludes with a designification of the Lord's Prayer ("Our father who art in nada. Nada be thy name . . . "), because we were seriously into "nothing" at that time, and into making something out of it, which we did for four-and-a-half years. Then we moved to New York and continued our adventures.

Over the intervening years, between that time and now, I have been asked a lot of questions about *A Clean Well-Lighted Place,* because it did have its moments. But I am never asked the same questions for very long. Back in the nineteen seventies, people always wanted to know if it was any *fun,* and I always told them, yes, it was a great deal of fun—nervous, anxious, vertiginous, heart-rending fun. My favorite thing, I told them, was showing up at my little store in the morning. I'd come in through the back door, make some coffee in the office, carry it into the dark gallery, and hit the lights. The space would spring to life, and I would just stand there for a little while, looking around and sipping my coffee. Then I would go back to the office, pull over the phone and the Rolodex, and go to work. That was the best part.

In the nineteen eighties, people stopped wanting to know how much fun it was. They wanted to know how much money we made, and they were shocked and dismayed to learn that we didn't make any money. We made a living. We paid our bills, paid our artists, and eventually paid off our note. We had a place to live, food to eat, work we liked doing together, and no "spare time." Had I been more candid, I would have confessed that we were totally disinterested in making money. That was what my professors at the University did. They "made money" working in a vicious bureaucracy, so they could spend it in their "spare time" doing exactly what they liked—which, as far as I could tell, was

writing crummy novels about working in a vicious bureaucracy, and summering in Italy. Thus, I have always associated the desire to make money with a profound lack of confidence in one's ability to make a living, to make one's way in the world through wit and wile. So I wanted to make a *living,* which I succeeded in doing, and I wanted to *win,* which I rather spectacularly failed to do.

I had this idea of an art made for the living, you see—of an art that might flourish in the crazy zone between the priests of institutional virtue and the bottom-feeders of commercial predation—of an art that might embody the marriage of desire and esteem (which is, of course, what a marriage is). So I liked to distinguish my practice as an "art dealer" from that of "picture merchants" and "curators." Because picture merchants were dedicated to exhibiting what they thought the public *wanted,* and curators were dedicated to exhibiting what they thought the public *needed.* Everything I did as an art dealer, however, was based on the hopeful, Emersonian premise that on occasion, sometimes, we just might find, we want what we need—that private desire and public virtue might find themselves embodied in a single, visible object.

The vogue of Andy Warhol was my gaudy emblem of this occasion, and, looking back, I can honestly say that Andy showed me the way out of graduate school—that he freed me from its smothering obsession with intentions and intentionality. Because Andy's rhetoric of fame meant that "what Andy meant" was irrelevant. The work *was* its public vogue. I attributed this moral to Jasper Johns's flags as well, because a flag does not derive its "authority" from the fact that Jasper Johns or Betsy Ross made it. It is invested with power and significance by the faith and commitment of those who salute it. So I can see now that, by becoming an art dealer, I was positioning myself to exacerbate the effects of art rather than to speculate on its causes.

I was betting on a practice based on the marriage of desire and esteem; and, at that time, there seemed a real probability that

such a practice might establish itself. But it did not. The antique obsessions with history, psychology, and good intentions that I had left behind in academia followed hard upon my heels into the art world. The antique polarities of body and mind, desire and virtue, brothel and convent reasserted themselves in cultural life, and I failed. But people in the eighties did not want to hear about failure . . . until the eighties failed. Then the questions changed again. They came full-circle, in fact, and around 1987, students happily ensconced in just the sort of graduate redoubts from which I had originally fled began asking me how I ever could have been an art dealer.

How could I stand the degradation of selling objects to people who *knew nothing* about art? Didn't I feel lonely and alienated out there amidst the pandemic schizophrenia of bourgeois culture? And what about my complicity in the hedonistic commodification of critical practice!? These must be good questions, I decided—or at least questions with some longevity, since they were the same questions posed to me by my classmates and professors when I escaped graduate indenture in 1967. Traditionally, I have answered these questions with an enigmatic smile, but since—for a change—things seem to be changing for the better, I have decided to have a shot at them now.

Regarding the degradation of trying to sell objects to people who know nothing about art, I can only assure you that *everyone* in this culture understands the freedom and permission of art's mandate. To put it simply: *Art ain't rocket science,* and beyond a proclivity to respond and permission to do so, there are no prerequisites for looking at it. This is the first thing I learned as an art dealer, because everyone who came into my little store—the paper boy, the mailman, the plumber, the tourists, the hippies, and the suburban matrons—"understood" what was going on, even when they did not approve. They may have objected to the political or sexual content, but they had no ontological problem with giant paintings or scruffy push-pinned drawings—with neon

and press-type stuck to the walls—or with piles of debris on the floor. Some were just more interested than others.

My paper boy, Ritchie Turk, was interested. He was fourteen, but he was interested—and by virtue of his daily exposure, he became such a little connoisseur that I routinely solicited his opinion on things. (Ellsworth Kelly, R. Crumb and Ed Ruscha were Ritchie's favorites, so go figger.) The opinions of Mr. Sparks, my regular mailman, were less reliable, although he enjoyed expressing them once we became pals. As a career bureaucrat and a devout Christian Scientist, Mr. Sparks had no problem with text or abstraction, but he *hated* "messy." The paintings that Joan Snyder and David Reed and Stephen Mueller were making at that time drove him particularly bonkers, since, according to Mr. Sparks, they were not only messy, they lacked "oomph." I told him that he was right, that "oomph" was momentarily outré, but it would doubtless come back into style. So much for education.

Regarding my putative alienation from the pandemic schizophrenia of bourgeois culture, I never felt it. Even though I was the only big-time art freak in town, I was a part of Austin's Psychedelic Rotary Club, its commercial counter-culture that consisted of rock-and-roll bars, fugitive publishing ventures, assorted book stores, restaurants, organic groceries, radio stations, head shops, recording studios, and entrepreneurial endeavors of more dubious legality. (Austin, by the way, is the only place I've ever lived where they announced the marijuana pollen count as part of the weather report.) Also, I could pass for straight, because even though I was in art, I was also in *business,* a shopkeeper. So I could sit around at the coffee shop down on Congress Avenue, talk cash flow and receivables, and complain about the assholes in the State Comptroller's office. And it may sound stupid, but after the hothouse babble of graduate school, I actually felt like I was living in the world.

Finally, as to my complicity in the hedonistic commodification of art, I can tell you two things: First: *Art is not a commodity.*

It has no intrinsic value or stable application. *Corn* is a commodity, and so is long-distance service, since the operative difference between bushels of corn and minutes of long-distance service is the price. Price distinguishes commodities that are otherwise similar and destabilizes the market, whereas price *likens* works of art that are otherwise dissimilar and stabilizes the market. When I trade a work by Kenny Price for a work by John Baldessari, as I once did, I am not conducting a commodity transaction, I am hopefully engaging in a subtle negotiation of analogous social value.

Second: *Art and money never touch.* They exist in parallel universes of value at comparable levels of cultural generalization: Art does nothing to money but translate it. Money does nothing to art but facilitate its dissemination and buy the occasional bowl of Wheaties for an artist or art dealer. Thus, when you trade a piece of green paper with a picture on it, signed by a bureaucrat, for a piece of white paper with a picture on it, signed by an artist, you haven't *bought* anything, since neither piece of paper is *worth* anything. You have translated your investment and your faith from one universe of value to another.

If you can't tell one universe from the other, that's *your* problem, but not an unusual one, since art and money are very much alike, in both embodiment and conception. To put it simply: Art and money are cultural fictions with no intrinsic value. They acquire exchange value through the fiduciary investment of complex constituencies—through overt demonstrations of trust (or acts of faith, if you will) of the sort we all perform when we accept paper currency (or, even more trustingly, a check) for goods or services. This is the act of faith that I performed when I traded the Kenny Price for the John Baldessari—but with a difference, since, even though I sold the Baldessari for more than I paid for the Kenny Price, I still want both of them back, because I prefer the universe of art to the universe of money.

The point, however, is that the issuing institution or indi-

vidual can never guarantee the value of art or money sent forth into the world. It must be sustained through investments by complex constituencies of individuals, public institutions, and private corporations. The government may say a dollar is worth a dollar. Fiduciary investment tells us it's worth thirty-five cents. The Whitney Museum may say that Wanda Whatzit is the next big thing, but only the sustained investment of money, journalism, exhibition space, scholarly prose, foundation awards, loose talk, and casual body language can maintain Wanda's work in public esteem. So it helps to remember that the language of external investment extends this far—all the way from the casual shrug at a gallery opening to the gaudy résumé on some bureaucrat's shiny desk.

Moreover, if you stand at a gallery opening, or on the floor of the stock exchange, and watch people watching the body language of major players, you will begin to understand why folks are not watching *your* body language. Why? Because external investments of trust are weighted. Specifically, the value of any monetary, written, verbal, or physical investment in a work of art is directly proportional to the amount of *risk* the investor takes on behalf of the work in question. When the Museum of Modern Art acquires your work, for instance, it takes a larger risk than the Arts and Crafts Museum in Hometown, U.S.A., should it select your masterpiece for acquisition. When Leo Castelli decides to take you on as an artist, his risk is substantially greater than that of Bob's Art and Framing in West Las Vegas, should they grant you an exhibition. So you want to show with Leo and sell to MOMA, because MOMA and Castelli, by virtue of their investment in your work, may, if they are spectacularly wrong, call the value of their entire endeavor into question. So either your work is worth more at MOMA or Castelli's, or their endeavor is worth less. (The odds favor the former, although things *can* change.)

But there is a caveat here. Since there is no absolute authority in the art world, or in the economic world either, we may pre-

sume that for every opinion, there is a contrary one. Thus, the social value of a work of art, or an art critic, or a theory, or an institution must be distinguished from its social *virtue,* since bad reviews, stupid acquisitions, and theoretical attacks, even as they question the social virtue of an object or investment, must necessarily invest it with social value. The raw investment of attention, positive or negative, qualifies certain works of art as "players" in the discourse. So, even though it may appear to you that nearly everyone hates Jeff Koons's work, the critical point is that people take the time and effort to hate it, publicly and at length, and this investment of attention effectively endows Koons's work with more importance than the work of those artists whose work we like, but not enough to get excited about.

Moreover, on the principle of "my enemy's enemy," there will always be those who find anything worth hating worth liking. Take the example of Clement Greenberg. You have probably heard of him. He was an art critic from the postwar era whose practice and preferences were totally discredited and defunct by the time I entered the art world in 1967. Academic critics, however, by laying siege to Greenberg's gutted and abandoned citadel for the past thirty years, have invested his misty bullshit with such a disproportionate level of social value that the waning authority of academic criticism (due to bad investments) has occasioned a grass-roots recrudescence of Greenberg's favorite stuff: color-field painting, which, even as we speak, is being translated into money.

All of which is to say that the interplay of art's domain and money's is very complex. The relationship of money to any individual work of art, however, is very simple. There is none. Since relative economic value can only be assigned to sets of things (to the works of one artist, one period, one style, etcetera), and since even one-of-a-kind objects are valued within the set of "one-of-a-kind-objects" (Catherine the Great's dildo as compared to Louis XIV's bedpan), any unique work of art is both worthless and priceless insofar as it *is* unique. In practice, the culture usually sets a

minimum value on works of art, which is really just an ante. When I was an art dealer, any biggish work of art was worth five-hundred dollars. Any littlish work of art was worth two hundred. Today, a biggish work is worth a thousand dollars and a littlish work is worth three hundred. Everything you pay over that is the consequence of previous external investments taken at risk.

So you pay a grand for a painting from an unknown artist's studio. If you are a serious collector, taking a risk, you increase the value of the work just by buying it. If you are a *cheap* serious collector, you try to get a discount on account of this, but this is really bad form, because if you wait until that artist has a dealer, you are going to pay more. If you wait until she has good reviews, you are going to pay more still. If you wait until Paul Schimmel down at MOCA notices her work, you are going to pay even more than that, and if you wait until *everybody* wants one, of course, you are going to pay a whole hell of a lot more, since as demand approaches "one" and supply approaches "zero," price approaches infinity. *But you are not paying for art.* You are paying for assurance, for social confirmation of your investment, and the consequent mitigation of risk. You are paying to be *sure,* and assurance (or insurance, if you will) is very expensive, because risk is everything, for everybody, in the domain of art.

That's why art dealers and art critics stand to gain or lose money as a consequence of their efforts. Because it is a matter of heart and not of policy, a matter of live commitment and not of bureaucratic accreditation. Money is the emblem of the risks you're willing to take to have some say in the way things look. If you don't take risks, if you only confirm the prescience of previous investors, you acquire no power, create no constituencies, and have no effect. So you *must* take risks, but not just any risk, because if you are not "right" a fair percentage of the time—which is to say, if you are not persuasive about the art on whose behalf you take these risks—your efforts are equally inconsequential, and citizens devoted to inconsequential activities are rarely rewarded

in this republic: they are tenured (as well they should be). In order to have any say at all, then, one must take risks and do so persuasively, and continue to do so.

Thus, the pressure mounts, since for any participant in the art world with a reputation for taking successful risks, each subsequent investment risks more, and is therefore more valuable. This holds true for all investors in art's social value: artists, dealers, collectors, critics, curators, scholars—everyone. Thus, money and risk vary inversely in all transactions related to art. The greater your risk, the less you pay and the more you receive. This is or should be an incentive to *participate,* to take extravagant chances, to execute daring acts of faith on behalf of your beliefs and in advocacy of your particular marriage of desire and esteem. Try to think of it as a dynamic system, a chaotic flow generated by the perpetually negotiated interplay of two simultaneous but totally distinct domains of value. Or forget all that and remember that art is cheap but priceless—and blessed assurance very dear.

Magazine Writer

Since my old pal Grover Lewis no longer walks among us, let me begin by saying that, as a physical creature, by the standards of the culture, Grover was nobody's dream date. But he had an air about him, something likable and complicated. He had this lanky Texas stance, a big mouth with a big smile, and attired as he usually was, in boots, jeans, and some goofy forties shirt, faintly squiffed and glaring at you through those thick Coke-bottle glasses, he was a caricaturist's delight: all eyes, mouth, angles, sweetness, and ferocious intelligence. Moreover, he was a Southern Boy to the end. He believed in truth and justice, and through all the years of dope and whiskey, Deadheads and deadlines, movie stars and rented cars, he remained an alumnus of that old school.

Women always called my attention to Grover's "courtly manner"—alluding to his charm even. But to me, he was always Prewitt in *From Here to Eternity*, a clenched fist in a frail package— prince and pauper in equal parts—always passing some outrageous, absolute judgment on your life and work, while appealing to your sympathy by bumping into a chair. Which is pretty much my definition of "exasperating"—that uncanny ability to break your heart while making you smile—so you never knew whether to thank Grover or forgive him for his impertinence. In my own case, since we were old and permanent friends (and Texas boys, too, cagey with mutual respect), I usually settled for neither.

Grover was, after all, the most stone wonderful writer that nobody ever heard of, and blind as a cave bat in the bargain. He had been since birth, so he had to wear those wonky glasses. So, when he really ticked me off, I comforted myself with imagining Grover and his old running mate, Larry McMurtry, back at North Texas State in the fifties, as campus pariahs: two skinny, four-eyed geeks in goofy forties shirts scuttling along the sidewalk head to head, toting copies of *The Evergreen Review* and plotting their

mutual apotheosis—in the aftermath of which they would both be famous authors, claiming any female who fell within their view.

The pleasure I took in this imagined tableau of pathetic geek-dom was considerably enhanced by the improbable fact that both Larry and Grover, each in his own way, actually *achieved* their apotheosis (and its consequent surfeit of feminine companion-ship)—so rapidly, in fact, that by the time I met them in the early nineteen sixties they were no longer geeks. They were "promis-ing Texas writers." McMurtry had published his first novel, *Horseman Pass By*. It was soon to be made into the movie called *Hud*, and, in the interim, he was teaching creative writing at TCU, while resisting attempts to ban *Horseman* from the university library. Grover had been booted out of grad school for publish-ing "communist pornography" in a state-funded journal and had begun publishing essays in national magazines. He had also writ-ten a bleak, feral book of poems called *I'll Be There in the Morning, If I Live* and could be found reading from it in coffee houses and other fugitive venues. So, far from being geeks, when I met them, Grover and Larry were on their way, marking the path I fully intended to follow out of town.

By the early nineteen seventies, McMurtry was producing novels at a steady clip and living like a fugitive out on the high-way. Grover and I had seen the blessed vision—Texas in the rear-view mirror. We were ensconced on opposite ends of the country practicing something called "new journalism," which, in fact, was nothing more than Victorian reportage with neon punctuation—Dickens and Stevenson and DeQuincey in meaner streets with stronger drugs. Grover was in San Francisco working for *Rolling Stone*, writing landmark stories about movies and rock-and-roll—inventing pop genres like "the location story" and "the tour story." I was in New York, writing about art for *Art in America* and about rock-and-roll for *The Village Voice*. As a consequence, our paths began crossing in airports and bars, in press trailers and at coun-try music festivals. We forged a friendship based on our mutual

distaste for bar-ditch Texas and on our fatal love for the life we found ourselves leading. Both of us had read enough books and seen enough highway to know what a lovely moment it was.

We had grown up with the myth of the open range, with that unreflective, visceral cowboy hatred for fences, and, just for that moment, the fences were down. The institutions that strung them were in disgrace, and the borders were open: the president was a crook; the generals were losers; corporate culture was in disarray; and the universities were irrelevant. So there was a sense of making it up as you went along, with new rules in a new place, where, if you wished, you could bring your Deleuze and your Stratocaster, too. And there was plenty of sleazy fame to go around—except that, back then, it was still the colossal joke that Warhol intended it to be, still marketing and not yet a religion.

You could still write a tight, astringent literary piece about a rock-and-roll band or a pop mogul or a movie set, or even an evangelist, and it would pass for hype—the assumption being that people were cool, and everybody was in on the joke. So we wrote as well and as wittily as we could; then, with what we thought of as profligate generosity, we sailed our pieces out, like paper airplanes, into the woozy, ephemeral ozone of Pop America—feeling ourselves part of this vast conspiracy of coolness that extended all the way from Keith Richards, in extremis somewhere in France, to the vast republic of scruffy kids flipping albums in minimalls across the heartland. The sustained ironies of this new world distressed utopians and conservatives alike, but it was very Victorian, really. As Grover put it, we wrote about cottage industries that bubbled up out of the rookeries. We did pieces about people doing pieces, out there in the savanna between the corporate jungle and the ivory tower.

Ultimately, however, the fences would go back up, and as the eighties progressed, that space would evaporate. Suddenly, it was all Demi Moore and no more *demimonde*. Somehow, in a twinkling, "celebrity" had become a *class* in America, not an

aberration, and celebrities themselves were no longer cool people, no longer edge-walkers like Ray Davies and Dennis Hopper, amazed and bemused by their new ludic status. Suddenly, they were hopeless, helpless dweebs, nervous and afraid of losing what they knew they didn't deserve; and the people who worked for them in the celebrity game (who used to lay out lines for us and let us borrow the limo) ceased to be cool, as well. More and more, Grover and I found ourselves dealing with hysterical, defensive bureaucrats—guardians of the inner temple—who wanted to write our stories for us. The days of midnight rides with the Allman Brothers were over. Opportunities to write hip stories about pop subjects disappeared. Pop stories about hip subjects were all the vogue, and it was no fun anymore.

As I told Grover at the time, "Either we got old, or the president did." Probably it was both, but it hit Grover hard. He *loved* what he did and the status associated with it. And he *hated* where he came from. By the time he was ten, Grover explained, he had known enough hard times and chaos to last the entire population of Newport Beach into the next century. He hadn't liked it then and he didn't like it now. But he remained a Southern boy, stubborn as red dirt, bound and determined to stick to his last, lost cause or not, and to believe forever in that brand of truth and justice that had first set him free. And he was a *magazine writer*. His job was to hammer the detritus of fugitive cultural encounters into elegant sentences, lapidary paragraphs, and knowable truth; and, in truth, the loveliness and lucidity of Grover's writing always rose to the triviality of the occasion.

His burden was to suffer that chronic, Promethean anguish known only to slow writers with short deadlines and absolute standards, and he had lived with that. Whatever it cost Flaubert to conjure up *le mot juste* for Madame Bovary's trousseau, Grover paid comparable prices to evoke the butch camaraderie on the location of some lamentable movie, to capture the joy and desperation of some unremembered rock concert in a gym in south-

eastern New Mexico, to dramatize the antic absurdity of lunch with Paul Newman at the Pump Room. He accepted that discipline and bowed to it, soothing the anguish with whiskey, amphetamines, and carloads of cigarettes.

But the work dried up anyway. In Grover's view, this was because editors, at present, were either corporate swine or academic twits and he, Grover Lewis, had his fucking standards. I suggested that Marie Antoinette had her fucking standards, too, but to no avail. So there were several years in the eighties when, to put it mildly, Grover Lewis was a very grumpy dude, prowling like a blind lynx around the apartment in Santa Monica where he and his wife Rae had finally come to rest. I would drop by and find him reading ten books, one page at a time, making encyclopedic tapes of all his favorite songs, fulminating against things in general and writing at a pace that was stately even by Grover's standards.

It was not a good time, but finally, with nothing much to look forward to, Grover began looking back, tentatively at first, but then with a longer, stronger gaze at his final, terrible treasure, that brutal world of Texas white-trash geekdom from whence he sprang—at the redneck tribes of sharecroppers, well-diggers, religious maniacs, and petty thugs from whose blunt ignorance he had struggled so mightily to liberate himself. Opening up those raw memories gave him nightmares for a while but, even so, in 1992, he accepted an assignment to return to Texas and write a piece for *Texas Monthly* about Oak Cliff, the working-class suburb of Dallas where he spent the best part of a childhood, which, in truth, had no best part at all.

"Farewell to Cracker Eden" turned out to be a hard and beautiful piece of writing, and Grover was heartened by its reception. So, finally, in his most Faulknerian manner, he "resolved to track the black beast to its lair." He wrote a proposal for an autobiographical book about those years. It was to be called *Goodbye If You Call That Gone*, and it began like this:

> History and legend bind us to the past, along with an unquenchable memory.
>
> In the spring of 1943, my parents—Grover Lewis, a truck driver, and Opal Bailey Lewis, a hotel waitress—shot each other to death with a pawnshop pistol. For almost a year, Big Grover had stalked my mother, my four-year-old sister and me across backwater Texas, resisting Opal's decision to divorce him. When she finally did, and when he finally cornered her and pulled the trigger as he'd promised to do, she seized the gun and killed him, too.

To no one's surprise but his own, Grover got a contract to write this book, his first, for real money. About a month after that, Grover and I had a long conversation about the book. By this time, he was fully aware of the ironies that swirled around the project. It was not the story he was born to write, he said; he had already written that in a thousand magazines with the shelf-life of milk. It was, however, the book he *had* to write because he was born where and when he was, and to whom. And he planned to write it with a vengeance, because, at one level, he had been "Lonesome Doved," as he called it, referring to the experience of his friend McMurtry, who after twenty years of writing first-rate novels about living Americans in the contemporary moment, had been rewarded finally for a mythic novel based on an old screenplay about archetypal cowboys.

So Grover had a little litany that he had clearly worked up with me in mind: "They will admire you for writing about the present, oh yeah. But they will *love* you for writing about the past. They will praise you for writing about housewives and showgirls, bookworms and businessmen. But they will *pay* you for cowboys and rednecks. They will admire you for writing about the world before your eyes. But they will *adore* you for spilling your guts. And somehow," he said, "I'll subvert that crap and still write this book." *Bam!* He hit the table with his hand. It was the only vio-

lent gesture I ever saw him make. I was heartened by it.

But there was more to it than that, because in essence, by writing this book, Grover was dismantling the engine that drove the words that wrote it. He knew, and I knew too, that by writing the story of his parents, he was handing every armchair psychologist we knew a false key to his heart, because, clearly, the crazy, loving, violent figure of Big Grover flickered behind half the people he had written about, behind all the bad guys, roughnecks, and broken poets, behind Robert Mitchum, Duane Allman, Lee Marvin, Lash LaRue, Art Pepper, John Huston, and Sam Peckinpah, and Grover knew it.

"I can see it now, of course," he said, "how I would want to talk to somebody who was like Big Grover, who was bad and good, sweet and violent. How I would want to speculate on how he might have survived, done well, and been redeemed. That's a reasonable interest, I think, but it doesn't *explain* anything. That was just the *assignment,* you know, and I'm too good a reporter to let the assignment distort the story. I always got the story that was there. From all these people. The only difference Big Grover made, I think, was that I was really interested in those guys and predisposed to forgive them for their rough edges. That made better stories, I think."

It would have made Grover's book a better book, too, I think, but about two months after we spoke, Grover hurt his back moving something on his desk. He went to the doctor with it and was diagnosed with terminal lung cancer. He was immediately thrust into chemotherapy, which scalded his throat, so we never spoke again. He died six weeks later and was buried in Kanaraville, Utah, Rae Lewis's hometown, in a little Mormon cemetery in a high mountain meadow on a day full of wind and scudding clouds, hard rain, and banners of angled sunshine.

A small group of us stood in the mud around the grave, hunched against the rain and blinking in the shafts of dazzled sunlight. A girl in a long, country dress played an Irish melody on the

fiddle. It was so damn cinematic I could barely stand it. All it needed was Beau Bridges and a commissary truck, so, to distract myself from the proliferation of easy ironies, I thought about the fragment I had read of *Goodbye If You Call That Gone*. About these lines: "The fatal event took place in my hometown of San Antonio when I was eight. By then I had experienced at first hand such a numbing amount and so many varieties of violence that I was left with a choice between an invitation to death and the will to live." Grover, of course, being Grover, chose both.

A Glass-Bottomed Cadillac

Howdy, this is Hiram King "Hank" Williams, the old Driftin' Cowboy, born on September 17, 1923 in Georgiana, Alabama, died on the road to Canton, Ohio on January 1, 1953, and speaking to you now from beyond the sunset by virtue of that special privilege granted to dead hillbilly singers on the occasion of their having been dead longer than they were alive. And first, before I get into the confessional stuff, I'd like to say Hi to my boy Bocephus and tell him that Heaven, when he gets here, is probably going to come as a bit of a surprise, because, for one thing, there isn't any Hell. We're all sort of jammed in together up here, and the place we're jammed into isn't a bunch of glorious clouds like you might expect. In fact, it seems to be this big cinder-block structure like the education building of a Methodist church in suburban Indianapolis.

It's got beige walls, terrazzo floors, acoustic-tile ceilings, and there isn't any TV or movies. There are just these big felt boards in all the rooms with cutouts of Cain and Abel, David and Bathsheba, and the New Orleans Saints stuck to them, so that you can kind of move them around and tell stories if you want to. And there aren't any harps or guitars either, just a couple of rooms with dinky Hammond organs that for one reason or another won't stay in tune, so there's not as much singing or praising the Lord as you might expect. But we do have wings. Every blessed one of us, and they're pretty nice wings, too, but since this place is all rooms and corridors, there's really not any good places to fly, except in the stairwells—and you can't really swoop and soar in a stairwell—and swooping and soaring, in my view, is the main fun of flying—and flying, insofar as I've been able to tell, in the last thirty years, would seem to be the main fun of being in Heaven. So all I'm saying, without trying to be bossy, is that if I'd been better informed about the afterlife, Bocephus, I might of modified my behavior some-

what back there on earth, and you can take that anyway you want.

Also, while I'm clearing up misconceptions, let me say straight out to everybody that the "ghost" in all those country songs is that darn Lefty Frizzel, and not me. I'm a major star. I do not do ghost gigs in other people's songs, and I'm only doing this cameo here because Hickey promised to let me tell my Heaven joke, which I made up because all these other angels kept coming up to me and saying, "Oh, Hank, you poor soul, we just love your songs. We got laid first time listening to one of your songs, and we was listening to another one on the truck radio when we finally run it off the interstate." Then they go on to tell me how much happiness and consolation my songs brought into their dinky little lives. They tell me what a pity it was that my own life should have been so dinky, too, and so unhappy, and then they look at me with their big old redneck angel eyes and ask me if it really was that sad, as sad as it seemed, my life that is, and I tell them, you darned tootin' it was sad, powerful sad, and then I give them a little nudge and say, "Why do you think they call them Hankies?" and that seems to satisfy them.

What I don't tell them, however, is that, if the truth were told, I ran so hard and stayed so crazy during my life on earth that sad hardly mattered. Sad I could deal with. Sad I could put in a song, and if it was a good song, one that tasted good in your mouth when you sang it, and felt good under your boot when you tapped it out, there was a chance you might tear up and sniffle a little bit when you sang it. But otherwise, the sadness just stayed put, right there where you put it, in the song. So you could say, I guess, that those songs were like bus-station lockers where I stowed the pieces of my broken heart—and forgot them. Because, except when I was writing songs, I didn't spend too much time worrying about the state of my heart. I spent a good deal more time trying to keep my liver and my lungs and my dick in working order, which, considering the way I lived, was no small task.

Anyway, I could deal with sad. Scared as hell, however, and

guilty as sin, I couldn't put out quite so easy—like the cat or like a fire. Scared as hell and guilty as sin, ate my insides so I could only treat them with the booze and the pills and the beautiful needle that I was so scared of and felt so guilty about, and, strangely enough, say what you will, they always give me the courage to seek what they made it impossible for me to get. And we did our little dance for twenty-nine sleazy little years, fourteen of them spent in skull orchards and blood buckets singing myself hoarse, drinking myself crazy, breathing smoke, and taking abuse off sweaty stinking field hands who hated me for being no different from them. So it wasn't exactly your Texaco Star Theater Dream Vacation. But, at times, in places, it was better than nothing—mostly after midnight, in hotel rooms alone, on those few nights when I got the uppers and the downers and my old guitar in perfect tune, and all of a sudden the words, and the sound of the words, and the swiftness of the music, and the goddamn hurt in my heart all went *click* and cinched in there, permanently, so they'd never come apart again, and that was something. *You be daffy and I'll be dilly, we'll order up two bowls of chili.* And I never knew quite how it happened. It was my own true gift and it was the damnedest feeling I ever felt, of having things just fit.

The thing of it is, of course, I never got ahold of anything else nearly that clear, never got anything else under control, even. I kept expecting to, all along, but in the end I never even got to step back and look at things straight on. I started out looking up from under, and ended up looking down from above. I never even *saw* the everyday world most folks live in, not the way they see it, anyway. I used to dream about it, though, like I had a house on a street, and I'd go out and get the milk and the paper off the stoop and sit down in this shiny breakfast nook and have some Wheaties while I read up about the Dodgers. But I got all that out of movies and from the couple of times I went out to Fred Rose's house in Nashville, but what can you do? You ride your own horses and go where they take you, and I come to the party on a herd of pale

white ones, on dark green bottles, in the *Book of Revelations,* out in the paddock, and cooking in the spoon, and they ran crazy through my life.

I was about eleven, I think, when I found out that whiskey kills shy. And since that was about the time that my mom, Lily, started kicking my ass out onto the stage with no questions asked, I began taking to the stuff as a private resort. Now I knew, even then, that I lacked the constitution and the stamina to be a drunk, but I damned sure had the inclination, the "proclivity," as Fred Rose would say. So, finally, in total, I reckon I was drunk or doped two days out of every three I was alive, and that's counting the time I was a little bitty baby and don't recollect, which is just as well since the first thing I can remember was being sick with the croup. So, to tell you the truth, I'm probably not the best source of information about my own adventures, since I missed a good deal of them. As it turned out, I spent twenty-five of my twenty-nine years scuffling around on the bottom, maybe six months sitting pretty on top, and the last three years in dreamy slow-motion, just *falling,* off the wagon, off the stages, off the barmaids and the snuff queens, off that damn white horse in my backyard, which either hurt my back or helped my morphine supply, depending on how you look at it. And once I started, I kept on falling off everything I got up on, except, of course, the booze and the pills, and the beautiful needle. I got up on them, and I stayed up, getting higher and higher and tireder and tireder until I was so light, so frail, until there was so little of this world, of this earth left in me that I just began to fade, like Gene Tierney in that movie about the sea captain.

You see, I figured I'd already been found out. I *really* thought everybody could see the decision that I had to make. If I give up on the booze and drugs, I'd lose my confidence, and my fame along with it. But, if I didn't give them up, I'd probably lose my life. So everybody, I figured, would know that I didn't really want to die; I just didn't want to stop shining. I didn't want lose my

stardom. They'd all understand, I thought, that it all came down to the fact that I'd rather be nothing than a nobody, and, from that point of view, knowing what all I would've done not to be a nobody, I guess the luckiest thing in my life is that I got to be a Somebody, and still be an honest person about how I felt. Because I was *going* to be a Somebody, honest or not. That's why I have to laugh at that silly old Acuff saying my music would have stayed "country," no matter what, that I would have never "gone rock-and-roll." Because, folks, I tell you true—and you can go to the bank with this—to me, being country was just one of them terrible accidents of birth. It was the disease my music was a cure for, and if I thought it would have helped me get a hit record, friends, I would have not only gone rock-and-roll, I would gone naked with a flower behind my ear.

And it's hard for people to understand what it feels like, to be out there in the night at some cloudy crossroads, with your jaw clenched and your heart pumping, all full of jagged angles and wanting to be Somebody with every ounce of gristle and meat that bears your name. And it's hard to explain what it costs. But I can tell you this, *you get a lot on you.* And I got a lot on me, which was the one thing my daddy told me not to do. Every time I was leaving the house to go out to play, or to go to Sunday school, or to run down to the store for Ma, that's what he'd say. He'd be sitting there at the table, and I'd stop at the door and say, "I'm going out, Pa," and he'd kind of halfway look around and say, "Well, don't get any on you, squirt." Fat fucking chance is what I say to that.

I remember this one time, it must have been '49 or '50, when me and Harley was making a swing up through western Pennsylvania. We was doing a string of package shows in them little mill towns. We stopped off in Johnstown one morning on our way to Altoona, so Harley could get something done to the car. Actually, it was just an excuse for Harley to sneak off and call his wife back in Goodlettsville and reassure her that, no, he had not been killed yet driving around with the notorious Hank Williams.

But I thought I would take the opportunity to cash this Benzedrine prescription I had picked up in Uniontown a couple of nights before, so I left Harley with his head under the hood and strolled down the main drag to this dingy little drugstore.

There was a bell on the door and a fine looking woman of about thirty-five standing behind the soda fountain. She had black frizzy hair, a hefty front end, and "Madeline" stitched over the pocket of her apron. It might as well have said "Divorcée." Anyway, I hiked myself up onto the stool, ordered a Cherry Coke and gave her my great big break-your-heart smile. She smiled back at me while I pulled out my flask and poured a little snort into the Cherry Coke, so I waved the flask in her direction. She shook her head no, but she kept on smiling. I recognized that smile. It was clear to her that I wasn't nothing out of a steel mill. I was wearing my eight-gallon, white-felt Stetson hat, my pointy-toed, handmade, lizard-skin boots, and my brand new, custom-tailored, cream-colored, flannel western suit. And what's more, my *picture* was on the cover of the *Hit Parader* magazine she was reading when I come in. So when I asked her if she might be able to fill this prescription for me, and handed it across the counter to her, it more or less confirmed what she suspected.

She said, "Yes sir, Mr. Williams," and blushed right down into the front of her blouse. "You sure look a whole lot like your picture," she said to me while she was tapping the speckled birds from the big bottle into the little one. From there on we had a fairly breathless conversation, the upshot of which was that she'd give she didn't know what all for the chance to go down on a living legend like myself. And I told her that one of the things that I was living for, and legendary for, was granting the wishes of handsome women. So without so much as a by-your-leave she led me back into this dusty storeroom, which I'm sorry to say was far from the least romantic place I'd transacted this sort of business. And after rearranging a couple of cases of Grapette, I suddenly found myself the happy recipient of a Class A, New Orleans

Bourbon Street blow-job, right there in Pennsylvania.

Needless to say, by the time she finished, my spirits had improved considerably, but for some reason she looked up at me, wiped the back of her hand across her mouth and kind of smirked. "Well, you ain't so much, Mr. Living Legend," she said. And *hell,* I thought she was kidding. I told her that if we could take a short time-out for a milkshake, I'd be glad to rearrange the Grapette and fuck her brains out right there. At which point, she got huffy as hell. Drawing herself up, putting her hands on her hips, she squeaked at me: "Just what kind of a woman do you think I am?" And I said, I didn't know what kind of a woman I thought she was, but I knew for a fact that she was a cocksucker. At this, she sneered down at the scene of the crime and said, "Do you call *that* a cock?" And I said, "No ma'am, I call it Little Hiram." And she spit my own cum all over the front of my brand new, custom-tailored, cream-colored flannel cowboy pants, and stalked out of the storeroom.

When I come out behind her, zipping up, she was standing behind the counter glaring at me. So to get the last lick in, I pulled a couple of twenties out of my pocket and threw them on the counter as I marched by. She snatched them up angrily and cocked her arm like she was going to throw them at me. Then, all of a sudden, she stopped and burst into this *beautiful* smile. Her eyes were shining, and I couldn't believe it! She was just smiling at me as I walked out the door, like I was Jesus, tucking those bills into the front of her blouse.

I walked all the way back to the service-station half expecting to be shot or arrested, with my coat buttoned up, wondering if there was any way I could hold my guitar that night so as not to show the pecker tracks all over the front of my pants. I didn't see how it could be done. I could just hear old Lon back there in south Alabama saying, "Don't get any on you, Hank." Right, Pa. But I shouldn't have worried. As we were driving off, I gave Harley a slightly toned-up version of what had happened, and he said,

"Aw, no problem, Hank." He reached into the back seat and grabbed the beautiful Mark Cross calf-skin toilet kit Fred's wife got me in New York. He said, "Poke around in there. I'm sure we've got something to fix it." So I did, and for the first time in my life I realized what it meant to be a Somebody. It meant you had a lot of different kinds of soap.

Back in Georgiana, we had one brand for all purposes. Home-made lye, cooked in the kettle and cracked off the scum. If that didn't do it, it didn't get done. And right there, on my lap, neatly tucked into that fancy toilet kit, I had special soap to wash my body with, special soap to wash my face with, shampoo to wash my hair with, toothpaste to brush my teeth with, detergent to wash out my nylon shorts with, saddle soap to clean my boots with, and goddamn it if there wasn't this little bottle of something called Exeene, specially designed to get cum stains off cream-colored flannel britches. There was a beautiful logic to it, too, because in the process of getting to be a Somebody, you were *gonna* get a lot on you, and when you finally got to be a Somebody, you had all these special potions that purify you and leave you white as snow—to cleanse you of all the stains that show.

It's such a damn shame, then, that we got to die of the stains that don't show. But I should reassure you here, by way of consolation, that in the end, when it finally came some three years later, after all the shouting and shooting-up and guilt and greed and fear that preceded it, it wasn't all that bad: cruising along over the snow-white New Year's breast of West Virginia, with the scrawl of the black, bare trees undulating as they slipped across the steamed side-windows and disappeared into the past, with the old Driftin' Cowboy faded and beyond fatigue, snuggled up under a fancy plaid blanket, on the good-smelling leather of the back seat, in the warm embrace of Sister Morphine. It was so damned improbable, you know, for little Hiram Williams from south Alabama, as tired as he was, to be moving so warm and effortless toward the warmth of the people that loved him. And

it was slightly wonderful, as it always was, to be nestled in the bosom of a powder-blue Cadillac in the heart of America, floating along without effort, on that shiny black ribbon of highway that might have been glass, a thousand-feet deep, with this clean-cut, thoughtful stranger at the wheel.

He was just a kid, really, the guy behind the wheel, with a collegiate crew cut, wearing a pale blue, oxford-cloth shirt under a dark blue, pullover V-neck sweater. He wasn't my friend or anything, like Harley was. Friends couldn't be trusted with me anymore. I was past that. He was just another chauffeur nursemaid, a quiet one this time, without a lot of fool questions. Just a guy hauling a load, gauging his speed so as to make the delivery right on time for the gig. Dead or alive, I thought vaguely. As a hot number or cold meat: It didn't really matter which. Not to me, and probably not to the fans. Six of one, half-dozen of another, really. Either way, I figured, it would be a big thrill for the folks in Canton. I mean, wasn't I the Driftin' Cowboy? And wasn't he always wanted dead or alive? You bet your bustle he was. But who the hell cares, really? I decided I'd close my eyes and listen to the big balloon whitewalls whir and swish on the ice-cold pavement as it rushed under the chassis about eight inches below. Then, I could actually *see* the pavement rushing beneath me, as if it were a glass-bottomed Cadillac. And wouldn't *that* be something, I thought. A glass-bottomed Cadillac. And why the hell not? I'd call Dwayne the very second my next single hit the charts, and I could afford it. Hell, if I could afford Audrey, I could afford a *fleet* of glass-bottomed Cadillacs.

But I let go of that thought and watched it drift away from me as if it were a balloon. And I was drifting, too, and gaining altitude. Pretty soon I was just beneath the woolly gray clouds looking down on the jumble of snow-covered fields, faint rectangles spreading away across the rolling country like scattered manuscript pages, defined by feathered snow along the fence lines. Seen from above, the bare, black trees looked like calligra-

phy, like Fred Rose's angular lead-sheet notation, which I never could read, and couldn't read now on the snowy pages beneath me. Oh, yeah, I was really the Driftin' Cowboy. No doubt about that. *Do I start planning my entrance?* Why not? It was always my favorite thing about being a star, that moment when I stepped out of the wings, just getting hit with all that heat and light and noise. It always felt so good that I wanted to go back and do it again. The whole idea of getting something before you'd done anything: It was almost like real love, I guess. "Hello, Ohio!" I would say tonight, stepping into that magic crackling light, "Did you know this old country boy has crossed your snowy heart?"

Then, at the very last damn second, right before there wasn't any Hank Williams anymore, I realized what I'd done. I'd done the same damn thing to Bocephus and Audrey that poor old Lon had done to me and Lily. "Damn it," I thought, and tried to crawl back. But my hands just flopped around until I died and disappeared. And that was the last thing I figured out too late. I was so *slow,* you know, about some things, to be so fast at others. Hell, it wasn't until very shortly before that I figured out what Lon *had* done to me, without his really having a choice. I was writing this song about him being an engineer on the log train, and when I came to the line about hearing his whistle off in the distance, I suddenly remembered an evening when I was about five. I was running on my cold bare feet across the no-man's land of frozen red mud between the house and the facilities, hop skipping across rust-gray puddles with ice around the edges, and all of a sudden I heard that log-train whistle. The minute I got into that outhouse I started bawling. I just sat there and cried, because my daddy was always off somewhere running that log train, or just off somewhere in his head.

I knew then that the sadness in every whistle I ever heard, every whistle I ever wrote up in a song, was that log-train whistle telling me my dad was somewhere else. And I remember way back, before he moved to the VA hospital, how he'd sit there in the

kitchen with his elbows on the table just staring at me with those big, blank, rabbit eyes of his, like I was a freak of Mars or something, and not his born son at all. And, sometimes, when I was feeling frisky and cutting-up as kids will do, he'd all of a sudden start crying, not making any noise, but really bawling with these big tears rolling down his cheeks. Later, I'd come to understand that Lon was wound kind of tight on account of his having been gassed in the Great War. But, by that time, I couldn't stop being resentful of him.

The thing is, Lon didn't tell me *nothing* about *nothing*—about how to act, or what to do, or how to dress, or even how to play a damn sport. He'd been over the Atlantic, clear to Europe, so I knew he knew that stuff. But he didn't show me nothin', not even how to bait a hook. I had to learn that like everything else, by looking out of the corner of my eye while my buddies baited theirs. And, naturally, they noticed that Lon hadn't shown me how and had a real big time at my expense. And remember, back then, south Alabama was a whole hell of a lot farther back in the sticks then it is now. There wasn't that much difference between whites and blacks on a day-to-day basis. And even stuff like electric lights and pavement was unusual. And Lon, damn it, didn't even teach me nothin' about south Alabama. I used to think it might have been different if my back hadn't got banged up. Then I'd've been able to enlist in the Army like Lon had, and if I'd got some medals and all . . . But I don't know, maybe it wasn't Lon's fault at all. Down deep, I was always a backwoods cat, shy and distrustful by my very nature, slinking among the darkling pines and cypress with a solitary heart and a soul like a spinster's cunt—tender and empty and always waiting for that magic mysterious sparkling something to come fill it up—and knowing that it never would.

Which is not to say that I was a Gloomy Gus, far from it. I always felt a little bit outside, and a little bit below. So I was always trying to please and always expecting to be caught red-handed at something, found guilty of breaking some rule I'd never heard of.

So I always pretended to be cutting-up and doing things in silly ways, like I really knew how to do them, but was just goofing around for fun. Even after I got famous, I remember this time in Tulsa, me and the band got taken to this bowling alley. And everybody was saying, "Boy, I sure like to bowl. Do you like to bowl, Hank?" And I said, "Oh, yeah, I *love* to bowl," having not the faintest fucking notion until we got to the alley what bowling was. But I killed a pint in the car driving over there, and done all sorts of crazy things when we got there, so as not to let on—like rolling the ball back between my legs and pushing it down the lane with the toe of my boot. This was pretty hard on the nerves, I tell you, and even worse after I was a big star. But a fool knows how to be foolish, so it wasn't too hard to make everything into a joke. If they figured out how really stone ignorant I was about things, they very rarely let on.

But it didn't really matter, because, to be honest, I never really trusted another man except for maybe Fred Rose and Rufus Paine. But they, being a New York Jew and a black African blues man, respectively, were not all tore up with the idea of Southern Manhood like me and my buddies. And between the two of them, Fred Rose and Rufus Paine, they taught me how to make my special kind of redneck song, which is really just a combination of the black man's blues I learned from Rufus Paine and the Jew craftsmanship I learned from Fred Rose. Between the Jews and the Blues, I used to say, the only redneck thing about my songs was me singing them through my nose. Because they taught me that the true songs, the real songs, the ones that lift you up, are built and well built out of the heart's lumber, the singing word of your feelings about things. And all the rest don't mean doo-doo as long as you're accurate about that.

People kept telling us how country songs had to be simple and true to be great. Fred and I knew that was bullshit. We knew they had to be *clear* and *perfect*. Because if they were, they'd be the only clear and perfect thing in the stinking ditch most of us live

in. Let me take an example, *She's my Eskimo baby, she's my Eskimo pie*. Now, that's George Jones, and that's simple. And that, God help us, is probably true. But it's also bullshit. *Today I passed you on the street and my heart fell at your feet*. That's *not* simple and that's *not* true. But it will never come undone. Because it is clear and perfect about the feelings, which, unfortunately, your average Southern boy would no more admit to having then he would admit to having the clap.

So, however much my songs made me into a rich Somebody, they never made me into one of the boys. Because the boys, no matter how thankful they was for me putting their feelings into words, still couldn't respect me for it—no more than they could respect a Hebrew or an African or a woman or anybody who forgot to act like a goddamn Roman Emperor, and let his feelings show, especially his romantic feelings. It's pretty silly, when you think about it, since nobody but Frenchmen and Hollywood homos still believe that old saw about how Southern men are as cold and bold as their women are flighty and sentimental, when the fact is just the reverse. In truth, no Southern woman has believed a single word out of the mouth of a Southern man since 1861, when the men went riding off on their chargers shouting, "Not to worry, sugar plum. We be home early from the war." As a result, your average Southern belle of today is about as sentimental as a chain saw. And though she might twitter on about good manners and religion and such, when it really comes down to it, she don't believe in nothing but hard currency, land in clear title, and rigged elections. Lily and Audrey didn't even believe in the last two. On the other hand, your average Southern gent, of which I was a touching example, believes in his heart of hearts and despite of his rough and tumble ways, in *fair play*—and remains a fool for any kind of romantic adventure that requires charging the cannon to demonstrate his pure and constant allegiance to some lost cause, which, often as not, turns out to be one of them beautiful Southern girls without an ounce of mercy nor a jot of fair.

But I wanted to trust women and to be trusted by them, though I can't imagine why. I'd've never expected that of a man. And it wasn't that women wouldn't love me. They would. It was just that they wouldn't *keep on* loving me irregardless. I wanted to be loved that way—the way I loved them, right or wrong, good or bad, fair or foul—like Stonewall Jackson loved the South, lost cause or not, like Jesus loves us all (but with a little more fucking thrown in). Because I wasn't ever going to be all good. Not with whiskey as my copilot. But I always tried to be *extremely* good, when I *was* good. To balance out the extremely bad that was bound to crop up from time to time. But I didn't intend to perform for love, not in private. I wanted it fair, open, aboveboard, and in advance. But they just couldn't see that part of it, not the religious side.

The love I got was always practical and profitable, when I was thinking about something more along the lines of constant. And my mama, Lily, Christ, she didn't know nothin' but how to pinch a penny until it screamed and complain. She busted my ass and let me grow up ignorant as a stump of everything in the world but woman-talk, about all the good things little Southern boys did for they mamas that got them out of south Alabama. But she did do that, Lily did. She got me out of south Alabama, and I was grateful for it. It was just too bad that I got out of there with such a clear picture of how painful it was to be clean and thrifty and Christian. Because after I achieved that Louisiana border, I never felt the least inclination to try it for myself. Why be an upright Christian citizen, I thought, if it keeps you in such a damn foul humor all the time?

Of course, the woman was just trying to make herself irreplaceable so I wouldn't run off on her like Lon did. But, by the time I figured out that, it was too late again. I had already replaced Lily with someone just as crazy, crazier even. I mean, Lily drove me toward the stage like I was a draft ox, but at least she had the sense not to follow me up there into my safe place. Because the

stage was my hideout, you know, my last resort. Right up there in front of God and everybody I was my own man. I could find some warmth up there, with nobody standing in my light. Until Audrey, that is. And God knows I loved her better than free whiskey, but she chased me clean out onto the stage, up to the edge, and over into the orchestra. I nearly throttled her a hundred times for the few times I really tried it, and the damn woman was so *thick,* she could not understand. She thought I was "stifling her career," and I couldn't explain it to her noways. That stage was my *club.* You know how them railroad barons and Tammany politicians had these private clubs just for them and their buddies? No women allowed, not wives, nor mothers, no how? Well, when I was up there on the stage with the Driftin' Cowboys, that was my club, and the damn crazy female would just not let it be.

Still, I don't want you to think that my life was just fighting and cheating, and whiskey and mojophine, and crying and dying. A lot of it was laughing and loving and just living. Having a soda pop and breathing the air. I remember I wrote this song for Audrey one time, which nobody much recorded, called *Why Don't We Try Anymore?* The song was about the feeling of not wanting to try anymore, so the answer to the question wasn't part of the song. But the answer is that you try because, when you quit, you die, and life is better than death, I promise. I remember this one time, right after we moved into the big house in Nashville, I'd come in from the road and crashed out for about two days, and when I woke up, it was about five in the morning and I didn't know where I was. I was in this big, cool room with light colored walls full of gray, predawn light, stretched out on this big, soft bed with crispy, clean sheets. Wherever I was, I'd never felt so good in my life. And then I saw Audrey sleeping beside me, and I knew it was my house, and I felt even better. Without waking Audrey, I got up and tiptoed downstairs in my stocking feet, loving the feel of that plush carpet through my old white socks. Downstairs, I got me a Coca-Cola out of the Frigidaire and carried it into my

den, which had a picture window looking out over the lawn, and, just as I walked into the room, the sun broke over the hillside and the whole yard of St. Augustine grass, covered in dew, burst into Technicolor, just like in *The Wizard of Oz*. And I stood there, in my dark den, smelling the leather and sipping my Coke, looking at that bright-green yard, and I thought to myself, "Hank, just this one morning, just this single sunrise, is your everlasting reward." And, for once, I was right.

The Little Church of Perry Mason

From time to time, if I am not careful, people whom I do not know very well will come up to me and ask if I have any religion. I always say, "Not yet," and then (in order to mitigate this confession) I volunteer that, even though I have no religion, there are some things that I do religiously. I listen to *Exile on Main Street*, in its entirety, at least once a year. I reread *Under the Volcano* and *Tristram Shandy* often enough to keep them fresh in my memory, and, whenever possible, I watch reruns of *Perry Mason*—the black-and-white television series from the nineteen fifties starring Raymond Burr as Earle Stanley Gardner's fictional defense lawyer. Now, for the purposes of this essay, I must elaborate on that confession somewhat and admit that watching *Perry Mason* "whenever possible" has been pretty damned often over the years—that in fact, I have probably spent roughly three times as many hours in front of old *Perry Mason* episodes as I have spent listening to Mozart and reading Shakespeare combined. This is not a happy statistic, but there it is.

I began watching *Perry Mason* when I was an adolescent, during its original run from 1957 to 1966 (a total of 271 episodes). At that time, the appeal of the series was tripartite. First, it took place on the streets of Los Angeles—which was unusual for TV shows at the time—and Los Angeles was the coolest place in the world. Second, the series was sponsored by a sequence of Detroit automakers, so Perry always drove the shiniest models of the newest cars down the palm-lined thoroughfares. Third, and most importantly, Perry Mason *trusted* people. That was his "superpower"—and he used it to defend the innocent.

This made Perry Mason a fairly unusual hero for the fifties. He wasn't particularly strong or wise or brave or good with his fists. In fact, he was a bit of a dandy—arrogant, overly clever, and sometimes downright sneaky. But he was basically a "good guy"

who wore neat suits, drove cool cars, and trusted people. He had this uncanny ability to intuit native innocence. He could listen to the wildly improbable stories of the unjustly accused and just *know* they were the truth. Thus, for any kid growing up in the fifties—unjustly accused of being pampered, delinquent, and vaguely responsible for not having fought in World War II or suffered through the Great Depression—Perry Mason was an attractive and redemptive figure. Just the fictional probability of being presumed innocent in those fat, nervous, distrustful times was a big deal—and evidently it has remained so, since, subsequent to its cancellation, the series has never been out of national daily syndication.

I know this, because I have not had a day job for a very long time; and, over the years, watching *Perry Mason* reruns has gradually come to *signify* my not having a day job, to function as a sacrament in the Church of Unemployment. I cannot tell you how many quiet mornings I have spent sitting around hotel rooms and furnished apartments in the United States and Mexico, smoking cigarettes, plunking the guitar, and watching *Perry Mason*—telling myself, "Well, at least I don't have a day job. And there is nothing wrong with that. I am not guilty of anything. Perry would see that in a minute."

At present, *Perry Mason* runs every morning on WGN out of Chicago; then it runs an hour later on WTBS out of Atlanta; and then, two hours after that, Perry and Della Street and Paul Drake and Lieutenant Tragg and Hamilton Burger reappear on the local Warner Brothers station here in Las Vegas. Whenever I am at home, then, I can usually catch at least part of one episode every day. (Usually the second half, the courtroom ritual, for which the first half is just set-up.) In periods of serious regression, I catch all three episodes, dozing comfortably through the sections I have memorized. Considering the ubiquity of *Perry Mason* nationwide, I presume that I am not the only snoozing devotee; and considering the sponsorship of these reruns (personal-injury lawyers,

credit-clearing firms, The Devry Institute of Technology, and The International School of Blackjack Dealers), I must assume that I am not the only one for whom *Perry Mason* functions as a sacrament in the Church of Unemployment.

For all of us, I think, Perry and his legal secretary, Della Street, and his detective sidekick, Paul Drake, must constitute a kind of trinity—the Trinity of the Professional Family. They evoke for us a kind of ideal collegial atmosphere, which, if it actually existed, would make steady employment less onerous—although we are used to its nonexistence by now, accustomed to our disappointment. In the beginning, back in the fifties, Perry and Della and Paul were enacting this fantasy of happy, serious, collaborative work at the moment it *became* a fantasy, at the moment in history when the American ideal of the working family was finally supplanted—first in the workplace by corporate formalism, and then, in the domestic sphere, by this tarted-up, late-Victorian paradigm of Arcadian households tucked away from the tumult of commerce in tidy suburban cloisters.

So, at its inception, the fantasy of *Perry Mason* arose to fill the vacuum left by the schism of love and work, to hold that place for us in memory and expectation. Thinking of it like this, as a compensatory narrative, probably explains why so many rock-and-roll musicians of my generation were (and probably still are) addicted to *Perry Mason*. Leaving aside the fact that rock-and-roll musicians tend to watch a lot of morning TV, that they have an affinity for shuffles like "The Perry Mason Theme," and are often in need of defense attorneys, the fact remains that a rock-and-roll band, at its heart, aspires to be just the sort of working family that is idealized in *Perry Mason*.

The issues are the same: love and work, justice and democracy. Charles Williams, in his lovely essay about television writing, argues that all popular narratives, in the maintenance of these issues, elaborate a single plot—*The family is threatened; the family is reunited*—in infinite variations: The galaxy is threatened; the

galaxy is reunited. The earth is threatened; the earth is reunited. The nation is threatened, the city threatened, the neighborhood threatened, the family threatened; they are all reunited. Unfortunately, as Williams notes, all of these plots, in practice, aim at restoring Daddy to his rightful place at the head of the table.

There is, however, an even more basic plot at work in *Perry Mason* and in rock-and-roll—one that preempts the reign of Daddy and speaks to the primal, social imperatives of human beings adrift on the prehistoric veldt: The band is threatened; the band is reunited. *That's* the plot, and before the pressure of its imperatives, gender roles are only decoration, like the cars and the coco palms. Miss Marshall Chapman, my ex-paramour and rock-and-roll co-conspirator, put it best one night in South Carolina. We were working up "The Perry Mason Theme" for her walk on . . .

"See!" she said, executing her Perry Mason walk, standing very erect, holding her elbows in and moving from the shoulders, kind of swooping across the stage, light on her feet. "It's not a boy thing. It's not a girl thing. It's a cool thing. Cool is what you do!"

Which is simply to say that, in rock-and-roll and *Perry Mason,* the integrity of the family roles are not at issue. What matters is the integrity of the family *endeavor,* the style of love and work, because the traveling band and the working family exist not just to preserve values, but to invent them, to propagate them by doing things in the world. In this sense, then, both rock-and-roll bands and Perry Mason's staff reconstitute the ideal of the American family in its original, nineteenth-century form, as a quasi-democratic, mercantile unit (the family farm, the family firm, the vaudeville act)—as a collective endeavor in which the static rigor of single-provider patriarchy is mitigated by issues of competence and merit, by the exigencies of collaboration, and, finally, by the ethics of the task at hand, which, in *Perry* and in rock-and-roll, is the affirmation of American innocence in the face of pervasive guilt and complicity.

Thus, the front story in any *Perry Mason* episode—*Someone*

is murdered; the murderer is identified and found guilty—is never the real story. Because in the Church of Perry Mason, the victims are also guilty; they are, every one, so deserving of their fates, so thoroughly unmourned and unmournable that *everyone* in the narrative, excepting Perry and the defendant, is complicit in the death. Perry demonstrates this during the trial and then exposes the most guilty of the suspects as the murderer. But this is not his real job. Perry's real job is the public validation of his client's private decency, because the story in any *Perry Mason* episode— the real story in a journalistic sense—is that one person, in the whole sordid, sun-drenched Babylon of Los Angeles, is innocent! So we root for Perry's professional family, and hope that, by establishing one person's innocence, his family might survive in harmony to demonstrate the innocence of others—to perpetuate the possibility of redemption.

This, it seems to me, is a relatively benign fantasy. The possibility that private decency might be publicly validated and that human beings might work together happily to this end are not, after all, such terrible dreams. They are not "real life," but popular narratives are not real life, and everyone knows it. In truth, such narratives are the *churches* of everyday life. They bless its ragged contingencies with rituals of closure and reassurance, and, since we have freedom of religion in this republic, each of us may worship at the church of our choice—or, if we wish, worship like ancient Romans, at as many churches as we please, according to our local needs. I have done this myself on occasion, when the pressure of circumstance has led me from the Way of Perry Mason.

For four years in graduate school, I hardly watched Perry at all, or even watched television. I thought I was becoming refined, but I can see now that I didn't need to go to church because I was *living* in one. I was swaddled in the Church of Higher Education, effortlessly borne along in the tempo of its calendar. Semesters began and ended, like weekly episodes, in an endless cycle of redemption and renewal; and, in the safety of this cloister, reas-

surance and closure were the last things on my mind. What I wanted, required, and dreamed of was contingency, a lot of it, so during those years, I worshipped at the Church of Difficult Art, Improvisational Politics, and Dangerous Drugs, with James Joyce and John Hawkes, Tom Hayden and Herbert Marcuse, LSD and methamphetamine.

The moment I quit graduate school and went into the business of difficult art, however, contingency became my livelihood and not my blessed refuge. So the TV sprang back to life. For a year or so, I was helplessly addicted to *Mission Impossible,* which I quickly recognized as the Church of the Small Business Guy, because for one hour, every week, there was a task to be performed, and by God it was! If you needed expertise, you sent out for the best people—and they all showed up! Right on time, and they didn't hate one another, or call in sick, or show up stoned, or complain about the bucks, or loaf on the job. They were fucking *professionals,* who could operate the equipment—and the equipment, my friend, *always worked!*

So, once a week, on *Mission Impossible,* the job got done, slammed down and nailed tight. By the end of the hour, the "Mission Impossible Team" was driving away into a freeze-frame, heading home from work. Then, the next morning, I would drag myself down to the gallery and sit around all day, waiting for some asshole to come fix the copy machine. Clearly, I needed a *team,* but the truth was, I liked the flakiness of my endeavor, the weird kids who worked for me, and the (un)stable of artists that I exhibited; so, ultimately, *Mission Impossible* proved too corporate for me, too Episcopalian. It had no rhetoric, no sociability, and no moral passion. We never got to see Barney's workshop or Cinnamon's boudoir. It was all procedure, efficiency, deception, and bottom line. So, it was probably inevitable that, in the end, I would return to *Perry Mason*—and to rock-and-roll.

Thus it was, in the late nineteen seventies, that I found myself camped out with Miss Chapman and her band, Jaded Virgin,

in Myrtle Beach, South Carolina, in a stucco cottage on the beach, in the midst of a three-week gig at a blood-bucket farther down the beach where we were granted the privilege of playing *very* loud because the building was situated within five yards of a giant, wooden roller-coaster. Every night, all night long, every four-and-a-half minutes, the coaster cars came thundering by, shaking the walls and bouncing bottles on the tables. We just smiled and cranked it up. So it was a good gig. It would have been a *great* gig, if the jerks at the local television station hadn't fucked with *Perry Mason,* but they did.

In order to insert more ads for The Carolina School of Miniature Golf Course Management into their programming, these freaking philistines simply cut their *Perry Mason* episodes immediately after the "confession scene"—the one in which the guilty party, having been shrewdly unmasked by Perry's courtroom machinations, usually jumps to his or her feet and proclaims: "Stop this! I can't go on. I did it! I killed him. But you have to understand. He laughed at me. He *laughed* at me!" (Breaks down in sobs.) The End. What! The End!? You got to be kidding! By Wednesday of our first week in Myrtle Beach, the entire band was up in arms at this bastardization of the liturgy. It became a source of general unhappiness and much discussion—and even taking into account the lack of sane proportion that is endemic to band behavior generally, the aesthetic point made in this discussion, I think, has some validity.

"I mean, Jesus, what about the *best part !*" (This was the consensus.) "What about the part where Perry and Della and Paul go out to dinner after the trial, and Perry tricks Paul into picking up the check? Or maybe Hamilton Burger comes over to say that they're still pals? Or maybe the defendant is reunited with her boyfriend? What about *that!* Or when they just sit around the office while Perry explains the part that Della doesn't understand, or Della explains it to Paul, and Paul makes some lame joke and then the music starts? What about that part? Without that, *the*

whole thing is just nothing. I mean, it's like you play a gig and everybody just packs up their gear and goes home to eat TV dinners—like you're playing 'Tumbling Dice' and at the end you just quit, without repeating the hook, without cycling those chords for five minutes, screaming, *'Yah got-ta roll me!'* into the sweat-speckled microphone. It's just not rock-and-roll."

And it's not *Perry Mason* either, since guilt is not at issue here. We are *all* guilty. Innocence is the object of wonder, the grail of our endeavors. So the working family must be reunited and the validity of its endeavor confirmed. We must eat and drink together, then, and discuss the events of the day, however disastrous, in order to continue. And even though one loses touch with the purity of these sentiments and stops believing in the possibility of a happy workplace, one continues to watch—just as one's great aunt continues to go to Mass—communing with the form of reassurance, with the aesthetics of the ritual.

So, one revels in the gorgeous black and white, and in fugitive glimpses of lost, populuxe Los Angeles. One appreciates the alacrity with which the story wings its way through miles of complex exposition to arrive in the courtroom just at the half-hour mark. One smiles at the complex locutions required to do so—at how everyone says everyone's full name in order to keep the characters straight. ("Yes, I was at dinner on Thursday night with my wife, Marge Winterwater, and her cousin from Bolivia, Astrid Montalbo, but we did not see my comptroller, George Trim, until the next morning.") One embraces the absence of screaming, explosions, and automatic gunfire (the better to snooze through), and grudgingly acknowledges the verisimilar portrayal of genuinely heartless American assholes, which privileges our joy in their demise; and, finally, one comes to appreciate what a wonderful actor Raymond Burr was—to seduce us so effortlessly and for so long into the idea of genuine trust, and the possibility of innocence, and the dream of a job worth doing.

ROMANCING THE LOOKY-LOOS

It is a cloudy spring night in the mid nineteen seventies. Waylon Jennings and I are sitting in the shotgun seats at the front of his bus, slouched down with our heels up on the chrome rail, watching the oncoming highway between the toes of our boots. We are leaving Atlanta after a tumultuous concert, about two weeks into Waylon's breakout concert tour. I am along to write a piece for a magazine about Waylon's ongoing transformation into a pop star—although, at this point in the tour, Waylon himself is somewhat less than sanguine about his rising status. Not that he's doing anything to deter it. He's just not particularly enjoying it.

"They think you just get up there and sing your songs," he is saying, addressing the highway. "They think it's just a one-way deal, but it's not like that at all. Because you start out playing for people who are just like you. That's the only place you can. You play for people who come from where you come from. They seek you out in little clubs because they understand what you're doing, so you feel like you're doing it for them. And if you go wrong in these clubs, you know it immediately. And maybe you *want* to go wrong. That's your option, but you know it when you do it. Then one day, you're not playing for people like you anymore. You look out there, like I did tonight, and realize that you're playing for people who *want to be like you,* and you can't trust these people. Because to them, whatever you do, that's you, and that's cool. Which would be okay *except!*—even though all these people want to be like you, you don't know who you are anymore, because it was the people in those little clubs that gave you that understanding in the first place. God knows where *they* are tonight. Sitting at home, probably. Pissed off at me. Listening to Willie Nelson records."

"So what do you do?" I ask.

Waylon shrugs and grins. "Right now, hoss," he says, "it's

146

completely out of my hands. I'm looking at those people out there, but I don't know what I'm seeing. And they're watching me, too. But they don't know what they're looking at. My best guess is that they'll keep on loving me till they start hating me, or their Waylon duds wear out. Because they already hate me a little, just because I'm me and they're them. That's why they always go on about how *talented* you are. Because they hate you. Because if *they* had this talent, they would be you. The fact that you've worked like a dog, lived like a horse thief, and broke your mama's heart to do whatever you do, that don't mean diddly-squat. To them, it's *talent.* Supposedly, you got it, and, supposedly, they don't. So eventually you're bound to disappoint them.

"My real people, they get jealous because their girlfriend thinks I'm cute and try to kick my butt. They get envious because singing pays better than roofing and try to kick my butt. But, basically, they understand that I do this job for *them*—that I'm up on stage with my Telecaster, sweatin' in the lights, coughing in the smoke, and trying to hear the monitor—that they're sitting out there all cool and comfortable with a bottle of beer and a bowl of peanuts. So when this all blows up, I'll just go back and do that, find out if I'm still me."

A month or so later, I find myself standing at the bar in CBGB's on the Bowery with Lester Bangs and David Johansen. We're listening to Tuff Darts, who are playing their official "teen anthem":

> *What this world needs is a lot more girls!*
> *What this world needs is a lot less boys!*
> *What this world needs is a lot more NOISE!*
> *(Noise ensues.)*

When the noise subsides, Johansen tilts his head and nods theatrically toward the door. Lester and I turn to watch as a lim-

ousine load of uptown trendies file slowly into the back of the club, settling their coats on their shoulders and waving smoke away from their nostrils with frantic little gestures.

"Who dat?" Lester says.

"The beginning of the end," says David Jo, "Spectators."

My dad called them "looky-loos." He would come home from playing in some bar or listening to someone else play, and Mom would ask, "How was the crowd?" If those in attendance were not up to his standards, he would say "looky-loos." Or sometimes he would just mutter "civilians," which meant the same thing. We all knew what he meant: Civilians were nonparticipants, people who did not live the life—people with no real passion for what was going on. They were just looking. They paid their dollar at the door, but they contributed nothing to the occasion—afforded no confirmation or denial that you could work with or around or against.

With spectators, as Waylon put it, it's a one-way deal, and in the world I grew up in, the whole idea was not to be one of them, and to avoid, insofar as possible, being spectated by any of them, because it was demeaning. You just didn't do it, and you used the word "spectator" as a term of derision—not as bad as "folksinger," of course, but still a serious insult. Even so, it wasn't something we discussed or even thought about, since the possibility of any of us spectating or being spectated was fairly remote. It is, however, something worth thinking about today, since, with the professionalization of the art world, and the dissolution of the underground cultures that once fed into it, the distinction between spectators and participants is dissolving as well.

This distinction is critical to the practice of art in a democracy, however, because spectators invariably align themselves with authority. They have neither the time nor the inclination to make decisions. They just love the winning side—the side with the chic

building, the gaudy doctorates, and the star-studded cast. They seek out spectacles whose value is confirmed by the normative blessing of institutions and corporations. In these venues, they derive sanctioned pleasure or virtue from an accredited source, and this makes them feel secure, more a part of things. Participants, on the other hand, do not like this feeling. They lose interest at the moment of accreditation, always assuming there is something better out there, something brighter and more desirable, something more in tune with their own agendas. And they may be wrong, of course. The truth may indeed reside in the vision of full professors and corporate moguls, but true participants persist in not believing this. They continue looking.

Thus, while spectators must be lured, participants just appear, looking for that new thing—the thing they always wanted to see—or the old thing that might be seen anew—and having seen it, they seek to invest that thing with new value. They do this simply by *showing up;* they do it with their body language and casual conversation, with their written commentary, if they are so inclined, and their disposable income, if it falls to hand. Because participants, unlike spectators, do not covertly hate the things they desire. Participants want their views to prevail, so they lobby for the embodiment of what they lack.

The impact of these participatory investments is tangible across the whole range of cultural production. It is more demonstrable, however, in "live arts" like music, theater, and art than in industrial arts like publishing, film, and recording. Because in the "live arts," participatory investment, as it accumulates, increases the monetary value of the product. You increase the value of an artwork just by buying it, if you are a participant. Thus, you will probably pay more for the next work by that artist you buy. You do the same if you recruit all your friends to go listen to a band in a bar. If all your friends show up and have a good time, you will almost certainly pay more at the door the next time the band plays. But that's the idea: to increase the social value of the things

you love, and the extra bucks are a small price to pay. They are next to nothing, really, compared to the value of forming a new, eccentric community, or compared to the pleasure of having one's views prevail.

One of the things I feel best about in my life is the tiny part I played in convincing the Artist & Repertoire people at Warner Brothers Records to sign George Clinton and Parliament-Funkadelic to their label. I mean, all that fun and funk, borne upon the Mothership, zooming out across the republic—and even though I only contributed to the talk around the office, it makes me happy just to know that I participated. This sort of pleasure, however, is totally alien to the mind-set of spectatorship. The butterfly effects of cultural eccentricity are of no interest to spectators; they either consume, or they critique. They are all right with the way things are, or they know *exactly* what's wrong with it (incest wishes, capitalism, both, etcetera).

Beyond this hegemony of corporate and institutional consensus, however, beyond the purview of uncannily lifelike blockbusters like *Jurassic Park* and the Whitney Biennial, everything that grows in the domain of culture, that acquires constituencies and enters the realm of public esteem, does so through the accumulation of participatory investment by people who show up. No painting is ever sold nor essay written nor band booked nor exhibition scheduled that is not the consequence of previous social interaction, of gossip, body language, fashion dish, and telephone chatter—nothing transpires that does not float upon the ephemeral substrata of "word of mouth"—on the validation of *schmooze*. Everyone who participates knows this, and knows, as well, that it doesn't cost a dime. You just show up, behave as you wish, say what you will, and live with the fleeting, often unexpected consequences of your behavior. At this bedrock level, the process through which works of art are socialized looks less like a conspiracy than a slumber party.

The whole process, however, presumes the existence of artists

who are comfortable with this tiny, local, social activity, who are at ease with the gradual, lateral acquisition of constituencies and understand that the process can take place *anywhere* and, if successful, command attention everywhere. The musical vogue of Prince and his entourage, of The Allman Brothers Band and their compatriots, and of Seattle grunge testify to the efficacy of this process. It only requires artists who would rather socialize their work among their peers, horizontally, at the risk of Daddy's ire, than institutionalize it, vertically, in hopes of Daddy's largesse. These, I fear, are fewer and farther between.

To cite the case at hand: I was visiting a group of young artists in Los Angeles a couple of weeks ago. They were obviously bright, ambitious people who were doing interesting work. Unfortunately, they could hardly *speak*—could not even converse like human beings—for sputtering their anger and outrage at the "fucking *Los Angeles Times,*" which had refused to provide advance coverage for their forthcoming "totally bitching underground rave-performance event." And, silly *moi,* my first thought was "Why would you want it in the *Los Angles Times?*" In my vernacular, "underground" meant just that, and "rave-performance event" meant dope, nudity, and loud noises. Demanding publicity from the *Times* for such an event seemed about one step up from asking your mom to bring her friends from the garden club.

But I didn't say this. (Nor did I quote Waylon and suggest, "I don't think Hank done it this way.") I said, "Hey! It's a rave. It's supposed to be fun. Invite your friends and word will get around." They just looked at me, kept on looking, until one of them said, "But all of our friends are artists. We want real people." Thus I entered a brave new world, and all I could think was, "What have we *done?!*" Because there I was, face to face with a generation of well-educated and expensively trained young artists whose extended tenure in art schools appended to the art world had totally divorced them from any social reality beyond it. The friends they drank beer with after Sophomore Lit, the people they dated in

high school, the guys they played soccer with, were but fading memories, lost to them now out in the hazy world of bourgeois America. Now, they were artists, in the art world, and their art-world job was to make art. And my art-world job, they implied, was romancing the looky-loos on their behalf, now that the *Los Angeles Times* had screwed them over.

And maybe that is my job these days. Maybe it's just old fashioned of me to think that young artists should bring their own stuff with them into the art world, and bring their own friends, as well, simply because democratic institutions (even frivolous ones like the art world) respond to constituencies of people, not objects. That's why I still endorse Peter Schjeldahl's advice on how to become an artist: "You move to a city. You hang out in bars. You form a gang, turn it into a scene, and turn that into a movement." Then, I would suggest, when your movement hits the museum, abandon it. Your demure emblem now adorns the smooth state—resides in the domain of normative expression, its status greatly magnified and its rich social contextuality effectively sterilized. Whatever happy contingencies fluttered around it disperse, as it departs society and enters "the culture," where it must necessarily mean less, but to a lot more people. It's spectator-food, now, scholar-fodder, so you may safely stick a fork in it, tell yourself you've won, and go to your room.

In recent decades, however, changes in American institutional life have made this scenario exponentially more difficult to pursue. First, Richard Nixon's expansion of the National Endowment for the Arts in the nineteen seventies has, over the years, effectively transformed the institutional art world into a government-regulated industry dedicated to maintaining a strict consensus of virtue. Second, the extended adolescence imposed on art students by lengthy tenures in graduate schools has effectively isolated them from the peers among whom they might discover their true, new constituencies. Third, the massive consequences of *Frampton Comes Alive* in the record industry and *Star Wars* in

the movie industry have instituted a reign of consensus in the world of commercial entertainment, as well—a quest for a consensus of desire, dedicated to producing "blockbusters" that please everyone, every time.

So, young artists find themselves confronted with two smooth juggernauts, one dedicated to a regulated consensus of virtue, the other dedicated to a calculated consensus of desire, neither dedicated to the more elusive and redeeming consensus of virtue *and* desire. Nor is there any reason to suspect that this will change, beyond my wishing that it would—and what do I know? Maybe young artists *like* the art world the way it is. Maybe they are willing to undergo extensive indoctrination in order to adapt to it. And if they do adapt, well maybe the art world will truck in looky-loos for their performances. I don't think so, but it could happen. If it does, the idea of art as a social practice may be declared officially dead, along with the idea that the practice of art in a democracy, under optimal conditions, is a game played by voluntary participants within the textures of the larger world—a game without rules, coaches, referees, or, God help us, spectators.

Without that liberating ideal, we will be left with a ritualized cultural exchange in which artists and objects, selected by professionals, submit themselves to the vagaries of casual, public spectatorship in officially sanctioned venues. We will divide the world into "artists" who have been trained in special schools, "spectators" who will admire the consequences of this training, and salaried "support workers" who will select the product and deliver it to market. In the popular arts, these spectators will support the artist by buying a ticket, or a CD, or a paperback. In the "fine arts," spectators will buy tickets too, but the ticket will not be construed as support for the artist, but as support for "the arts," which is to say, as a contribution to the salaries of the support workers who facilitate our public spectatorship. With the suppression of wicked commerce, then, fine artists will be required to support themselves otherwise than by their work, and the prac-

tice will be restricted to those who can.

This world would be fine, too, and possible, if art were nothing more than the production of sanctioned professionals, but it *is* more—and less, as well. It is a mode of social discourse, a participatory republic, an accumulation of small, fragile, social occasions that provide the binding agent of fugitive communities. It is made in small places and flourishes in environments only slightly less intimate. So, even if your art ends up in a museum— even if your "underground rave-performance event" ends up in the *Los Angeles Times*—even if your band ends up playing coliseums—you may be assured that what is being glorified in public splendor is just the residue, a mere simulacrum from which disinterested spectators may infer the experience of participants. This is why those works of art that enter the public domain without participatory constituencies are instantly recognizable as pale impostors, as institutional furniture purporting to represent constituencies that have yet to materialize. Waylon put it best that night on the bus: "When I play a little club," he said, "I'm playing songs for people I know. Up there in the lights in front of a stadium crowd, I'm just playin' Waylon for strangers."

The Heresy of Zone Defense

It's in the third quarter. The fifth game of the 1980 NBA Finals. Lakers versus Seventy-Sixers. Maurice Cheeks is bringing the ball up the court for the Sixers. He snaps the rock off to Julius Erving, and Julius is driving to the basket from the right side of the lane against Kareem Abdul-Jabbar. Julius takes the ball in one hand and elevates, leaves the floor. Kareem goes up to block his path, arms above his head. Julius ducks, passes under Kareem's outside arm and then under the backboard. He looks like he's flying out of bounds. But no! Somehow, Erving turns his body in the air, reaches *back* under the backboard from behind, and lays the ball up into the basket from the *left* side!

When Erving makes this shot, I rise into the air and hang there for an instant, held aloft by sympathetic magic. When I return to earth, everybody in the room is screaming, "I gotta see the replay!" They replay it. And there it is again. Jesus, what an amazing play! Just the celestial athleticism of it is stunning, but the tenacity and purposefulness of it, the fluid stream of instantaneous micro-decisions that go into Erving's completing it . . . Well, it just breaks your heart. It's everything you want to do by way of finishing under pressure, beyond the point of no return, faced with adversity, and I am still amazed when I think of it.

In retrospect, however, I am less intrigued by the play itself than by the *joy* attendant upon Erving's making it, because it was well nigh universal. Everyone who cares about basketball knows this play, has seen it replayed a thousand times, and marveled at it. Everyone who writes about basketball has written about it. At the time, the crowd went completely berserk. Even Kareem, after the game, remarked that he would pay to see Doctor J make that play against someone else. Kareem's remark clouds the issue, however, because the play was as much his as it was Erving's, since it was Kareem's perfect defense that made

Erving's instantaneous, pluperfect response to it both necessary and possible—thus the joy, because everyone behaved perfectly, eloquently, with mutual respect, and something magic happened—thus the joy, at the triumph of civil society in an act that was clearly the product of talent and will accommodating itself to liberating rules.

Consider this for a moment: Julius Erving's play was at once *new* and *fair!* The rules, made by people who couldn't begin to imagine Erving's play, made it possible. If this doesn't intrigue you, it certainly intrigues me, because, to be blunt, I have always had a problem with "the rules," as much now as when I was younger. Thanks to an unruled and unruly childhood, however, I have never doubted the necessity of having them, even though they all go bad, and despite the fact that I have never been able to internalize them. To this day, I never stop at a stop sign without mentally patting myself on the back for my act of good citizenship, but I *do* stop (usually) because the alternative to living with rules—as I discovered when I finally learned some—is just hell. It is a life of perpetual terror, self-conscious wariness, and self-deluding ferocity, which is not just barbarity, but the condition of not knowing that you are a barbarian.

And this is never to know the lightness of joy—or even the possibility of it—because such joys as are attendant upon Julius Erving's play require civilizing rules that attenuate violence and defer death. They require rules that translate the pain of violent conflict into the pleasures of disputation—into the excitements of politics, the delights of rhetorical art, and competitive sport. Moreover, the maintenance of such joys requires that we recognize, as Thomas Jefferson did, that the liberating rule that civilized us yesterday will, almost inevitably, seek to *govern* us tomorrow, by suppressing both the pleasure and the disputation. In so doing, it becomes a form of violence itself.

An instance: I can remember being buoyed up, as a youth, by reading about Jackson Pollock in a magazine and seeing pho-

tographs of him painting. I was heartened by the stupid little rule through which Pollock civilized his violence. *It's okay to drip paint,* Jackson said. The magazine seemed to acquiesce: *Yeah, Jackson's right,* it seemed to say, grudgingly, *Dripping paint is now within the rules.* Discovering this, I was a little bit more free than I was before, and I know that it was a "boy thing," about privileging prowess at the edge of control and having the confidence to let things go all strange—and I know, as well, that, in my adolescent *Weltanschauung,* the fact that Jackson Pollock dripped paint somehow justified my not clearing the debris from the floor of my room (which usually, presciently, resembled a Rauschenberg combine). Even so, I had a right to be shocked a few years later when I enrolled in a university and discovered that Pollock's joyous permission had been translated into a prohibitive, institutional edict: *It's bad not to drip!* the art coaches said. *It means you got no soul!* Yikes!

Henceforth, it has always seemed to me that the trick of civilization lies in recognizing the moment when a rule ceases to liberate and begins to govern—and this brings us back to the glory of hoops. Because among all the arts of disputation our culture provides, basketball has been supreme in recognizing this moment of portending government and in deflecting it, by changing the rules when they threaten to make the game less beautiful and less visible, when the game stops liberating and begins to educate. And even though basketball is not a fine art—even though it is merely an armature upon which we project the image of our desire, while art purports to embody that image—the fact remains that every style change that basketball has undergone in this century has been motivated by a desire to make the game more joyful, various, and articulate, while nearly every style change in fine art has been, in some way, motivated by the opposite agenda. Thus basketball, which began this century as a pedagogical discipline, concludes it as a much beloved public spectacle, while fine art, which began this century as a much-beloved public spectacle, has ended

up where basketball began—in the YMCA or its equivalent—governed rather than liberated by its rules.

Basketball's fluidity and adaptability in this century has been considerably enhanced by the fact that it has no past to repudiate—by the fact that it was *invented,* and amazingly well-designed as a passionate, indoor game. It was less well-designed to serve its original purpose, which was to stave off a delinquency problem in Springfield, Massachusetts in the winter of 1891, where the "incorrigible" working-class youth who hung out at the Y were perceived as needing some form of socially redeeming "physical expression" during those months when football and baseball were unfeasible. Ideally, this diversion would involve some intense (i.e., exhausting) physical activity that would leave both the gymnasium and the young hoodlums physically intact.

James Naismith was enlisted in December of that year to design such a game. So he evolved some Guiding Principles. Combining the most democratic, least territorial aspects of rugby and lacrosse, he invented basketball—and succeeded well beyond his wildest dreams. Within three years, literally thousands of gymnasiums, in every corner of the nation, smelled like teen spirit. Not long thereafter, the YMCA newsletter *New Era* began running a series entitled "Is Basketball a Danger?" It posed the following questions: Was basketball getting too rough? Was it too exciting for America's youth? Did it incite unruly behavior in its fans and participants? Did kids neglect their studies to "play it all the time"? And was it, therefore, losing the pedagogical aura of gentlemanly American sport and becoming professionalized? The answer to all these questions, in 1894, was Yes.

Within four years of Naismith's inventing the game, basketball's ground rules were in place. By 1894, the size of the court and the five-player team were normalized. The backboard was added to discourage spectators from goaltending, and the rules defining

passing and dribbling were codified. And, amazingly, from that time until this, all subsequent legislative changes to the game have been made in the interest of aesthetics—to alter those rules that no longer liberate its players, that have begun to govern the game through tedium and inequity. And all of these changes probably would have come to pass more rapidly had Naismith codified his most profound insight into the game that he invented: *It does not require a coach.*

Naismith thought his game would teach itself, which it does, and that the players, trying to win, would teach one another, which they do. But coaches were a part of the gentlemanly, parental tradition of American sport, so basketball got coaches whether it needed them or not. But consider the potential consequences had Naismith acted on his original intuition: Without coaches, there would be no "education." And without education, there would be no basketball gyms at universities. And without basketball gyms, there would be no "basketball programs." And without basketball programs—designed to exploit the unpaid labor of impoverished city kids by lying to them and corrupting their adolescence, by teasing them with the false promise of an education and the faint hope of a pro career—basketball would still be a brave and beautiful game.

The long-standing reform coalition of players, fans, and professional owners would have doubtless seen to that, since these aesthetes have never aspired to anything else. They have never wanted anything but for their team to win beautifully, to score more points, to play faster, and to equalize the opportunity of taller and shorter players—to privilege improvisation, so that gifted athletes, who must play as a team to win (because the game is so well-designed), might express their unique talents in a visible way. Opposing this coalition of ebullient fops is the patriarchal cult of college-basketball coaches and their university employers, who have always wanted to slow the game down, to govern, to achieve continuity, to ensure security and maintain stability.

These academic bureaucrats want a "winning program" and plot to win programmatically, by fitting interchangeable players into preassigned "positions" within the "system." And if this entails compelling gifted athletes to guard little patches of hardwood in static zone defenses and to trot around on offense in repetitive, choreographed patterns until they and their fans slip off into narcoleptic coma, then so be it. That's the way Coach wants it. Fortunately, almost no one else does; and thus under pressure from the professional game, college basketball today is either an enormously profitable, high-speed moral *disgrace* or a stolid, cerebral celebration of the coach-as-auteur—which should tell us something about the wedding of art and education.

In professional basketball, however, art wins. Every major rule change in the past sixty years has been instituted to forestall either the Administrator's Solution *(Do nothing and hold on to your advantage)* or the Bureaucratic Imperative *(Guard your little piece of territory like a mad rat in a hole)*. The "ten-second rule" that requires a team to advance the ball aggressively, and the "shot-clock rule" that requires a team to shoot the ball within twenty-four seconds of gaining possession of it, have pretty much eliminated the option of holding the ball and doing nothing with it, since, at various points in the history of the game, this simulacrum of college administration has nearly destroyed it.

The "illegal-defense rule" which banned zone defenses, however, did more than save the game. It moved professional basketball into the fluid complexity of post-industrial culture—leaving the college game with its zoned parcels of real estate behind. Since zone defenses were first forbidden in 1946, the rules against them have undergone considerable refinement, but basically they now require that every defensive player on the court defend against another player on the court, anywhere on the court, all the time. All offensive players need not be guarded, of course, and two defensive players may double-team a single offensive player, but nobody can just defend a space. Initially, it was feared that this

legislated man-to-man defense would resolve competition in terms of "natural comparative advantage" (as an economist might call it), since if each player is matched with a player on the other team, the player with the most height, bulk, speed, or quickness would seem to have a permanent advantage. But you don't have to guard the same man all the time; you can switch, and this permission has created the beautiful "match-up game" in which both teams run patterns, picks, and switches in order to create advantageous situations for the offense or the defense—to generate the shifting interplay of man-made comparative advantage that characterizes most post-industrial commerce. And once you learn what to watch in this game (basically, everything), it is civilized complexity incarnate—quite literally made flesh.

This is not to say that basketball is a religion. It is *better* than a religion. It is a gift and a pure allegory. Whatever local moralities I wish to assign to it, I may, and so may you, as you and I gaze down through the lens of hoops into the old barbarity that the game has elevated into joy. In doing so, of course, we recognize that the rules that once elevated us into joy now govern us. Still, in the complexity of the game, there is the promise of solutions as daring as Doctor J's. And they are *personal* solutions, because my basketball is not your basketball, and you are not me.

Probably you are not even a freelance writer, so you can hardly be expected to understand my pleasure at finding a refined armature for the "deadline life" in a game—of finding a spectacular analog for the nonstop intensity of it, an embodiment of the breathless *push* of writing and thinking about everything all the time, perpetually shifting from defense to offense, from reacting to acting, with no time off—the experience of arising each morning certain that if you don't write today, you won't eat in eight weeks, that if you don't get a job today, you won't eat in sixteen weeks—and knowing, most urgently, that the shot clock is ticking down and, eventually, as the deadline approaches, you are going to have to drive the lane. You are going to have to take the

ball in one hand and leave the floor, with Kareem between you and the basket—knowing, finally, that there is no hope of your making *any* of those zillions of fluid, instantaneous decisions that you must make in the air, if you are not borne aloft, buoyed up, as you leave the floor, by a serene, tenacious, gravity-defying confidence that, in just a few seconds, you are going to duck, twist, extend, and *slam that sucker down!*

James Naismith's Guiding Principles of Basket-Ball, 1891
(Glossed by the author)

1 There must be a ball; it should be large.
(This in prescient expectation of Connie Hawkins and Julius Erving, whose hands would reinvent basketball as profoundly as Jimi Hendrix's hands reinvented rock-and-roll.)

2 There shall be no running with the ball.
(Thus mitigating the privileges of owning portable property. Extended ownership of the ball is a virtue in football. Possession of the ball in basketball is never ownership; it is always temporary and contingent upon your doing something with it.)

3 No man on either team shall be restricted from getting the ball at any time that it is in play.
(Thus eliminating the job specialization that exists in football, by whose rules only those players in "skill positions" may touch the ball. The rest just help. In basketball there are skills peculiar to each position, but everyone must run, jump, catch, shoot, pass, and defend.)

4 Both teams are to occupy the same area, yet there is to be no personal contact.
(Thus no rigorous territoriality, nor any rewards for violently invading your opponents' territory unless you score. The model for football is the drama of adjacent nations at war. The model for basketball is the polyglot choreography of urban sidewalks.)

5 The goal shall be horizontal and elevated.
(The most Jeffersonian principle of all: Labor must be matched by aspiration. To score, you must work your way down court, but you must also elevate! Ad astra.)

AIR GUITAR

Colleagues of mine will tell you that people despise critics because they fear our power. But I know better. People despise critics because people despise weakness, and criticism is the weakest thing you can do in writing. It is the written equivalent of air guitar—flurries of silent, sympathetic gestures with nothing at their heart but the memory of the music. It produces no knowledge, states no facts, and never stands alone. It neither saves the things we love (as we would wish them saved) nor ruins the things we hate. *Edinburgh Review* could not destroy John Keats, nor Diderot Boucher, nor Ruskin Whistler; and I like that about it. It's a loser's game, and everybody knows it. Even ordinary citizens, when they discover you're a critic, respond as they would to a mortuary cosmetician—vaguely repelled by what you do yet infinitely curious as to how you came to be doing it. So, when asked, I always confess that I am an art critic today because, as a very young person, I set out to become a writer—and did so with a profoundly defective idea of what writing does and what it entails.

Specifically, I embarked upon a career in writing blithely undismayed by the fact that, as a writer, I was primarily interested in that which writing obliterates: in the living atmosphere of all that is shown, seen, touched, felt, smelled, heard, spoken, or sung. I knew this was a peculiar obsession, of course, but I thought writers were supposed to be peculiar. I thought it was just a "problem," that it could be solved, and that, once solved, the enigmatic whoosh of ordinary experience would become my "great subject"—that I could then proceed to celebrate the ravishing complexity and sheer intellectual pleasure of simply being alive in the present moment forever after. I thought.

So I began by writing poems, quickly shifted to fiction, abandoned that for pharmaceutically assisted pastiche, and abandoned that for gonzo reportage—always trying to get out of the book,

trying to get closer to the moment, and always floating farther from it, slamming myself up against the fact that writing, even the best writing, invariably suppresses and displaces the greater and more intimate part of any experience that it seeks to express. Ultimately, I would be forced to admit that all the volumes of Proust were nothing, quantitatively, compared to the twenty-minute experience of eating breakfast on a spring morning at a Denny's in Mobile—and that the more authoritatively and extensively I sought to encode such an experience, the more profoundly it was obliterated from the immediacy of memory and transported into the imaginary realm of remembrance, invested with identity, shorn of utility, and polished up as an object of delectation.

I would begin, every time, trying to approximate some fragment of that enigmatic whoosh and end up, every time, inevitably, writing an edited, imaginary version of myself. Which is simply to say that my "great subject" was not a subject for writing at all. It was a *cure* for writing. The quotidian experience I was seeking to evoke in writing, as it turned out, was nothing other than a *solvent* for the identity I was imposing upon it by writing. That gauzy filigree of decentered awareness I was seeking to know in writing was the body's last defense against such codified self-knowledge. Like sex, which marks its final intensification, and art, which supplies its visceral hard copy, that whoosh was the quintessence of everything that is not writing.

So the choice (as it presented itself to me in the intellectual jargon of the late nineteen sixties) was either to stop writing or divest my writing, somehow, of its presumed autonomy, of its implicit aspiration to timeless authority. The option of not writing never seriously presented itself. It was my living and a good kind of life. Also, by this time I understood that the burden of living as a citizen in a massive civil society included the responsibility of wrangling for one's pleasures, lest they dissolve into the smooth surface of rational administration. And writing could

do that: It could wrangle, if somehow, as a writer, one could shed the ludicrous, God-like mantle of *auteur* while retaining one's sotto voce as a private citizen.

By this route, then, I fell upon the option of writing with as much strength as I could muster in a weak genre—a contingent discourse, if you will—by narrating my experience of objects that were likely to *survive* being written about, and that, by surviving, might redeem or repudiate what I had written by replenishing all those challenges to knowledge and self-knowledge that are shorn away in the historical act of composition. I would write about works of art, then, about pieces of architecture and recorded music—objects that would continue to maintain themselves in the living present subsequent to my transporting them out of it.

In this way, I might stop destroying that which I wished to celebrate and cease celebrating myself in ways I had no wish to— for even though my writing about art might momentarily intervene between some object and its beholders, the words would wash away, and the writing, if it was written successfully into its historical instant, could never actually *replace* the work or banish it into the realm of knowledge. If the work survived, the writing would simply bob after it, like a dinghy in the wake of a yacht. If the work sank from sight? Well, too bad. The writing could disappear after it into the bubbles.

Art criticism, then, presented itself as a compromise between my "great subject" and the impossibility of writing about it; and, even though times have changed, even though I set out to become a writer in a weak genre—a critic in an age of art—and have survived to labor as a critic in an arid age of criticism, I still believe that the primary virtue and usefulness of criticism resides precisely in its limitations, in the fact that the critic's fragile linguistic tryst with the visible object is always momentary, ephemeral, and local to its context. The experience blooms up in the valley of its saying, to borrow W. H. Auden's phrase, but it does

not survive that moment.

I see the object. I translate that seeing into vision. I encode that vision into language, and append whatever speculations and special pleadings I deem appropriate to the occasion. At this point, whatever I have written departs. It enters the historical past, perpetually absent from the present, and only represented there in type, while the visible artifact remains in the present moment—positively *there*, visually available for the length of its existence regardless of its antiquity, perpetually re-created by the novelty of its experiential context. As a consequence, what I write and what I have written about diverge from the moment of their confluence and never meet again.

The writing gets older with each passing moment while the artifact gets newer. There are works of art on the wall of my apartment, for instance, that I have written about in the past. They remain as fresh and devious as the first day I set eyes upon them, invariably evoking the sense memory of that first bright encounter—while the *words* I wrote on that occasion, informed by that brightness, have yellowed into antiquity and seem to me now as weathered and grotesque as Dorian's portrait tucked away in the attic. Thus, in the same sense that there is only historical writing, there is *no* historical art beyond those imaginary works that critics describe in writing. For even though a visible artifact must necessarily predate the language that describes it, the artifact itself, as we stand before it, is always *newer* and *more extensive* than any word ever written about it—newer and more extensive, even, than the visual codes incorporated into it, because whether we like it or not, we always confront works of art as part of that selfless, otherless, unwritable instant of ordinary experience.

In the process of writing about works of art, then, we make the same sort of Draconian decisions that we do when writing about nonart experience. We write about what can be written about. We decipher that which lends itself to cipher and discard the rest as surplus. Unlike the lost surplus of nonart experience,

however, the surplus we ignore in works of art survives, remains available to be invested with meaning by subsequent viewers under different circumstances. But a problem remains, which is that the aspects of visible artifacts that are most effectively translated into writing usually have little or nothing to do with the *occasion* for writing about them, which, in my case, invariably resides in the pleasurable, confusing, or horrific nature of the experience itself—an experience in which there is neither surplus nor cipher. "In the landscape of spring," the koan reminds us, "the branches are neither long nor short." They are simply present, precedent to the standards and expectations we impose upon them as we name their attributes, pronouncing them long or short, strong or weak, young or old.

In the act of writing about art, then, you press language to the point of fracture and try to do what writing cannot do: account for the experience. Otherwise, you elide the essential mystery, which is the reason for writing anything at all. The easy alternative is just to circumnavigate the occasion of seeing something— to "professionalize" art criticism into a branch of academic art history—to presume that works of art are already utterances in art-language that need only be translated into a *better* language to achieve perfect transparency. In this way, the practice of criticism is transformed into a kind of Protestant civil service dedicated to translating art-language into a word-language that neutralizes its power in the interest of public order. The writer's pathological need to control and reconstitute the fluid universe of not-writing is fortuitously disguised by this stratagem—since in a truly "professional" discourse, no more intimate engagement with the "needy" object is required than that of a doctor with a patient, and no more stress need be placed upon the language than that required by the clinical assignment of names to symptoms.

Thus, the hypocrisy of the "disengaged critic" writing about art is closely analogous to that of the "disengaged psychoanalyst" writing about sex: Any acknowledgment of the ordinary pleasures

attendant upon the event itself is rigorously suppressed (as professional impropriety) and, along with it, any recognition of the multitudinous challenges to self-knowledge that are attendant upon those pleasures. Professionals will tell you in conversation (not in writing) that these subversive pleasures are simply "understood." But that just begs the question, the line between "pleasure understood" and "pleasure denied" having become increasingly fine as the therapeutic option of telling us things "for our own good" falls ever more readily to hand.

The justification for this pretense to disengagement derives from our Victorian habit of marginalizing the experience of art, of treating it as if it were somehow "special"—and, lately, as if it were somehow curable. This is a preposterous assumption to make in a culture that is irrevocably saturated with pictures and music, in which every elevator serves as a combination picture gallery and concert hall. The question of whether we can enjoy, or even decipher, the world we see without the experience of images, or the world we hear without the experience of music, seems to me pretty much a no-brainer. In fact, I cannot imagine a reason for categorizing any part of our involuntary, ordinary experience as "unaesthetic," or for imagining that this quotidian aesthetic experience occludes any "real" or "natural" relationship between ourselves and the world that surrounds us. All we do by ignoring the live effects of art is suppress the fact that these experiences, in one way or another, inform our every waking hour.

In my own case, I can still remember gazing at the lovely, lifting curve of a page upon which Oscar Wilde's argument that "life imitates art" was inscribed and knowing that this was the first "big truth" I had come across in writing. I can remember, as well, standing on the corner of 52nd Street and Third Avenue on a spring afternoon, six feet from a large citizen gouging the pavement with a jackhammer, and thinking about the Ramones, amazed at the preconscious acuity with which I had translated the pneumatic slap of the hammer into eighth-notes and wondering

what part, if any, of the pleasures and dangers of the ordinary world might rightly be considered "natural." So it seems to me that, living as we do in the midst of so much ordered light and noise, we must unavoidably internalize certain expectations about their optimal patternings—and that these expectations must be perpetually and involuntarily satisfied, frustrated, and subtly altered every day, all day long, in the midst of things, regardless of what those patterns of light and noise might otherwise signify. Thus, in the light of what I perceive to be the almost total absence of "unaesthetic" experience in ordinary life, the necessity of art criticism addressing our ordinary experience of art, from whence these expectations flow, seems all the more urgent.

The joys and perils of our internalized formal expectations are not going to go away, no matter how we excoriate them at their source. As a consequence, to paraphrase Adam Phillips, the language of pleasure and the language of justice are inextricably intertwined. I like to think that this is what Thomas Jefferson had in mind when he reconstituted that French trinity of *liberté, égalité, fraternité* as "life, liberty, and the pursuit of happiness," privileging our quest for quotidian equanimity and implicitly freeing us from the bonds of tribal brotherhood so we might perform the more cosmopolitan tasks of equal citizenship. Certainly, this intertwining of pleasure and justice is what Emerson had in mind when he insisted that all constructions of public virtue must be tested on the anvil of private happiness.

In any case, the question of who decides what we can or cannot enjoy, and how we may enjoy it, joins art criticism ineluctably to the realm of politics, where the battle between our professed standards, our cultural expectations, and our ordinary private desires is fought—and *must* be fought because, even though there is no persuasive evidence that human character has changed in the last millennium, there is ample evidence that the way we see, and the things at which we look, have changed considerably—and that these alterations in what we see and how we look at

things have had some behavioral consequences that can only be considered redemptive. Moreover, as intriguing as it is to speculate on the intentions that have created these landscape-changing images, evidence further suggests that these changes derive less from the authority of artists and institutions than from the novel and often inappropriate uses to which existing images have been put—from new accommodations of pleasure and justice arising from the willful contingencies of perception and interpretation at work upon ordered visual information.

In "The Anxiety of Influence," Harold Bloom argues that artistic practice changes because younger artists must willfully misinterpret the work of their masters. I would suggest that we all must do so—that we are always looking for what we want. If we find it in an image, it's there, at least for the purposes of argument. Caravaggio was hired to celebrate and lend credibility to the problematic lives of the saints. To do this, he fell upon the novel device of portraying ordinary people, naturalistically, as characters in his imaginary narratives. The historic consequence of Caravaggio's device, however, had nothing to do with the lives of the saints and everything to do with the way we privilege and attend to the visage of ordinary humanity. Caravaggio and his masters would have wished it otherwise, but they were outvoted. That's that.

Police mentalities will always strive to impose correct readings, to align intentions with outcomes, and couple imaginary causes with putative effects, but *we always have a choice.* In a poorly regulated, cosmopolitan society like our own, the discourse surrounding cultural objects is at once freely contingent and counter-entropic. It neither hardens into dogma nor decays into chaos as it disperses. It creates new images and makes new images out of old ones, with new constituencies around them. It is a discourse of experiential consequences, not disembodied causes. Thus, the sheer magnitude of social experience and organizational energy generated in the wake of a single painting by

Velázquez so far outweighs and overrides the effort and intention that went into its creation as to make nature pale and angels weep. As a critic, I generate tiny bursts of this new organizational energy in hopes of generating more. 'Tis a small thing, but mine own.

Lost Boys

This was 1960. They were working as stewards on the *Bremen* as it ploughed its way back and forth across the North Atlantic between Bremerhaven and New York. The blond one, who was a farm boy from Bavaria, had a night gig doing magic tricks for passengers in the lounge. He pulled rabbits out of hats, did card tricks, ate razor blades—the usual. The dark one just sulked. The ship owners had forced him to abandon his pet cheetah at the dock, to leave it behind with friends in the Fatherland, and for most of their first crossing, he brooded darkly on the injustice of it all. (He was the fourth son of a staid banking family, a certified black sheep, and a bit of a brat, as well.)

Then, one afternoon, while the two friends huddled in the rain on the afterdeck of the *Bremen,* watching the wake disappear into the green mist, the dark one asked his Bavarian friend if it were possible to do magic with a cheetah. His friend replied rather solemnly that, in magic, anything was possible. When he was a child, he said, he had learned magic tricks from a little paper pamphlet he purchased at the candy store in their village. When he performed these tricks at home, in the kitchen of their farmhouse, they had elicited smiles from his father. If magic could do this, he explained, magic could do anything. So, on their next crossing, the dark one, Roy, had his cheetah, and the blond one, Siegfried, had a partner in his magic act.

In the beginning, they divided responsibilities they later would share. Siegfried would manage the illusions, and Roy would manage the cats. Between them, they had it knocked. The spectacle of social appearances and the domain of wild nature were theirs to command—theirs to manipulate as they wished, out on the high seas, like pirates, cut free from the past and everything it signified. "I can tell you this," Siegfried says today, "when I disappear from the lounge of that ship in the middle of the ocean, and reap-

pear as a cheetah, this is better than pulling rabbits out of a hat.
Yes! Me and Roy, we are on our way. It is better than anything."

The most recent product of their partnership is even better
than that. *Siegfried and Roy at the Mirage* is the hottest ticket in
Las Vegas and as good as it gets (whatever "it" might be). Created
by the two illusionists in collaboration with production designer
John Napier *(Cats, Starlight Express)* and writer-director John
Caird of the Royal Shakespeare Company, the show is at once a
seamless spectacle and a plausible, subversive conflation of
Wagner, Barnum, Houdini, Rousseau, Pink Floyd, *Fantasia, Peter
Pan,* and *A Midsummer Night's Dream.* This may sound strange,
but it would make perfect sense, if you had spoken with the artists,
as I did for a pop magazine, at their white-walled compound in
West Las Vegas, amidst their collection of lions and leopards,
white tigers and black panthers. Art and life? *Quelle différence?*

We sat at a long designer table with a thick glass top, just
off a shadowy, cavernous grand salon scattered with oriental rugs,
filled with leather furniture, and hung with paintings of wild ani-
mals (some of them splendid, original products of the Victorian
Renaissance, others fucking awful). We sat beside a long window-
wall that looked out on the interior of their Mission-Moroccan
compound. There, in dappled sunlight, snow-white tigers drifted
like smoke across the perfect green lawn, cruising among white
plaster effigies of themselves beneath swooping coconut palms,
which were themselves echoed, here and there, by swooping,
white aluminum versions of *themselves,* whited-out palms, like
tropical ghosts. The backdrop for this scene was a long, white,
tiger grotto full of bright, blue water with two fountains bubbling
and a substantial waterfall that was controlled by a rheostat,
located on the wall. ("Watch!" Roy says, as he turns the dial, "I
stop the flood!")

The "boys"—as everybody in Las Vegas calls them, although
they are now in their early fifties—exude the same elusive blend
of fact and fiction. Siegfried, the blonde one, is the more diffi-

dent, the steady one. In postwar Hollywood, his air of ironic, dam-
aged innocence would have gotten him cast as a sympathetic U-
boat commander. Roy, on the other hand, with his Eurasian
cheekbones and fop-rock hairdo, is more exotic—the glamour
puss of the team—a perpetual font of effervescent Germano-
Vegas hyperbole. They are "showbiz" to their toes, but I couldn't
help liking them, nor avoid feeling about them (as Fred Allen did
about Hollywood) that beneath all that phony tinsel, there is
real tinsel.

They were so quirky, so passionate and articulate about their
artistic intentions that it soon became clear that their new show
was, in their eyes at least, something more than a commercial fab-
rication—and clear, as well, that for all their phony, glamour-
mongering showmanship, Siegfried, at least (as would befit a
wizard named Siegfried), had given considerable thought to what
this phoniness, this glamour, and that showmanship might sig-
nify. "In this show," he told me seriously, confidentially, leaning
forward with his elbows on his knees, "we have changed the frame
around this dream, tried to put more in it, so now we hope peo-
ple see not just the tricks, but what it means . . . to us, of course,
to Roy and me, but also to them." The question of what this
magic means, however, is hard to talk about without talking first
about whatever the hell Las Vegas might mean, because, for
twenty-five years, Siegfried and Roy have been its official, rococo
"outsider artists"—its crazy children—as much a part of its
Zeitgeist as the neon and the crap tables.

So try to think of Vegas this way: as America's Saturnalia, as
the nonstop, year-round, 24-hour, American equivalent of that
ancient Roman festival during which slaves took the roles of mas-
ters, only better and more glorious than that, since American
slaves are less deeply afflicted by puritan values than their cur-
rent masters—so American slaves in the role of Mediterranean
masters, perhaps. Or just think of it as our province of stupid
dreams, but stupid dreams that tell true stories. Because desire (as

Ferenczi was always reminding Freud) is a way of telling the truth, not knowing it—and Vegas tells the truth in ways that violate the canons and conventions of our culture's high and low with equal impunity.

Siegfried and Roy at the Mirage, Splash, Kenny Kerr's *Boylesque* and *Nudes on Ice* are all as alien to *The Jeffersons* as they are to Jasper Johns—at once brighter and darker, cleaner and cooler, dirtier and more dangerous than either. Because, if high culture appeals to us as "extraordinary individuals," and low culture appeals to us as "average citizens," Vegas appeals to us as "common criminals"— as slaves in the role of masters—offering us respite from both the average and the extraordinary. In Las Vegas, we are all small-time troublemakers, closet wiseguys, delighted to let cabin boys, in the role of sorcerers, theatricalize our gaudy, subterranean "otherness" by regaling us with pleasures that are less requited, less sincere, and less hypocritical than those available in the culture at large—pleasures more redemptive of our protean, unbelieving, secret selves.

As a consequence, I never sit down to write something "serious" about The Strip without feeling, vaguely, like a Brazilian developer standing at the edge of a rain forest, flicking his Bic. Because there is something worth saving here, something critical to the eco-systems of the republic. Because people revel here who suffer at home—are free here who would otherwise languish in bondage. Bean-counters bet their kids' education on a roll of the dice. Kindergarten teachers gaze steely-eyed over the top of their cards, call your raise, and raise again. This is their secret place. From their hotel window, it stretches out into the night like a neon garden, supine in its worldly innocence, the pure virus of American culture denatured, literally, in the petri dish of the desert—virgin territory. Here, in the heart of the drift, is the last refuge of unsanctioned risk and spectacle—the wellspring of our indigenous visual culture—the confluence of all the hustle and the muscle—and I am going to gentrify its loveliest product with

commentary (our favorite way of lying to ourselves), because that is what I do to afford living here. Las Vegans understand that kind of compromise. Contingency is all.

To proceed with my task, then, I should begin by noting that *Siegfried and Roy at the Mirage* is better than it has to be, by a wide margin. It does the heart's work, changes our perception of everything like it, and bears a subversive subtext that is as transparent or opaque as you wish it to be. The show itself, in its increments, is a 144-minute series of technical effects, metamorphic illusions, atmospheric tableaux, and musical production numbers with a chorus of about thirty. It moves with the logic of a large-venue rock concert from confrontation to complicity to community, establishing its authority with a thunderous operatic opening, then relaxing into a more intimate and participatory atmosphere, then rising again through a sequence of benign but increasingly extravagant effects that elevate both the act and the audience toward a sense of resolution.

The spectacle opens on a fog-shrouded Wagnerian battlefield, shot through with lights and lasers. Here, for the first forty minutes of the show (its longest uninterrupted sequence), the two illusionists do battle with a squad of Druidic priests, their biomorphic minions, and a splendid mechanical dragon. The metaphor is one of conflict, and the illusions are those of peril and rescue. Siegfried is fed to the dragon and emerges unscathed; Roy is impaled by the dragon and resurrected by Siegfried; both Siegfried and Roy are apparently crushed in the dragon's claws only to reappear, swinging triumphantly out over the audience on ropes, à la Peter Pan. These are all rituals of friendship, and during one telling sequence, they take on more complex overtones, as Siegfried transforms a voluptuous, six-foot Valkyrie into Roy, then transforms Roy into an eagle, and then, soon afterwards, transforms himself into Roy. At this point, anyone used to

reading theatrical metaphors is going to start suspecting there is an agenda in place.

Following this long confrontational opening sequence, the focus narrows and the lights brighten. The two illusionists dispense with mythic reality for a sequence of straight "magic tricks" with the requisite Chinese boxes, swords, saws, and showgirls in bondage—a "golden oldies" shtick borrowed from rock-and-roll. The sense of sexual mania built into this traditional repertoire, however, is subverted by the camped-up tempo at which these illusions are performed.

Having shifted from mythic wizards to traditional magicians, Siegfried and Roy then further reify themselves as regular guys, stepping out of their roles to converse with the audience. They invite a spectator onto the stage, introduce their animals, and even show some home movies of Roy cavorting with a white tiger in the blue-water grotto. This informal interlude is the magician's equivalent of the acoustic segment in a rock concert. It's also the corniest part of the show, but intentionally so, I suspect, since some bond of intimacy needs to be established with the audience in order to carry it along through an increasingly redemptive sequence of illusions toward the Arcadian conclusion of the show.

These final illusions speak the language of resurrection, reconciliation, and ascent. An elephant rises from the floor of the stage on a circular platform apparently supported by several members of the chorus. A drape is flung over the elephant. It collapses. The elephant has vanished, and the chorus immediately breaks into fervent song—a gospel entreaty to "Oooh, bring him back. Bring the elephant back!" There is another flash, and their prayer is answered. The elephant has reappeared to much rejoicing, and here, as elsewhere in the show, the actual effect of vanishing and reforming an elephant is subordinated to the dramatic subtext of death and resurrection that underpins the kind of illusion it is.

The same holds true in the penultimate scene of the show. Here, death and resurrection are upstaged by ascension. A spin-

ning mirror ball, bombarded by lasers, floats down to hover about a foot off the floor. A snow-white tiger leaps out of it, then leaps back up and crouches on top of the ball. Roy then leaps onto the tiger and all three—man, tiger, and ball—go floating off, up into the laser-dazzled darkness while Michael Jackson sings the "Siegfried and Roy Theme." It's a magnificently goofy image— man astride the ghostly animal atop the spangled globe—somewhere between William Blake and *The Little Prince.* It provides the overture to the final tableau: Siegfried and Roy triumphant in a metallic-blue landscape populated with snow-white tigers. Home at last.

This completes the rhetorical dynamic of the show, its movement from confrontation to invitation to apotheosis. The actual, thematic content of the illusions themselves, however, is a little trickier and not quite so conventional, so I was casting about for some genre equivalent. I finally found it in Nina Auerbach's analysis of Victorian pantomime, whose metamorphic abundance, she argues, constitutes "the seductive essence of Victorian theatricality." In her book *Private Theatricals,* Auerbach discusses the growing disfavor into which these pantomimes fell in the late nineteenth century, attributing this disfavor to the burgeoning Victorian ideal of "sincerity"—to the ongoing dialectic between "sincerity" and "theatricality" in that period. Rather brilliantly, I think, Auerbach pegs this dialectic as a false one, pointing out that "sincerity" itself is a theatrical trope—"simple honesty" made brazenly and earnestly public.

The real issue in this debate, Auerbach suggests, was not the opposition of "sincerity" and "theatricality" but the opposition of the theatrically *autonomous* self (the "sincere" self) and the theatrically *protean* self (the "metamorphic" self) that is intrinsic to pantomime. Auerbach argues that these pantomimes challenged Victorian proprieties by creating "a world where gender was malleable, where history mutated with no transition into myth, where human pageants gave way to a fantasy of animals . . . [where]

dreams of bliss were indistinguishable from the horror of nightmares." And this, of course, is exactly the imaginative reality of *Siegfried and Roy at the Mirage*—an extended pantomime with music, during which the barriers that distinguish identity, gender, and species dissolve at a gesture.

It is hardly surprising, then, that the dynamics of *Siegfried and Roy at the Mirage* would evoke other late Victorian celebrations of metamorphic theatricality: works like *Peter Pan, Alice in Wonderland* and *The Jungle Book*—and earlier predecessors like *The Tempest* and *A Midsummer Night's Dream.* Further, in much the same manner as their precursors, Siegfried and Roy have deployed the interchangeable polarities of Auerbach's description (the "dreams of bliss" and the "horror of nightmares") at the endpoints of their spectacle, so the narrative flows from the nightmare of Armageddon to the dream of a Peaceable Kingdom. The content of every illusion, however, tells us that these transformations *go both ways:* Ends and beginnings are interchangeable in a protean universe.

Very little of the show's content would change, in fact, if the spectacle were played backwards. Only the rhetorical effect, the meta-statement, would change, and this change would almost certainly gentrify the entire affair. That is, if the show began with the Peaceable Kingdom and ended with Armageddon, with no other changes, the whole production would find itself perfectly in tune with our continuing German-Victorian preference for narratives of tragedy and historical fate over narratives of comedy and redemption. (We continue to privilege these narratives, I suspect, because their valorization of "tragedy" and their capitulation to "history" tends to justify our not doing much beyond "analyzing" these ineluctable forces.) In any case, by playing their show backwards, Siegfried and Roy could book it into the Brooklyn Academy of Music—where its subtexts would be no less subversive.

Siegfried and Roy at the Mirage, however, is best appreciated

in its innocence, the way it is and where it is—as the brightest facet of the American Saturnalia. Because, just as the Roman Saturnalia was an Imperial acknowledgment of Rome's Republican past, the Saturnalia of Vegas and the redemptive rituals of Siegfried and Roy recall a less class-ridden sense of American possibilities. In its own context, and on its own terms, *Siegfried and Roy at the Mirage* demonstrates the way cultural entertainment may redeem itself without the gentrification of context or the arbitration of elite standards. It presents us with one of those rare occasions when the frenetic ingratiation of the audience (that more or less defines "pure" entertainment) issues a sublime permission, encouraging us to embrace our own theatricality, instability, insincerity, and excess. In doing so, "the boys" transform the business of being entertained into a ritual of possibilities—a celebration of the perpetually reconstituted self. In a more innocent way, they ask Dorian Gray's question, "Is insincerity such a terrible thing?" And they give us Dorian's answer, "I think not. It is merely a method by which we multiply our personalities."

THIS MORTAL MAGIC

It's not so much what we do, or even what happens, it's the way things overlap and intersect: I was sitting at the desk in my office, in my apartment in Las Vegas, reading John Shearman's observations on the historical circumstances of Renaissance portraiture. Shearman had begun by positioning these portraits within the lives of their sitters, sketching in their lives before and after the paintings were made. Now he was suggesting, on this evidence, that the technical obsession with capturing the palpable vivacity of the sitter in Renaissance portraiture was very likely due to the fragility of life in that period, to the poverty of communications in Italy, and to the mobility of the class of people who had their portraits made—arguing that the portrait, where it hung, functioned less as a picture or a document than as an icon of the sitter's actual presence in the space from which she or he was absent due to death or duty. Thus the passionate vivacity of these pictures. The sitter was supposed to be there.

Reading about these short, perilous Renaissance lives on a quiet, desert morning in the late twentieth century must have sharpened my awareness of time whooshing by, because I suddenly remembered that I had to make a telephone call. Closing Shearman's book, I pulled over my Rolodex and flipped it open immediately, accidentally, to the late Scott Burton's card. I wasn't surprised to find it, since I stopped clearing dead people out of my Rolodex years ago. Throwing those little cards away into the trash is a very depressing chore—and leaving them there, with their disconnected numbers intact and their abandoned addresses appended, is a way of remembering, of being reminded in the midst of life. On this occasion, seeing Scott's name there, on the little white tombstone of his file card, in the midst of reading about mortality and Renaissance portraits, made me think of how nice it would be to go somewhere and see a full-blown, luminous sixteenth-century portrait of the artist in his glory.

I could have pulled an exhibition catalogue off the shelf and

looked at a photograph, of course, but photographs are nailed in the moment of their making, and when the subject is dead, this distance from the present only reminds you of that. I would have preferred an image that reminded me, persuasively, physically, that Scott had once been alive, that we had told some jokes, had some laughs—something that caught the little tremor that flickered around Scott's upper lip, always threatening to burst into a smile or a sneer, you never knew which. That's what painting used to do—what only painting can do—and does no longer, and this seemed a pity, since regardless of fashions in image-making, we continue to die at an alarming rate.

When I was a kid and stupid about art, I used to love Cézanne because he made me feel smart. Everything that I had been taught about modern art by modernist professors, I could find in his paintings: the declaration of the paint, the plastic language of the mark, the taut picture plane, the objecthood of the image, the inference of primary structures made manifest by the substitution of haptic information for pictorial data, the vertiginous tension between the depth implied by the image and the lateral dance of flat chromatics across the surface of the paint, and all the rest of it. And above all, I discovered in these formal attributes clear evidence of those American virtues my professors had appended to this Frenchman's practice. At one glance, I could see the strength and the honesty, the modesty and the simplicity. They seemed as evident to me in Cézanne's pictures as those qualities seemed admirable to me in the world.

Not long thereafter, I began to outgrow this manly modernism. Gradually, what had once seemed strong to me in Cézanne's pictures began to seem obdurate. The bluntness that I had reflexively attributed to his honesty began to seem stubbornly provincial. Where I had once inferred taciturn modesty in the work, I now saw willful, tight-fisted passive aggression—and then one day I could no longer remember why simplicity was a virtue,

nor why paint was so important. Apparently, I had grown up (if only a little) and so, in order to keep Cézanne and dispense with homely heroism, I rigged up a camp aesthetic that dumbed-down the pictures, that invested their misanthropic false naïveté with a kind of hip innocence—a rhetoric of studied clunkiness and sophisticated duh.

But Cézanne is not a painter who will stay stupid for long, and one afternoon in the National Gallery, after lingering with the swift and naughty Fragonards, I stopped in front of a Cézanne and it began teaching me. "Now, notice the dynamic of picture and painting, of image and paint. And don't be insensitive to the device that redeems the bottom-weighting of the image. And don't forget," (finger wagging) "here's the picture plane. Right here! Notice how I insist upon its flatness, how I insist upon its paintedness. I'm not trying to trick you like that libertine Frago, I'm going to show you how to see a *painting*. For your own good."

Since I was by this time an advanced student, I was expected to respond. I was supposed to say, "Yes, I see, and I am stunned by the mastery of that yellow mark. It is so strong, so casually laid into the background of the image, and yet it advances so strenuously that it asserts, at once, the hillside foliage of the French countryside, the irrevocable flatness of the painting, and the compositional power of its upper right-hand quadrant—and the light, of course! I could go on about the light . . ." After all this, hopefully, the picture might approve of my looking at it; and I realized then that, when I was a kid, Cézanne's pictures had made me feel smart by presuming, correctly, that I was stupid. They had treated me like a child who was ignorant of picture-making and its decorum.

Now that I was an adult, they continued to do so, although I no longer much cared. At this point, I was struck, for the first time, by the strangeness of the endeavor. I had always just taken it for granted that viewers were supposed to be concerned with such trivia, but when you thought about it, why would modernist

painters expend so much time and energy trying to educate a jus-
tifiably ignorant public in the specialized business of making pic-
tures with paint? And why would any member of the public care
to know, since, even at their most ingenious, these procedures are
only marginally interesting to the nonpractitioner? I didn't know,
but clearly, once modernists embarked upon this pedagogical mis-
sion, there was no length to which they would not carry it in order
to maintain their professorial status. Ultimately, they would per-
petuate the public's education in painterly practice for nearly a hun-
dred years, obsessively postponing our graduation by coming up
with ever more ordinary truths about painting upon which we
might be lectured (It's a rectangle! Wow! But it doesn't *have* to be a
rectangle! Yikes!), thus infinitely deferring the public's accredita-
tion as cultural equals. So these veridical lessons, being nothing if
not teachable, got taught and were learned, although having
learned them, one was left with little else to do but to teach others,
equally deluded, that the pleasures of art depend upon our appre-
ciation of its most paralyzingly obvious attributes and limitations.

So, I wanted to have a chat with Cézanne, as I stood before
his painting in the National Gallery. "Paul," I wanted to say,
"about this picture plane thing . . . uh . . . I *know* it's there, and I
know that you know it's there. So, couldn't we both just sorta
agree that it's there and fucking get on with it?" But then I
thought, Get on with what? Certainly nothing in the realm of
Frago's idea of getting on with it, since once you look at a Cézanne,
it has done what it does. It has slammed the door on the lived past
in the name of painting's tradition—has provided us with allu-
sions to Puvis de Chavannes, David, and Poussin in lieu of living
memory. In short, by pushing the picture plane forward and
insisting on its own materiality, Cézanne destroys the three-hun-
dred-year-old syntactical tense structure of painterly practice, sup-
pressing the inference of the past (or remoteness from the factual
present) that is intrinsic to the illusionistic image, insisting on the
priority of the present object over the past image.

Beyond that fiat, with Cézanne, lie the subtle pleasures of connoisseurship, which needless to say are substantial, but ultimately, this primary flatness is a great deal more than "a formal issue." It is always an argument for the importance of the visible, veridical present over the lost past, or the problematic vision, or the hitherto invisible objects that constitute the subject matter of pictorial illusion. In fact, if anyone who has thought about it for a moment can seriously suggest that anyone in the history of modern culture has ever suspected the picture plane of any picture, however expertly rendered, to be any place other than where it is, they have a better imagination than I do.

My point here is that pictorial illusion only has power *as* illusion. It is only interesting as an excerpted, ideological re-creation of what is lost, past, or only imaginable. Modeling and perspectival rendering do for an image what tense structure and negative constructions do for an utterance: They reconstitute the painting as extended discourse, framing it, temporalizing it, and more than cubing the amount of relational information that its structure can bear. They free its signifiers from their referents in present reality and make it possible for us to lie, to imagine, and to propose the problematic in a persuasive way. Like the card tricks of Ricky Jay, pictorial illusion is magic for people who do not believe in magic.

Those who do believe in magic need not concern us here. They exist outside the discourse and beyond contemporary culture, and thus, should we discover that the illusions of Ricky Jay or of Correggio really *are* magic, they would merit neither our attention nor our amazement, because this discovery would mean that we are, in fact, not the prisoners of time—and illusions are about nothing else. They are always about time—time past, remote, or imagined—and always a matter of timing, the subject of all our mourning. For three centuries, illusionistic images aimed to slow life down—to make visible the fluid, violent, and often invisible constituents of temporal cultural experience. Then,

in the nineteenth century, with the apotheosis of modernity, artists stopped slowing down life into images and began slowing down the images themselves.

Thus, in modern painting, our comfort level with illusion is always a matter of how exquisitely we delay the illusion's taking hold, since, for reasons of ideological fashion, we must always pay obeisance to the material present before we experience the imagined past. So the painter's mark in the nineteenth century becomes, quite literally, the *matter* of time, the vehicle by which we are allowed access—at the proper or improper speed—into the imaginary realm of the image. The tiny, transparent demi-tone of Bouguereau's mark, for instance, transports us much too swiftly and in much too bodily a manner through the promiscuously open picture plane; it deceives us instantaneously, robbing us in a wink of our millennial modernity and arousing in us deep, bourgeois fears of educated rhetoric—of being *seduced!* (Eeek!) The furious gestural brilliance in an oil sketch by Sargent, on the other hand, defers the resolution of the image for far too long; it makes us work for the image, and in that working, Sargent makes us aware of our unmodern need for it.

The nice, medium-sized, middle-class daubs of your average Monet, however, are just right; they allow us to throw a bone to the present object and then they float us away, disembodied, ever so gradually, into the Arcadian world of suburban real estate. The black-and-white photograph, with its chromatic phase shift, does very much the same thing, allowing us to have our modernity and our melancholia too—since both idioms, due to the attenuated nature of our transport into the domain of the image, tend to prioritize the plangent *lostness* of the past over the living conception of it that you find in, say, a portrait by Raphael. Thus, over and above their more obvious virtues, Impressionist painting and its descendants, along with black-and-white modernist photography, function as ideal viewing material for people who only *hope* they don't believe in magic and are consequently fearful of any-

thing that looks like it—fearful, I suppose, that, on account of some moral or educational deficiency, they might be seduced into delusion or despair by some persuasive man-made piece of rhetoric.

With modernists, this is a more-or-less forgivable pathology, due to the pervasive teleological mindset of those times. Its persistence into the subtle twilight of postmodernity in the age of AIDS and poison rivers is somewhat more difficult to fathom, unless we attribute it to the return of the repressed—to vestigial Marxism or some covert, utopian longing that has somehow survived into an age which has supposedly disarmed and dismantled History into a million herstories and histories. In any case, the prospect of a chromatically glamorous verisimilar image seen through a sleek open picture plane—whether by Raphael or Cibachrome—remains as outré and ominous as Linda Lovelace at a church picnic, lurking there to suck us in.

One wonders at the primitive terror that lurks behind this obsession with de-professionalizing the mechanics of painterly illusion, restricting its practice with training wheels and keeping it operational within the bounds of lay perception, neither too fast to mitigate the volition of innocents nor too slow to occlude their perception. Finally, I suspect, this ostensibly parental concern for innocents who might be seduced by illusionistic images is little more than a mask disguising the even more pervasive illusion that people, by looking at boring "honest" images, will somehow be cured of their affection for looking at interesting "dishonest" ones. Not very likely, I think.

The extent to which we long for the delight of illusion and distrust its efficacy is probably best demonstrated by the New York vogue of card handler Ricky Jay, who packed the house at the Second Stage theater for 106 performances a few years ago with his show entitled "Ricky Jay and His 52 Assistants." Jay is, indeed,

a masterful illusionist, and he refuses to divulge his tricks on the grounds of professional etiquette, but the devices by which his illusions are framed and made safe for New York audiences speak directly to that audience's prevailing anxiety over illusion. Basically, David Mamet's production of Jay's act does for magic what Cézanne does for painting—it replaces a living history of meaning with a technical tradition of professional achievement.

The setting for Jay's production, then, is not a field of dreams, but a library; and in Jay's educational patter, Dai Vernon and Charlie Miller provide the historical validation that Puvis de Chavannes and Poussin provide for Cézanne. Jay eschews the intimidating guise of Sorcerer and opts instead for the role of avuncular practitioner. Like Cézanne, he is a professor of his practice, whose tricks have footnotes and aspire, not to the secrets of the universe, but to the mastery of that practice. In this way, Jay's tricks are contextualized into "formalist magic" that invites our connoisseurship of arcana. Our innocent delight at being harmlessly seduced is ennobled in a brown haze of pedagogical earnestness.

This strategy of historically contextualizing forbidden subjects under the guise of "education for the masses" is probably as old as the idea of forbidden subjects itself. The interest lies in what is forbidden where. Here in Las Vegas, every showgirl revue peddles sex to middle Americans in much the same way that Ricky Jay peddles magic to New Yorkers, by providing the audience with nothing so risqué as contemporary bare-breasted babes, but rather a short course in the *history* of bare-breasted babes down through the ages. This points up an interesting distinction, since in Las Vegas we like our magic as mysterious as New Yorkers like their sex au naturel. It is a matter of taste, perhaps, but the rules would seem to be: What cannot be *naturalized* in New York must be contextualized. What cannot be *mystified* in Las Vegas must be contextualized. Which, I suspect, is why Las Vegas exists, and why the hottest ticket in town is *Siegfried and Roy at the Mirage,* a magical extravaganza in which the business of illusion has been given

its full complement of Wagnerian subtexts.

Thus, during *Siegfried and Roy at the Mirage,* when Roy ascends into the heavens on the back of a white tiger poised on a mirror ball, the subtext of levitation as a metaphor for transcending nature is explicitly made. At the climax of the show, an elephant disappears—and the chorus breaks into a gospel song inciting the magicians to bring the elephant back. When the elephant is made to reappear, the whole tradition of disappearing things and restoring them is located where it should be: in rituals of death and resurrection. And no one in the audience has been seduced by these illusions into believing anything. Quite the reverse. The grandeur of the promise around which these illusions are constructed demystifies the illusions themselves. You never think, How was it done? You simply take pleasure in seeing the impossible appear possible and the invisible made visible. Because if these illusions were not just illusions, we should not be what we are: mortal creatures, who miss our dead friends, and thus can appreciate levitating tigers and portraits by Raphael for what they are—songs of mortality sung by the prisoners of time.

GODIVA SPEAKS

My years as Lady Godiva . . . First, I have to admit that I hesitated to tell this story. Because straight America makes you hesitate. But I'm not a girl who hesitates for long, and, also, I'm not embarrassed. I look at my life, and it's not like I'm some "artiste" who's been *influenced* by pop culture. I *am* pop culture: Barbie, Pez dispensers, heavy metal, professional wrestling, cheese-flavored dog food. That's me. So to cut to the chase: How did I became a "lady wrestler"? Well, I grew up here in Las Vegas as a normal suburban kid, who looked like a *perfect* suburban kid, because I was always blonde and cute and smart, and when everybody began to get figures, I got a great one. And when everybody had to do drawings in class, I was good at it, and when we all went out for sports, I could do that, too. So that was me in everybody's eyes: Little Miss Perfect.

I decided to be an artist when I was in high school, so when I graduated, I got an art scholarship to UNLV and spent three years there, scribbling away, still being Little Miss Perfect. Then, *bang!* I couldn't be perfect anymore. I just bailed. Right down I-15. Escape to L.A.! I got a house in the Hollywood Hills and waited tables in Santa Monica. I hung out in rock-and-roll clubs and partied my ass off. Enjoying my early twenties, don'tcha know. Then one night a friend from high school called me up: "Hey, Dawn," she said, "Come back and do this wrestling thing with me!" I said, "*Wrestling thing!* You got to be kidding! I'd never do anything like that!" Then I thought, "Hey, why not?" So I threw enough clothes for two weeks in my Toyota and headed back up I-15, back to Vegas. (Like I said, I'm not a big hesitater.) Three months later, I let go of my house in Hollywood. And that's how I became one of the Gorgeous Ladies of Wrestling.

In the meantime, my parents had moved to Georgia and it turned out that my friend only wanted me in Vegas so I could look

after her. Because she was having "personal" problems. They only got worse after I got here, so she dropped out of the wrestling gig, and there I was: Lady Godiva, with three squares a day and they put you up, right in the middle of the Las Vegas Strip. So I'm working for this guy who used to be married to Jayne Mansfield. I'm hanging with Jackie Stallone. I'm a member of the weirdest sorority in the world. And you have to understand, I grew up in Vegas, but I'd hardly ever been *in* a casino. My dad was a *federal agent*, for Chris'sake. He was here because of all the shit that goes down—mostly the guns, but other stuff too. So, he had a pretty clear view of the darker side of things.

I mean, one night when I was a little girl, my mom and dad and I are having dinner. At Tony Roma's down on Sahara, and suddenly there is this enormous *kaboom!* The building shakes, and the plates bounce around on the table, and my dad just calmly gets up, puts a hand on each of our shoulders, and says, "Y'all stay *right* here." Then he pulls out his gun, flips out the little deelie, checks the bullets, and flips it back in. He sticks the gun back in his holster, mutters "I'll be right back," and walks right out the door. My mom and I just look at one another. It turns out that some wiseguys have wired Lefty Rosenthal's Cadillac out in the parking lot, but it wasn't a very good bomb. It caught fire before it went off, so Lefty got out of the car before it went up, so my dad pulls Lefty away from the fire, sits him on the curb, and takes charge of the scene. After a while, my mom and I are the only people left in the restaurant, so we go outside and watch.

Anyway, that's my dad—a take-charge guy and a very scary dude. He's the reason girls go into therapy, because their dad is like my dad. I mean, he was always a loving and supportive parent, but he was definitely hard on me and sheltered me a lot. As did my mom, who is a sweet little Southern lady with this thick, Southern Baptist background. But they didn't make me afraid of things, you know. So here I am on The Strip in this crazy wrestling thing, and my friend has split, and I think, "Hey, I can *do* this."

I had been a major jock in high school. I did gymnastics, soft-ball, volleyball, tennis. You name it. So I was better prepared for wrestling than nearly all of the other girls. A lot of them had dance backgrounds, but some of them had never done anything physi-cal except sex. So I was okay. Gymnastics teaches you to know where you are when you're upside-down in the air, and wrestling is like surfing in that way. It's good to know where you are, when you're upside-down.

Anyway, the Gorgeous Ladies of Wrestling wasn't your stan-dard pro wrestling tour. First and foremost, it was a syndicated TV show invented by its producer, who was a complete lunatic. He's the guy who used to be married to Jayne Mansfield. He cre-ated the characters, laid out the storylines, the formats, every-thing. I was what they called "talent" (Not!)—which meant I didn't get paid enough money, but I loved it anyway. I was twenty-two years old and getting to do things that nobody my age was getting to do, especially not girls my age. We taped all the TV shows here in Vegas, in this old warehouse behind the Riviera. Every Saturday night we would tape matches for five or six hours. Everything out of sequence. Three or four months of shows in one night. We'd just do matches, matches, matches, matches. Sometimes I'd wrestle five times in one night, which is a bitch because not only do you have to remember what you're doing in each match, you also have to figure out where the story is going, and where your character is in it. And, of course, you have to look *gorgeous* every time. You've had your ass kicked three times, right? But you go out there and do it again, looking fresh as a daisy.

The show also used a lot of comedy sketches. We'd tape these out of sequence too, on two other nights during the week. Which is a lot of dialogue to do in a hurry. Especially when it's not par-ticularly memorable dialogue. Which it wasn't. But what's fun-nier than a pie in the face, right? So we beat it to death, did it with a smile, and people loved the show. And whatever we did, how-ever corny it was, it was all put together well, and it wasn't snotty.

192

Also, at the opening of each show, the girls did rap songs—and *that* was as about as pathetic as you can imagine. You want to see Little Miss Whitebread do a rap, right? It was lame, but that was funny too. We also got to do diatribes, where we threatened our opponents, and I'd get to write some of that. Actually, I got to write a lot of stuff as time went on. I wrote all my raps and a lot of the raps for girls who weren't so verbally inclined.

So it was really a . . . well, I shouldn't say a *grueling* schedule, because there's a lot worse schedules, but it was a real *physical* schedule. It wasn't like doing a soap opera that's on every day, but it was still a lot of work. And then, when we had about a season-and-a-half's worth of matches in the can, we'd go out and wrestle on the road. And the live show was totally different from the TV show. The TV show was tongue-in-cheek. It didn't have to be larger than life. It got to be smaller than life, in fact, but in the live show we'd try to do big, spectacular things. Major showbiz.

This was fun. When you went out on the road, you got to position your characters in the ongoing narrative that was being shown on television, since certain rivalries were being built up through the season. So they would put the best rivalries together for the live matches. Like my main rivals . . . well, I had quite a few since I was one of the stronger bad guys. But my main rivals were Roxy Astor, Cheyenne Cher, and Daisy. A Park Avenue snob, a cheerleader, and a big, dopey, six-foot-three giant. That was Daisy, who was my best friend on the tour, and her "back story" was great. In the first season, she was enslaved by a dwarf. For gambling debts. Her character was this sweet, shuffling, innocent girl who was very impressionable. Sometimes she was a good girl, because the good girls would sway her over, then we bad guys would get hold of her. In fact, she was the best wrestler of all of us . . . the best female wrestler I've ever seen.

Actually, I've never thought about it till now, but we bad guys always called ourselves that: "bad *guys*," while the good characters were always "good *girls*." I guess it's like a gender thing—because

"bad girls" means something else—and we were "bad" in the way that guys are bad. Anyway, other bad guys were Hollywood, who was real good-looking and a really good wrestler, and Big Bad Momma, who weighed about 310, and Beastie, who was a great bad guy. Her character was a blend of Road Warrior and Gene Simmons of Kiss. She was *so* great. A lot of the time, she was my partner. I would enter the ring on this big, white horse (of course), and Beastie would lead the horse. But her character was also very stupid, so Beastie and I would get into fights after every match because she would do something to mess up my evil plans. Also, she was just as impressionable as Daisy, so all the good girls had to do was throw her a hot dog and she was theirs. Candy, hot dogs, beer, and she's yours. And you want that, don'tcha?

Dementia was really great, too. She never said a word, carried an axe around, and wore a hockey mask. Also s&m, Sarah and Mabel. They were sort of *Deliverance* types, backwoods rednecks who wore bags on their heads. So we liked them. And there was Stinky, who was a Brooklyn punk with a skunk-colored mohawk. Stinky stunk. She would debilitate her opponents by exposing her armpits. And my character, of course, was this upper-crust British jet-set tramp, sort of like Fergie, but better looking. The story was that Godiva was the great-great-great-great-great-great-grand-daughter of Lady Godiva, the Lady of Coventry. You know her story, I'm assuming. I left Coventry because I had been kicked out of several boarding schools. I got kicked out of the last one for a public display of nudity. So I moved to New York, saw the Gorgeous Ladies of Wrestling on TV, and thought, "This is for me!" and started wrestling. So that was Godiva's "back story." She was a fun-loving girl . . . very self-serving and smart. Her philosophy in the ring was do what you have to do to win. And if you have to cheat a little, well, cheat a little. It was a great character, and I had to speak with an English accent all the time, because you were never supposed to be out of character. Even after the show, if you went out partying, you stayed in character. So the good girls and

the bad guys couldn't go out together. And I had to keep my accent. They brought in a coach from California to teach me, so I sounded like Michael McKean in *Spinal Tap*, but the accent put this distance between me and Godiva. Which was okay.

On the road, though, I was *always* Godiva, and the road was the *best*, even though you get tired of girls, girls, girls. I mean, put thirty women together on a tour bus for two months and someone is always on their period. And you never get any privacy. I remember this one tour. We named it "The Piss Poor Tour," because it was four of us to a room and totally fleabag motels, but even that one was a blast. Because when you're doing something like this, something that's just so weird, you really get a sense that weird is normal. And that everybody else is weird.

So it was a gas. And people loved us. In the South, we were like Michael Jackson. They chased us down the street. One night in Biloxi, our tour bus had to have a police escort because there were so many fans around the back entrance of the coliseum. Also, we had to go and eat after every show. One night, we had to drive ninety miles because carloads of fans kept following the bus, pulling alongside and waving. Which sounds great unless you haven't eaten all day, and you've just had your butt kicked and you've sweated every ounce of nutrient out of your body.

But that's wrestling fans. They are like no other. I remember one woman. She was ringside, big as a house and with very few teeth. And she was screaming at me so loud it was almost distracting. *Screaming* at me. Screaming obscenities. Telling me how horrible I was. How fat and ugly I was. How fucking this, how fucking that. Screaming. And afterwards, what does she do? She comes running up to get my autograph. "Did you see me out there?" she says, and I'm saying, "Lady, you were breaking my heart!"

Thinking back, there were a lot of lost souls in that group, a lot of very confused girls. The girls I hung around with were like me, middle-class kids out to have a good time, rock-and-roll

chicks. Then there was a lesbian clique, and then there were the degenerates and delinquents, who were sort of on their way to stuff even weirder than the Gorgeous Ladies of Wrestling. One of them is now a major porn star. But once we'd been together for a while, we were sort of like one big family, and it was like any other family. You got your fucked-up family members and your shit-together family members. But you could pretty much deal with everybody, because you pretty much had to, having a physical job where your safety depends on the girl who's your opponent.

But we were having fun. Partying, you know, having a good time out there in the night. And we were cool, because we could take care of ourselves. Guys always ask me, "Did you have body-guards?" and I go, "Come *on*, guys!" Because people didn't fuck with us. Or if they did, they wished they hadn't. Actually, though, the bars and clubs were a lot more dangerous than the ring. We knew what we were doing in the ring, and, also, it wasn't all that serious. What the Harlem Globetrotters are to basketball, we were to wrestling. The Globetrotters are great basketball players, right? But they're goofing on you, and so were we. We weren't out there sweating and bleeding. We were out there being campy and being girls. But, even though it was a goof, we had our fucking stan-dards. I think the audience got that. They'd really get into it, shouting and screaming, but at some level they knew. I know they did, although the only proof I have is the one time I saw a girl get hurt in the ring. Real bad. Her elbow came out and went up to *here*. Prior to that, the whole audience had been screaming "Kill her! Kill her! Break her arm! Break her arm!" Then, when her arm came out . . . dead silence. *Dead* silence. So people aren't stupid. They get in there and they want to believe it and have fun believ-ing it, but I don't think they really want to see someone's elbow come loose.

Or even want to see a naked woman, not there, not really, and, you know, people always ask me if I felt exploited as a woman when I was wrestling, and I've thought about it. Because I *have*

felt exploited in other contexts, but if you asked me about the Gorgeous Ladies of Wrestling, I'd have to say, not really. It was a goof, but we were always shown as strong and capable women. We may have been sleazy, but we were not wimps. Nobody ever cried as a part of the show. Nobody would reduce their character to that. I threw plenty of temper-tantrums, naturally. Every time I lost, I threw a tantrum. So, I was pretty bratty and the cheer-leaders were pretty bratty, too, but nobody ever cried. Also, there was *no* male image in the show. The only guys were the referees and the ring announcers, all of whom were weenies—little, wimpy guys. So we would terrorize them. We'd pull their pants down and make fun of their boxer shorts. We'd tie them up and throw them out of the ring. So, actually, it was kind of therapeutic. We stood pretty much on our own out there. And it was a sexy show, but it wasn't a sex show, and I don't have a problem with sexy. I'm sexy, live with it.

Actually, you want to know where I felt exploited? After I had done *Playboy* and *Donahue* and *Family Feud* and all that, I began getting some chances to do Hollywood stuff. So I did this pay-per-view thing in Hollywood, and I *hated* that. Hated the people. Hated the whole thing. The women all acted really stupid or really bitchy—and maybe they were. And these guys just moved you around like a sack of grain and dictated every tiny move you made. And, I'm not saying that being a Gorgeous Lady of Wrestling was major-league *creative* or anything, but it was better than that. First, we always had an audience, and, within the context of the show, we got to do our thing and contribute enough to keep us awake.

You got to write your diatribes and your rap songs if you wanted to. And you and your opponent got to plot your own matches. The storyline was planned out by the writers, of course. We were given a basic storyline and an outcome, but other than that, the two girls who were wrestling worked it out together. So it was like improvising on a song or a dance or something.

Actually, it was a lot like rock-and-roll. All of it. It was the

same world: the coliseums, the arenas, the clubs, the Denny's in the middle of the night. And it was a gas to be weird and famous in that world, which is a guy world. It put you on a stronger footing as a woman. These dudes were getting *our* autographs, you know. So I got to teach some wrestling holds to Flea, who plays bass for the Red Hot Chili Peppers. My friend Hollywood and I dated these two guys from Mötley Crüe for a while, which was major L.A. glamour stuff back then. And the best thing, I'll tell you about. I was going on the Jerry Lewis Telethon in New York to introduce Sammy Davis, Jr., right? And I hear this voice behind me saying, *"Jeeeesus, it's Lady Godiva!"* So I turn around, and it's Joey Ramone! Right there! Now, is that cool or *what?*

FRIVOLITY AND UNCTION

The darker side of channel surfing: I was ensconced in a motel in the heartland on a Sunday evening. Abandoned by my keepers at the local university, I was propped up on the bed, eating a burrito and swooping through the channels when I realized that I had just flipped past a rather bizarre primetime option. Reversing my board into the curl, I flipped back a couple of channels, and, by jiminy, there it was: the auction room at Sotheby's, in the teaser for *60 Minutes*. I was teased, naturally, so I "stayed tuned" for what turned out to be a televised essay on the fatuity and pretentiousness of the art world. Morley Safer played Gulliver in this essay. Various art personalities appeared in the role of Houyhnhnms. I just sat there frozen, like a deer in the headlights. Then I caught the drift, relaxed, and tried to get into it. No one was being savaged about whom I cared that much. Nothing very shocking was being revealed. It was just the same old fatuous, pretentious art world, and nothing confirms me more strongly in my choice of professions than a good healthy dose of sturdy, know-nothing, middle-American outrage at the caprices of this world.

Over the years, I have become something of a connoisseur of mid-cult portrayals of the art world. Among my favorites are the six or seven "art episodes" of *Perry Mason,* with their egregious fakes and heartless frauds, their felonious art dealers, patronizing critics, vain artists, and gullible collectors. I also keep a warm place in my heart for Waldo Lydecker, the psychopathic art critic and connoisseur played by Clifton Webb in *Laura*. For a kid like me, stranded out in the big bland, beguiled by glamour and hungry for some stylish action, the image of the effete Waldo in his posh Manhattan digs, reclining in his perfumed bath, shattering someone's reputation with a whisk of his poison pen, was a deftly alluring one—and remains so, in fact.

No more alluring, however, than the rough, improvisational

world that I inferred from Luce Publications' sneering coverage of Jackson Pollock's unruly triumph and Andy Warhol's apocalyptic opening at the Institute of Contemporary Art in Philadelphia—where they took down the paintings to make room for the party. For myself, and for many of my friends, these news magazine stories provided our first fleeting glimpse of something other—of something braver and stranger. We recognized the smirky, condescending tone of these stories, but kids are expert in decoding this tone, which invariably means: This may look like fun, but don't do it. But it still looked like fun, and thus, far from retarding the progress of peculiar art and eccentric behavior, poor Hank Luce inadvertently propagated it, seeding the heartland with rugged little paint-splashers and frail, alien children with silver hair.

The world portrayed in Morley Safer's essay on *60 Minutes* did not look like fun. No matter how artfully decoded, the piece was not going to lure any children out of the roller-rink in Las Cruces. It was obsessed with money, virtue, and class-hatred—issues ill-designed to put your thumb out in the wind. Safer's piece did, however, fulfill the conditions of satire: It was unrepresentative, ungenerous, and ruthlessly unfair—but it was not wrong. It was wrong-headed, ignorant, and ill-informed about art, as well, but if these afflictions disqualified folks from commentary, more than half of the art community itself would be stricken mute. So I was cool with Safer's jibes. It's a free country and all like that, and who the hell watches *60 Minutes*, anyway, unless they're stranded in a motel out by the highway in the middle of America?

Also, Safer's piece did present some possibilities. It was not going to lure any loonies out of the woodwork, but what a *delicious* straight man Safer was!—what an exquisite target for dazzling *repartie*, for manifestations of *élan*, demonstrations of *panache*, and other French attitudinal stratagems that might constitute a lively and confident response to Morley's mid-cult unction. "Morley who?" "Sixty what?" "You watch TV on Sunday night?" "Don't

you have any *friends!?"* Even rudimentary dish like this would have been welcome, but it never materialized. In fact, a great many of my colleagues just lost it. What seemed routinely unfair to me was construed by them as cruelly *unjust!*—and this "injustice" was quickly transformed into "oppression," conjuring up, once again, the fascist heel, stomping down upon the frail ladybug of "the art community."

In the following weeks, people who should have known better filled the air with self-righteous bleats of indignation and defense—no easy task since one could hardly attack Safer without seeming to defend the perspicacity of West Side collectors, the altruism of Sotheby's auctions, and the *gravitas* of Christopher Wool. Even so, the art world just capitulated. Far from exhibiting magisterial disdain, the director of a major American museum even appeared with Safer on *The Charlie Rose Show.* Challenged by Safer with the undeniable fact that contemporary art lacks "emotive content," this director of a major museum insisted, in effect, that "It does *too* have emotive content!" confessing that he, personally, had burst into tears upon entering Jenny Holzer's installation at the Venice Biennale. *Well, didn't we all,* I thought (there being tears and tears), and at that moment, had there been an available window or website at which I could have resigned from the art world, I should certainly have done so.

I couldn't believe it. Within the year, I had seen similar and even more acerbic pieces on the music business and the film industry in primetime, and the members of *these* communities had somehow managed to maintain their composure—had kept their wits about them and simply refused to credit the Church Lady standards to which they were being held accountable. None of my colleagues (excepting the redoubtable Schjeldahl) quite rose to this challenge, and it occurred to me that their pedantic squeal was not dissimilar to the aggrieved hysteria with which the French Academy responded to the father of my profession, La Font de Saint-Yenne, when he published the first *Salon* in 1737—a tract

that is no less entertaining, ignorant, and ill-informed than Safer's. So I found myself wondering why the music and film communities could respond to bourgeois punditry with such equanimity, while the French Academy and the contemporary art world went certifiably ga-ga. I came up with one answer. Music and movie people are not in denial about the frivolity of their endeavor, while the contemporary art world, like the French Academy, feels called upon to maintain the aura of spectacular unction that signifies public virtue, in hopes of maintaining its public patronage. It was like a *Brady Bunch* episode: "Accused of frivolous behavior and fearful of losing their allowance, the Brady kids take Holy Orders and appear on *Charlie Rose*. 30 min. Color."

So here's my suggestion: At this moment, with public patronage receding like the spring tide anyway and democracy supposedly proliferating throughout the art world, why don't all of us art-types summon up the moral courage to admit that what we do has no intrinsic value or virtue—that it has its moments and it has its functions, but otherwise, all things considered, in its ordinary state, unredeemed by courage and talent, it is a bad, silly, frivolous thing to do. We could do this, you know. And those moments and those functions would not be diminished in the least. Because the presumption of art's essential "goodness" is nothing more than a *political fiction* that we employ to solicit tax-payers' money for public art education, and for the public housing of works of art that we love so well their existence is inseparable from the texture of the world in which we live.

These are worthy and indispensable projects. No society with half a heart would even think to ignore them. But the presumption of art's essential "goodness" is a conventional trope. It describes nothing. Art education is *not* redeeming for the vast majority of students, nor is art practice redeeming for the vast majority of artists. The "good" works of art that reside in our museums reside there not because they are "good," but because we love them. The political fiction of art's virtue means only this: The practice and

exhibition of art has had beneficial public consequences in the past. It might in the future. So funding them is worth the bet. That's the argument; art is good, sort of, in a vague, general way. Seducing oneself into *believing* in art's intrinsic "goodness," however, is simply bad religion, no matter what the rewards. It is bad *cult* religion when professing one's belief in art's "goodness" becomes a condition of membership in the art community.

So consider for a moment the enormous benefits that would accrue to us all, if art were considered bad, silly, and frivolous. Imagine the *lightness* we would feel if this burden of hypocrisy were lifted from our shoulders—the sheer *joy* of it. We could stop insisting that art is a "good thing" in and of itself, stop pretending that it is a "good thing" to do—to do "good"—and stop recruiting the good, serious, well-educated children of the mercantile and professional classes to do it, on the grounds that they are too Protestant, too well-behaved, too respectful, and too desirous of our respect to effect any kind of delightful change. We could abandon our pose of thoughtful satiety, reconceive ourselves as the needy, disconsolate, and desiring creatures that we are, and dispense with this pervasive, pernicious, Martha Stewart canon of puritan taste with its disdain for "objects of virtue" and its cold passion for virtue itself.

We could just say: "Okay! You're right! Art is bad, silly, and frivolous. So what? Rock-and-roll is bad, silly, and frivolous. Movies are bad, silly, and frivolous. Basketball is bad, silly, and frivolous. Next question?" Wouldn't that open up the options a little for something really super?—for an orchid in the dung heap that would seem all the more super for our surprise at finding it there? And what if art were considered bad *for* us?—more like cocaine that gives us pleasure while intensifying our desires, and less like penicillin that promises to cure us all, if we maintain proper dosage, give it time, and don't expect miracles? Might not this empower artists to be more sensitive to the power and promise of what they do, to be more concerned with good effects than

with dramatizing their good intentions?

What if works of art were considered to be what they actually are—frivolous objects or entities with no intrinsic value that only acquire value through a complex process of socialization during which some are empowered by an ongoing sequence of private, mercantile, journalistic, and institutional investments that are irrevocably extrinsic to them and to any intention they might embody? What if we admitted that, unlike seventeenth-century France, institutional and educational accreditation are presently insufficient to invest works of art with an aura of public import—that the only works of art that maintain themselves in public vogue are invariably invested with interest, enthusiasm, and volunteer commitment from a complex constituency that is extrinsic both to themselves and to their sponsoring institutions?

If we do this, we can stop regarding the art world as a "world" or a "community" or a "market" and begin thinking of it as a semi-public, semi-mercantile, semi-institutional agora—an intermediate institution of civil society, like that of professional sports, within which issues of private desire and public virtue are negotiated and occasionally resolved. Because the art world is no more about *art* than the sports world is about *sport*. The sports world conducts an ongoing referendum on the manner in which we should cooperate and compete. The art world conducts an ongoing referendum on how things should look and the way we should look at things—or it would, if art were regarded as sports are, as a wasteful, privileged endeavor through which very serious issues are sorted out.

Because art doesn't matter. What matters is how things look and the way we look at them in a democracy—just as it matters how we compete and cooperate—if we do so in the sporadic, bucolic manner of professional baseball, or in the corporate, bureaucratic manner of professional football, or in the fluid, improvisatory manner of professional basketball. Because, finally, the art world is no more a community than Congress is a community, although,

like Congress, it is in danger of *becoming* one and losing its status as a forum of contested values where we vote on the construction and constituency of the visible world. Works of art are candidates, aspiring to represent complex constituencies. So it is important that the value of art, *as* art, remains problematic—and equally important that none of us are disinterested in its consequences, or involved just for the "good" of art, which is not good. So consider these three benefits.

First, if art were considered a bad, silly, frivolous thing to do, works of art could fail. They could do so by failing to achieve a complex constituency—or by failing to sustain a visible level of commitment and socialization—and this failure would be public and demonstrable, since everyone involved would be committed to their own visual agendas and none to the virtue of "art." Such failure, then, would constitute an incentive to quit or to change—with the caveat that works of art with any constituency at all may sustain themselves in marginal esteem until, perhaps, their time has come. The practice of maintaining works of art in provisional esteem simply because they *are* works of art and art is good, however, robs artists of the primary benison of mercantile civilization: certifiable, undeniable, disastrous failure.

In warrior cultures there is no failure. There is only victory and death. In institutional cultures there is neither failure nor success, only the largesse or spite of one's superiors. Failure, however, is neither death nor the not-death of institutional life; it is simply the failure of one's peers (or the peer group to which one aspires) to exhibit any interest in or enthusiasm for one's endeavors. And there is no shame in this. In fact, such failures constitute the primary engine of social invention in Western societies, because these failures mean that you are wrong or that your friends are wrong. If you suspect that you are wrong, you change. If you think your friends are wrong, you change your friends, or, failing that, become a hobbyist. There is no shame in this, either.

Second, if art were considered a bad, silly, frivolous thing to

do, art professionals, curators, museum directors, and other bureaucratic support-workers might cease parading among us like little tin saints—like Mother Teresa among the wretched of Calcutta—and our endeavors would be cleansed of the stink of their unctuous charity. Because if everyone's involvement in the frivolity of art were presumed to be to some extent self-interested, these caregivers would have to accept the obligation of taking care of *themselves* in pursuance of their own ends, and if these ends were just to hang around with artists and put on shows out of which nothing can sell, they could finance these purportedly public-spirited self-indulgences themselves.

This would abolish a fiction that is nowhere confirmed in my experience: that the art world is divided into "selfish commercial people" and "selfless *art* people"—the selfish commercial people being the artists, critics, dealers, and collectors who take the risks, produce the product, and draw no salary—the "selfless *art* people" being the disinterested, public-spirited, salaried support-workers, who take no risks, produce no product, and dare not even *buy* art with their art-derived salaries, lest they be guilty of "conflict of interest." The truth is that *everyone* is interested and self-interested and should be. Everyone waters their own little flower (although some do so at less risk than others). Moreover, *everyone* is public-spirited: Everyone who waters their little flower tends the garden, as well, because no one is such a fool as to imagine their flower might flourish if the garden goes to seed.

Yet we continue to presume that honest virtue somehow inheres in those art functionaries who receive salaries, ideally from public sources, and that vice just naturally accrues to those who must live by their wits. Through the exquisite logic of Protestant economic determinism, virtue is ascribed to those who can afford to live nice, regular middle-class lives as a consequence of their submission to whatever authority dispenses their salary, and those who disdain such authority are, well, problematic. For the first time in history, in American art circles, the term "commercial

artist" does not designate a guy who draws Nikes for *Sports Illustrated*. It designates an artist without a trust fund who has been unable to secure a grant or a teaching job.

If everyone declared their own self-interest, however, brought their own little flowers out of the hothouse and took responsibility for acquiring the wherewithal to water them, artists, critics, and dealers, who get paid by the piece, could stop parenting their self-appointed parents by donating their production to be frittered away or auctioned off by the support systems that supposedly support *them*—which, in fact, only erodes the market for the work donated and almost certainly insures the need for continued charity. Having said this, we must remember that presumptuous demands for theatrical gratitude by self-appointed caregivers are not local to the art world; they are the plague of this republic. The police complain that citizens don't support them; museums and alternative spaces complain that artists don't support them; radicals complain that workers don't support them; feminists complain that women don't support them. Nobody will do anything for anybody anymore, it seems, without a big hug in return. Yet, if such voluntary care constituted genuine advocacy, these demands would not be made. Thus, when they are made, they may be taken as self-serving and ignored. Making and selling and talking about art is simply too much fun and too much work to be poisoned by that perpetual begging whine: "We're only trying to help!"

Finally, if art were considered a bad, silly, frivolous thing to do, I could practice art criticism by participating in the street-level negotiation of value. I might disregard the distinctions between high and low art and discuss objects and activities whose private desirability might be taken to have positive public consequences. As things stand, my function as a critic is purely secondary unless I am writing or talking about work in a commercial gallery. Otherwise, I am a vestigial spear-carrier in aid of normative agendas. In commercial galleries and artists' studios, the value of art

is problematic by definition; and in these spaces, dealers, collectors, critics, and any other committed citizen who is willing to risk something enter into an earnest colloquy about what this silly, frivolous stuff might be worth.

If I praise a work in a commercial space, I invest words in it and risk my reputation. In doing so, I put pressure on the price by hopefully swaying public opinion. If I praise an exhibition in an institutional space, however, I am only confirming public policy. And since no art is for sale, I am really doing nothing more than the institution itself: giving the artist "exposure" (which should be a felony) and reinforcing the idea of art as a low-cost, risk-free spectator sport when in fact it is a betting sport. Thus, my institutional bets are nothing more than fodder for grant applications and résumés—a fact that becomes clear when I choose to detest an institutional exhibition, since, in doing so, I am questioning the fiduciary responsibility of expending public funds on such an exhibition and undermining the possibility of future funds. This, I have discovered, is taken very seriously indeed, although it has *nothing* to do with investing art with social value and everything to do with art's presumed, preordained virtue and the virtue of those who promote it.

So, I have been thinking, if art is "good" enough to be deserving of public patronage, just what does it do? I would suggest that since such work must be designed in compliance with extant legislation and regulatory protocols, it can only work on behalf of this legislation and those protocols. It can encourage us not just to obey the laws that we all fought so hard to pass, but to *believe* them, to internalize the regulatory norms of civil society into a "cultural belief system." Unfortunately, art that aspires to this goal is nothing more or less than *tribal art,* a steady-state hedge against change and a guarantee of oppression in the name of consensus, however benign.

To cite an instance: a young art professional, in aid of this tribal agenda, actually had the gall the use Robert S. McNamara's

Vietnam-era expression "winning their hearts and minds" in my presence. When I recovered from my flashback, I told her that, in my view, if you catch their eye, their hearts and minds will follow. She didn't even get the reference, and I could tell that it seemed perfectly reasonable to her that artists would subordinate their endeavors to the norms of "right-thinking people." This is good tribal thinking. In mercantile democracies, however, the practice of secular art, from Édouard Manet to Cindy Sherman, has invariably been the product of "wrong-thinking" made right. Because such works represent more than what they portray. They represent us in the realm of the visible, and if they represent enough of us, and if we care enough, yesterday's "wrong-thinking" can begin to look all right. It's a dangerous game, but it's the only one in town.

So, I'll tell you what I would like. I would like some bad-acting and wrong-thinking. I would like to see some art that is courageously silly and frivolous, that cannot be construed as anything else. I would like a bunch of twenty-three-year-old troublemakers to become so enthusiastic, so noisy, and so involved in some stupid, seductive, destructive brand of visual culture that I would feel called upon to rise up in righteous indignation, spewing vitriol, to bemoan the arrogance and self-indulgence of the younger generation and all of its artifacts. Then I would be really working, really doing my thing, and it would be so *great!* And it is *going* to happen, is already beginning to happen. The question is whether or not we will recognize it when it catches our eye.

Mayflies, An Envoi

"I am very free now," he said.

We were sitting on the verandah overlooking the dry lake bed. The angle of the shadow fell across his face so I could only see his lips and chin. They were smooth and well-made. Patrician features, I suppose, expressing no particular sense of strength, nor any sense of weakness, either. He was just a pleasant looking young man wearing a fresh linen shirt, pressed black linen slacks, and a pair of rubber flip-flops. He sat in a tall rattan chair with his legs crossed, his hands resting in his lap, his head tilted back into the pyramid of shadow.

"I am very free now," he said again, sounding calm as he said it, although I couldn't see his eyes. "I am more free," he said, "than any member of my family in the past four hundred years. Of all those who have gone before me, I am the one most free."

The young man's declaration didn't seem to require a reply, or, at least, I couldn't think of one, so I nodded to acknowledge what he had said. He nodded to acknowledge my acknowledgment and continued.

"For instance," he said, "I used to gamble. I thought that was required of me. So I did it. Now, I can see that I am too free even for that, and when you are too free even for baccarat, you are extremely free."

"More free than I am," I said.

"Yes, but you are extremely lucky," he said. "And that is a lot better than being extremely free."

I didn't want to discuss it. It seemed to me that he was extremely lucky, too. Lucky to have found a friend when he needed one. I looked off toward the pink mountains.

"They say Coronado marched through here," I said, raising my arm to point, "right through that notch in the mountains, on his way north."

"He must have felt at home," the young man said. "This is a landscape in which I feel at home. It is very old."

"Old," I said. "But not very free."

"Landscapes cannot be free or not-free," he said. "Unless you are political. But it is interesting to think about. Perhaps one of us, one of my family, came riding up through here with Coronado. I do not know for certain. It is not documented, as the connection of my family with Columbus and Velázquez is documented, but it is very likely nevertheless. Wherever there are beans, there will be those to count them. Particularly if they are government beans."

"Bean-counters," I said.

"Bureaucrats," he said, "civil servants, pirates of the quill. That is the traditional calling of my ancestors."

"My ancestors were shopkeepers," I said.

"Shopkeepers speed things up," he said. "My ancestors devoted their lives to slowing things down, to stately progress that was so stately, it was not, in fact, progress at all. I have one ancestor who devoted his adult life to discrediting Don Diego de Silva Velázquez. Day in and day out, while the great painter was painting, my ancestor was diligently scrutinizing his accounts, searching for some implication of fiduciary irresponsibility. The idea was to deny Velázquez his knighthood, of course, and my ancestor was not successful in this. He did succeed in slowing things down for many years, however, just by industry and innuendo."

"Your family is very old," I said.

"Compared to yours, perhaps. Compared to this landscape, we are a few generations of mayflies. So why should I bother about them?"

"Because they are a very old family compared to mine," I said.

"A good point," he said, with the faintest of smiles on his lips, "perhaps I am rationalizing my obligation."

"You don't have to rationalize anything," I said flatly, "if you intend to pay me."

"So, perhaps I am slowing things down? Engaging in dila-

tory stratagems? Expressing my genetic proclivity? So, perhaps I am less free than I said I was."

"So, perhaps you should make an effort to get as free as you say you are," I said. Actually, I was in no hurry. I was tired of driving and had no intention of pressing matters toward their inevitable conclusion, since that would require my getting back behind the wheel. Still, the kid was getting on my nerves a little bit.

"Do you know the great tragedy of my family?" he said, continuing to slow things down. "The great tragedy is that we nearly had a Pope. That is what my great aunts would tell me when I was a child. They would be dressing me for Mass and they would say, 'Remember, we nearly had a Pope. We would have had a Pope,' they would say, 'were it not for that drunken sodomite from Avignon.'"

"Which drunken sodomite?" I asked.

"Oh . . . some French Cardinal," he said, waving the fingers of one hand in front of his face as if he were brushing away a fly. "It's a family legend. The details vary according to the person you are talking to. Either this arrogant frog refused to stay bribed and allowed the smoke to go up for an Italian. Or the noble Cardinal died stinking drunk in the arms of a young priest on the night before the election. With the same consequences."

"Is that so bad?" I said. "Not having a Pope?"

"Well, perhaps not. But having a Pope is a very great honor. So, many of my great aunts date the decline of our family from that moment. From that moment we *nearly* had a Pope."

"So you lost the Super Bowl," I said, "and the franchise went to hell."

He nearly laughed at this. "You are an extremely American person," he said.

"I play the ponies, Paco," I said. "You don't have to tell me about bloodlines." I smiled when I said this because I was trying not to be angry with him. He was really not such a bad kid.

"Please, don't be angry with me," he said, picking up on it.

"I bought this place so I could be alone. And now I am a little lonely in it."

"I understand," I said.

"You do?" he said.

"Yes. I understand that I have driven all the way out here to collect a loan that I made to a friend. And I understand that he is not going to pay me until he has told me everything that he wants to tell me. Everything he thinks I should know."

"So you do understand."

"That much, at least."

"Well, understand, too, that I have really stopped gambling. I look forward to visiting you, and not gambling the whole time I am there."

"You're always welcome," I said, "whether you gamble or not."

"I am ashamed that I lost so much, so foolishly, you know. But I am also a little ashamed that I can afford it."

"Now you sound like an American," I said. "But that's not what you wanted to tell me."

"No," he said. "I wanted to tell you about the greatest of my great uncles, the greatest of my ancestors. And about the greatest adventure in European history. The voyage of Columbus. That was a great adventure, was it not?"

"As adventures go," I said.

"And my ancestor was on that voyage, you see. But he was not an adventurer. He was a spy for the King. He was sent to spy on Columbus, of course, but most of all to spy on the Queen's spies, who were spying on Columbus—and to make sure there was no breach of fiduciary responsibility in the expenditure of hemp, canvas, and biscuit."

"A bean-counter," I said.

"A transatlantic bean-counting snitch on the greatest adventure in the history of Europeans," he said.

"That was his job," I said.

"Yes, and my ancestor did it well," he said. "He died in

Hispaniola, of some American disease, I think. Or perhaps he was murdered. I don't know, but there was no disgrace in it, since he left exquisite records. Some of them were used later to prosecute Columbus."

"And that bothers you," I said.

"Well, how should I feel? I understand bean-counting, the need for it, and the need to slow things down, but when I was a child, I told my friends that my ancestor was a great adventurer, a dreamer. That he was with Columbus, not against him, trying to slow him down. Of course, if he *had* been with Columbus, he would have been in the vast minority on that voyage, since nearly everyone was against him, spying on him, or counting beans."

"So you wish somehow to redeem the guilt of your greatest ancestor. That is very American."

"No. I merely wished to transcend bean-counting, to speed things up, for once. So I sent my money forth to battle the baccarat shoe and hoped to follow it. But it sailed away into the slot and left me sitting there, where you found me."

"A lesson for us all," I said.

"A lesson for me, at least," he said, drawing a folded check from the pocket of his white linen shirt. Leaning forward, he handed it to me.

I unfolded the check. "This is for the full amount," I said. "Are you sure you can afford it?"

"All too sure," he said.

"I don't want to leave you short of walking-around money," I said.

"If I intended to walk around," he said, "I would not be short of money to do it with."

I slipped the check into my billfold and smiled at him. "You realize this leaves me with no reason to come back and visit you," I said. "If you only paid me half, I would have a reason to come back."

"Well, then I will come and visit you."

"And not gamble," I said, rising to my feet.

"And not gamble," he said. "From now on I will neither slow things down nor speed things up. I will ride the pulse of things and look at the desert."

"You have a nice place to do it from," I said. "Very nice."

I extended my hand to him. He rose to his feet and took it.

"Thank you, my friend," he said, clasping my hand in the two of his. "Of course, the floors are not yet what they should be, but I plan to work on them. Out here, where no one can see me working. Then, when the floors are correct, I will really be free."

Acknowledgments

Since this book comes out of the air, I must express my deepest gratitude to those whose words and gestures I have snatched out of it and appropriated for my purposes, especially to Dawn Rice Sanders, whose narration of her life as a lady wrestler I have simply typed up, and to Waylon Jennings, whose fugitive observations on the performing life I have conflated into an uncharacteristic soliloquy. Thanks to Waylon, as well, and to Willie Nelson, Bobby Bare, and Hank Williams, Jr. for their insights into the life and art of Hank Williams; and thank you to Isaiah Berlin, Jane Jacobs, Jacqueline Lichtenstein, Nathalie Sarraute, and Leo Steinberg, who are uncredited in a text upon which their writings have had considerable impact. To Gary Kornblau, editor deluxe, my affection and respect for once again having the style to disdain fashion. To Mary Jane Crook, Martha Marshall Chapman, and Susan Freudenheim, who suffered at close range the eccentricities made manifest in this text, my undying affection—and to my wife, Libby, love unadorned.

Finally, since the experiences recounted in this book have been compressed, elided, collaged, and occasionally disguised to protect the guilty, my apologies to those who remember it differently, or remember it all too well.

"A Home in the Neon" appeared in *Art issues* #35 (November/December 1994) and was reprinted in *Art & Design* #51 (November/December 1996); "Simple Hearts" appeared as "Parrot Fever" in *Art issues* #44 (September/October 1996); "Shining Hours/Forgiving Rhyme" appeared in *Art issues* #40 (November/December 1995); "Pontormo's Rainbow" appeared in *Art issues* #45 (November/December 1996); "A Rhinestone as Big as the Ritz" appeared as "A Rhinestone as Big as the Ritz: Liberace and His Amazing Museum" in *Art issues* #22 (March/April 1992); "The Birth of the Big, Beautiful Art Market" appeared in *Art issues* #42 (March/April 1996); "A Life in the Arts" appeared as "Chet Baker: A Life in the Arts" in *Art issues* #19 (September/October 1991); "My Weimar" appeared in *Art issues* #41 (January/February 1996); "Freaks" appeared as "Freaks Again: On Psychedelic Art & Culture" in *Art issues* #31 (January/February 1994) and was expanded from gallery notes written to accompany "The Contemporary Psychedelic Experience" at the Chapman University Guggenheim Gallery (March 17–April 27, 1993); "The Delicacy of Rock-and-Roll" appeared in *Art issues* #39 (September/October 1995) and an abridged version was reprinted as "Rage and a Haircut" in the *Utne Reader* #73 (February 1996); "Dealing" appeared as "Art is Cheap" in *Art issues* #47 (March/April 1997); "Magazine Writer" appeared as "Grover Lewis: An Appreciation" in the *Los Angeles Times* on June 25, 1995; a shorter version of "A Glass-Bottomed Cadillac" appeared in *Country Music Magazine* (January 1984) and was performed by Barry Tubb at Lubbock or Leave It: Butch Hancock's Performance Space in Austin, Texas during a four-week run beginning on January 11, 1996; "The Little Church of Perry Mason" appeared in *Art issues* #36 (January/February 1995); "Romancing the Looky-Loos" appeared in *Art issues* #46 (January/February 1997); "The Heresy of Zone Defense" appeared in *Art issues* #37 (March/April 1995); "Air Guitar" appeared as "Critical Reflections" in *Artforum* Vol. XXXIV, No. 1 (Summer 1995); "Lost Boys" appeared as "Lost Boys: Siegfried and Roy at the Mirage" in *Art issues* #14 (November 1990), with parts taken from the author's interview with the artists that appeared in *Interview Magazine* (August 1990); "This Mortal Magic" appeared as "A Matter of Time" in *Parkett* #40/41 (1994); "Godiva Speaks" appeared in *Art issues* #38 (Summer 1995); "Frivolity and Unction" appeared in *Art issues* #43 (Summer 1996); "Mayflies" appeared in *Silence Please: Stories After the Works of Juan Muñoz"* (The Irish Museum of Modern Art, Dublin and Scalo Zurich–Berlin–New York, 1996).